Put any picture you want on any state book cover. Makes a great gift. Go to www.america24-7.com/customcover

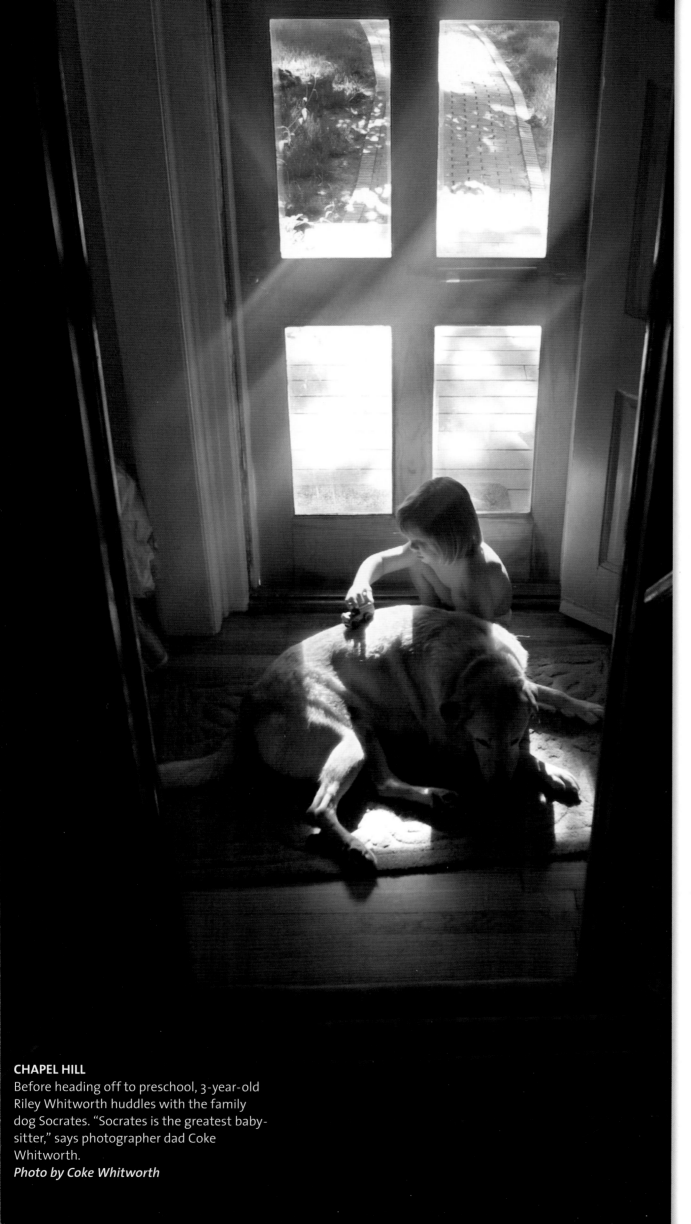

CHAPEL HILL
Before heading off to preschool, 3-year-old Riley Whitworth huddles with the family dog Socrates. "Socrates is the greatest baby-sitter," says photographer dad Coke Whitworth.
Photo by Coke Whitworth

North Carolina 24/7 is the sequel to *The New York Times* bestseller *America 24/7* shot by tens of thousands of digital photographers across America over the course of a single week. We would like to thank the following sponsors, the wonderful people of North Carolina, and the talented photojournalists who made this book possible.

Adobe

OLYMPUS

LEXAR
Media

snapfish

jetBlue
AIRWAYS

WEBWARE

Google

DIGITAL
POND

ebay

LONDON, NEW YORK, MUNICH, MELBOURNE, and DELHI

Created by Rick Smolan and David Elliot Cohen

24/7 Media, LLC
PO Box 1189
Sausalito, CA 94966-1189
www.america24-7.com

First Edition, 2004
04 05 06 07 08 10 9 8 7 6 5 4 3 2 1

Published in the United States by
DK Publishing, Inc.
375 Hudson Street
New York, NY 10014

DK Publishing, Inc. offers special discounts for bulk purchases for sales promo-
tions or premiums. Specific, large-quantity needs can be met with special
editions, personalized covers, excerpts of existing guides, and corporate
imprints. For more information, contact:

Special Markets Department
DK Publishing, Inc.
375 Hudson Street
New York, NY 10014
Fax: 212-689-5254

Cataloging-in-Publication data is available
from the Library of Congress
ISBN 0-7566-0074-X

Printed in the UK by Butler & Tanner Limited

First printing, October 2004

CAROLINA BEACH
Tough day at the office: Full-time artist
Wayne McDowell finds inspiration from
sky, sand, and sea at the south end of
Carolina Beach.
Photo by Logan Mock-Bunting

NORTH CAROLINA 24/7

24 Hours. 7 Days.
Extraordinary Images of
One Week in North Carolina.

Created by Rick Smolan and David Elliot Cohen

DK Publishing

About the America 24/7 Project

A hundred years hence, historians may pose questions such as: What was America like at the beginning of the third millennium? How did life change after 9/11 and the ensuing war on terrorism? How was America affected by its corporate scandals and the high-tech boom and bust? Could Americans still express themselves freely?

To address these questions, we created *America 24/7*, the largest collaborative photography event in history. We invited Americans to tell their stories with digital pictures. We asked them to shoot a visual memoir of their lives, families, and communities.

During one week in May 2003, more than 25,000 professionals and amateurs shot more than a million pictures. These images, sent to us via the Internet, compose a panoramic yet highly intimate view of Americans in celebration and sadness; in action and contemplation; at work, home, and school. The best of these photographs, more than 6,000, are collected in 51 volumes that make up the *America 24/7* series: the landmark national volume *America 24/7*, published to critical acclaim in 2003, and the 50 state books published in 2004.

Our decision to make *America 24/7* an all-digital project was prompted by the fact that in 2003 digital camera sales overtook film camera sales. This technological evolution allowed us to extend the project to a huge pool of photographers. We were thrilled by the response to our challenge and moved by the insight offered into American life. Sometimes, the amateurs outshot the pros—even the Pulitzer Prize winners.

The exuberant democracy of images visible throughout these books is a revelation. The message that emerges is that now, more than ever, America is a supersized idea. A dreamspace, where individuals and families from around the world are free to govern themselves, worship, read, and speak as they wish. Within its wide margins, the polyglot American nation manages to encompass an inexplicably complex yet workable whole. The pictures in this book are dedicated to that idea.

—*Rick Smolan and David Elliot Cohen*

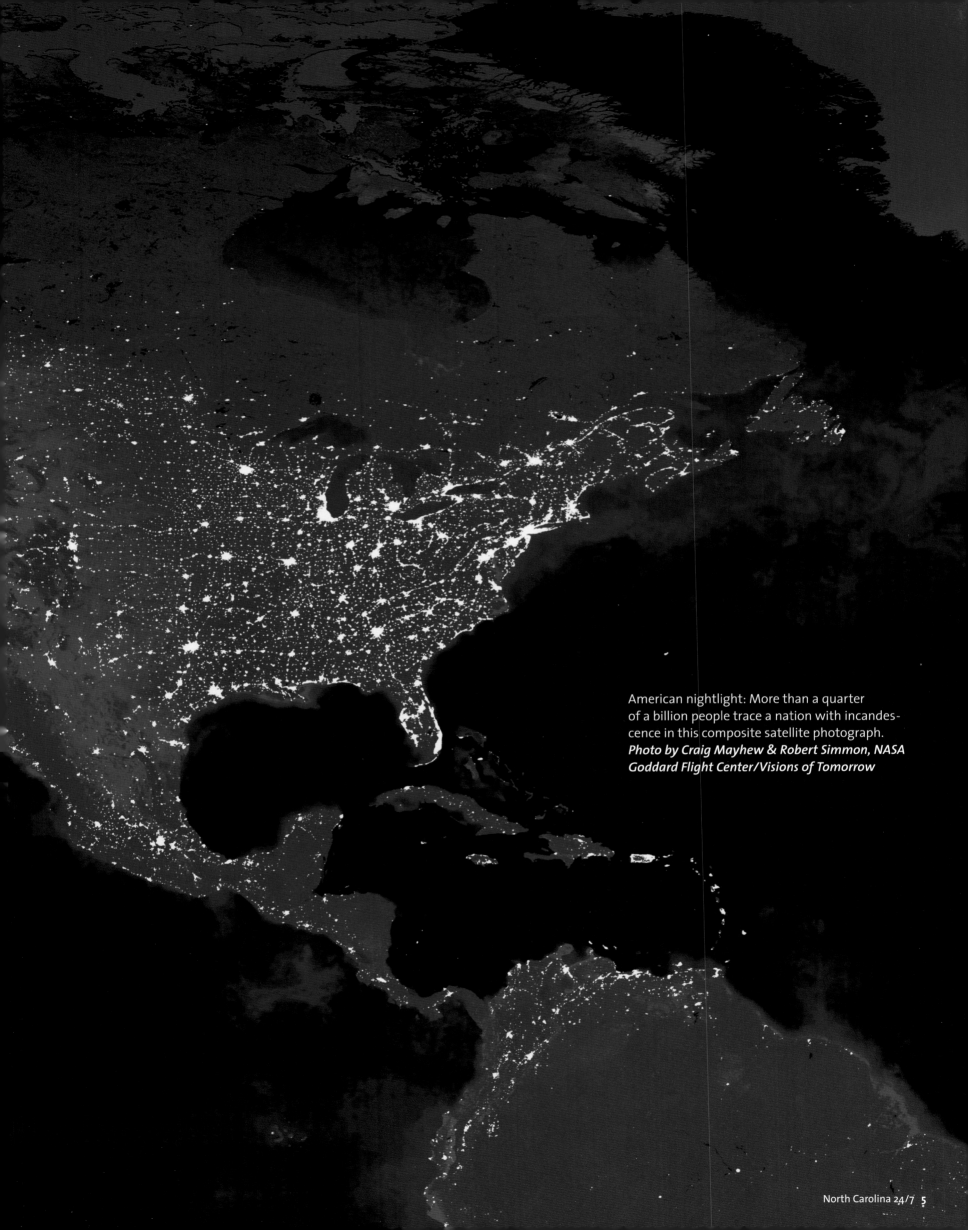

American nightlight: More than a quarter of a billion people trace a nation with incandescence in this composite satellite photograph.
Photo by Craig Mayhew & Robert Simmon, NASA Goddard Flight Center/Visions of Tomorrow

Bluegrass and Sweet Tea

By Tommy Tomlinson

Let's start out with this: We've got the best barbecue. Don't come in here with your beef ribs or your brisket. Slow-cooked pork from towns like Lexington and Shelby is what they serve in heaven's buffet line. And Winston-Salem is where they invented Krispy Kremes.

So you won't go hungry.

If you want a day from nature's top-10 list, take the Outer Banks ferry out to Ocracoke Island and watch the sun come up over the Atlantic. Then loll on the beach, take a long nap, catch a few fish, walk across the island—it takes about two minutes—and watch the sunset on Pamlico Sound.

Your money is probably already here, in the Bank of America and Wachovia towers in Charlotte, or in one of the other big banks across the state. Don't worry: Jimmy the night guard is watching the vault.

We don't really like to talk (Michael Jordan) about our homegrown celebrities, but (Billy Graham) it's easy to (John Coltrane) look them up (Andy Griffith) yourself.

As far as world-altering events go, we'll see whatever you got and raise you the Wright Brothers at Kitty Hawk. Maybe nothing else that changed mankind so much was over so soon; that first flight lasted just 12 seconds, not even long enough for Orville to open the complimentary bag of pretzels.

But enough of all that. I've got a sack full of stories, like how the North Carolina Tar Heels got their nickname, or why the state's two most beloved

figures are race-car driver Richard Petty and pro wrestler Ric Flair, but to tell them all we would have to bump some photos, and believe me, you don't want that.

The pictures in this book were all taken in the same week of May 2003. A few of them show North Carolina's famous sights or special events. But most of the photos capture what is typically called ordinary life, although once you see it through these photographers' eyes, you won't think of it as ordinary again.

Our state has a lot to be proud of right now. We have two of the most impressive second-place finishers in recent memory: Clay Aiken (runner-up on *American Idol* and the Carolina Panthers (runner-up in the 2004 Super Bowl). U-Hauls roll across our borders every day with people coming for the jobs or the climate or just a good glass of sweet tea. There are so many folks who moved from up North to Florida, then turned around and ended up here, that we gave them a name: halfbacks.

But those are temporary things. Here is the enduring North Carolina: the view from a lookout on the Blue Ridge Parkway, the eastern cornfields bending in the breeze, a bluegrass band tuning up at dusk.

No state has ever looked better in slow motion.

So take your time with this book. North Carolina will be here when you're done.

Tommy Tomlinson *is a news columnist for the* Charlotte Observer. *In January 2004,* The Week, *a news digest magazine, named him the best local columnist in America*

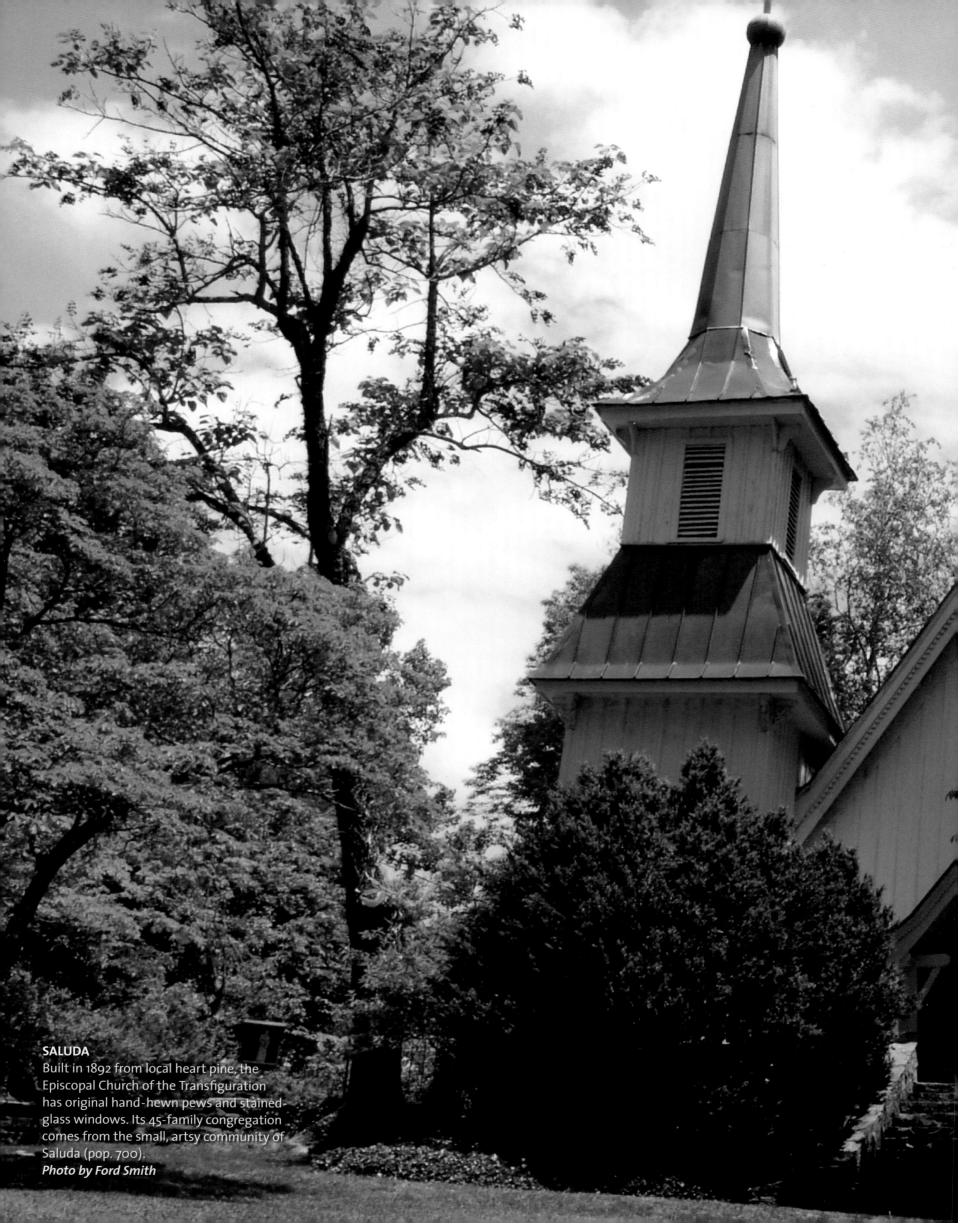

SALUDA
Built in 1892 from local heart pine, the
Episcopal Church of the Transfiguration
has original hand-hewn pews and stained-
glass windows. Its 45-family congregation
comes from the small, artsy community of
Saluda (pop. 700).
Photo by Ford Smith

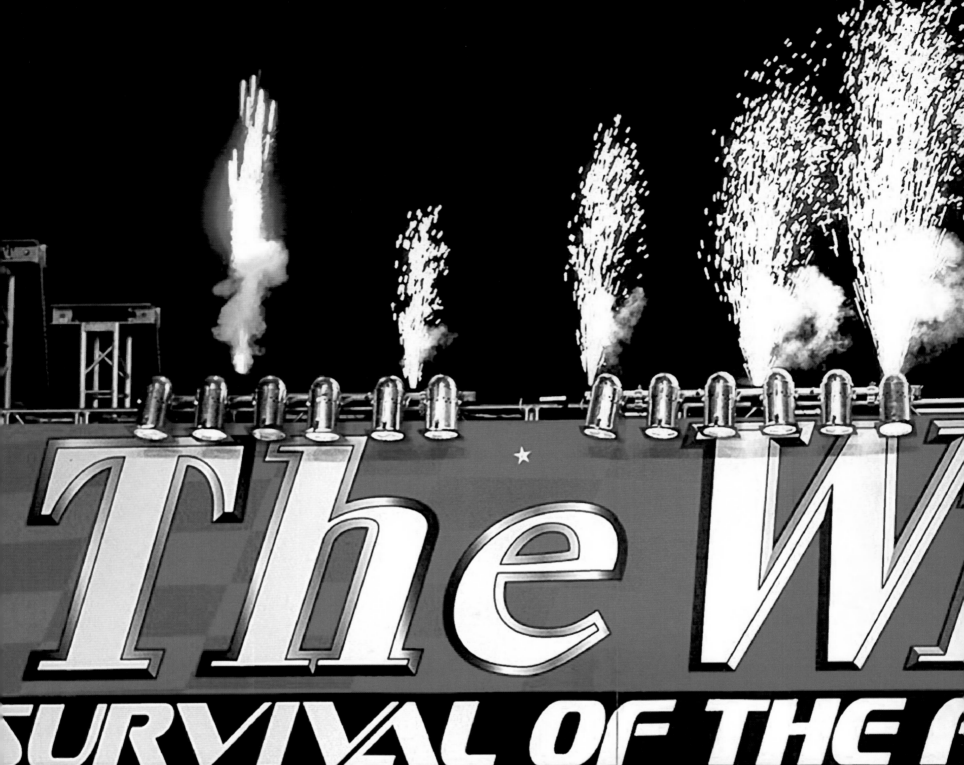
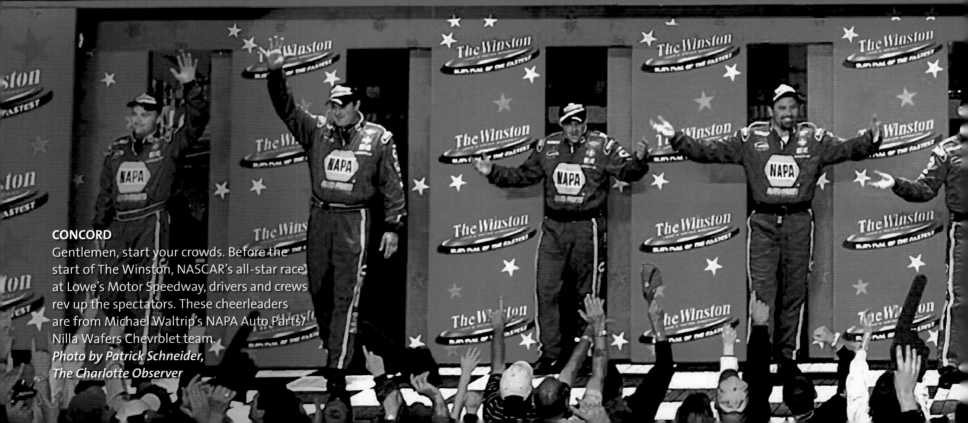

CONCORD
Gentlemen, start your crowds. Before the start of The Winston, NASCAR's all-star race at Lowe's Motor Speedway, drivers and crews rev up the spectators. These cheerleaders are from Michael Waltrip's NAPA Auto Parts/Nilla Wafers Chevrolet team.
Photo by Patrick Schneider,
The Charlotte Observer

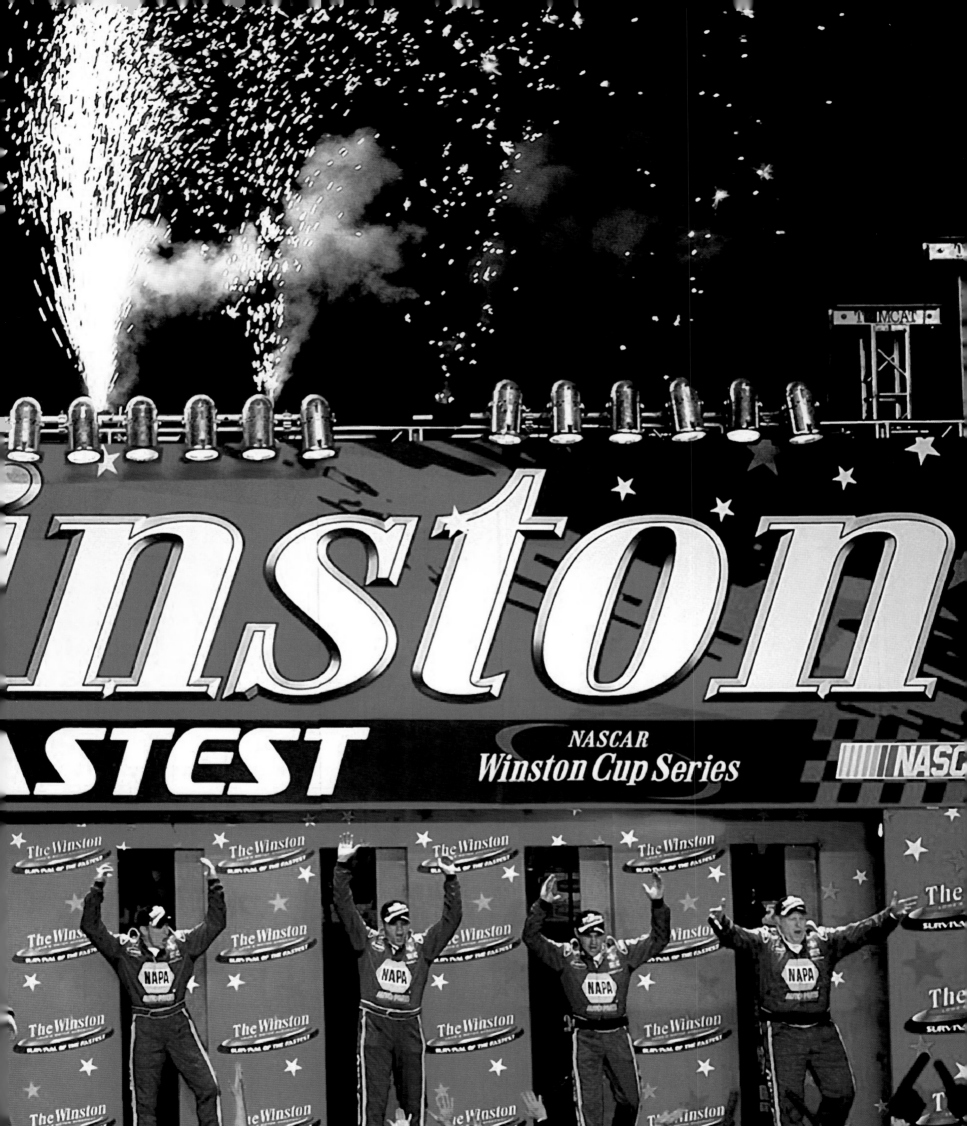

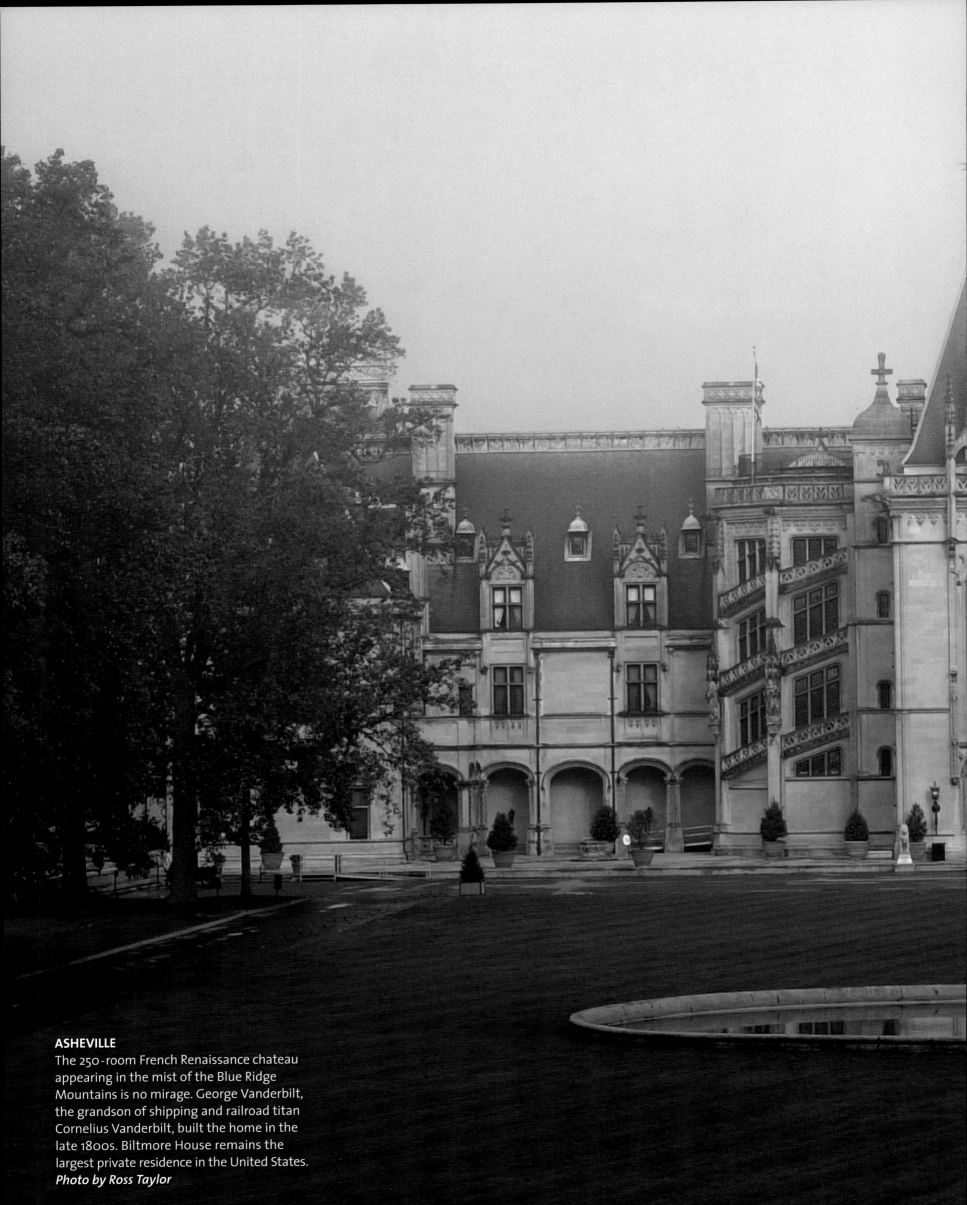

ASHEVILLE

The 250-room French Renaissance chateau appearing in the mist of the Blue Ridge Mountains is no mirage. George Vanderbilt, the grandson of shipping and railroad titan Cornelius Vanderbilt, built the home in the late 1800s. Biltmore House remains the largest private residence in the United States.
Photo by Ross Taylor

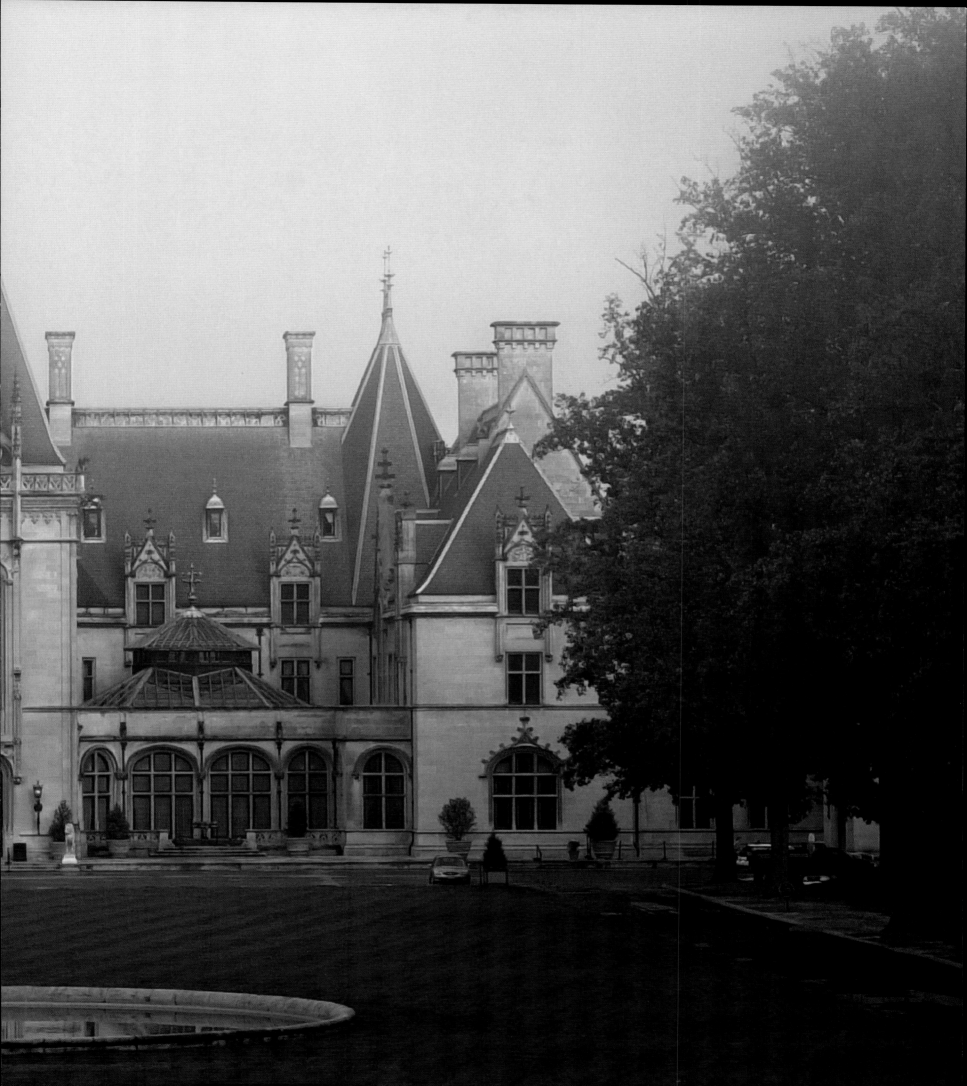

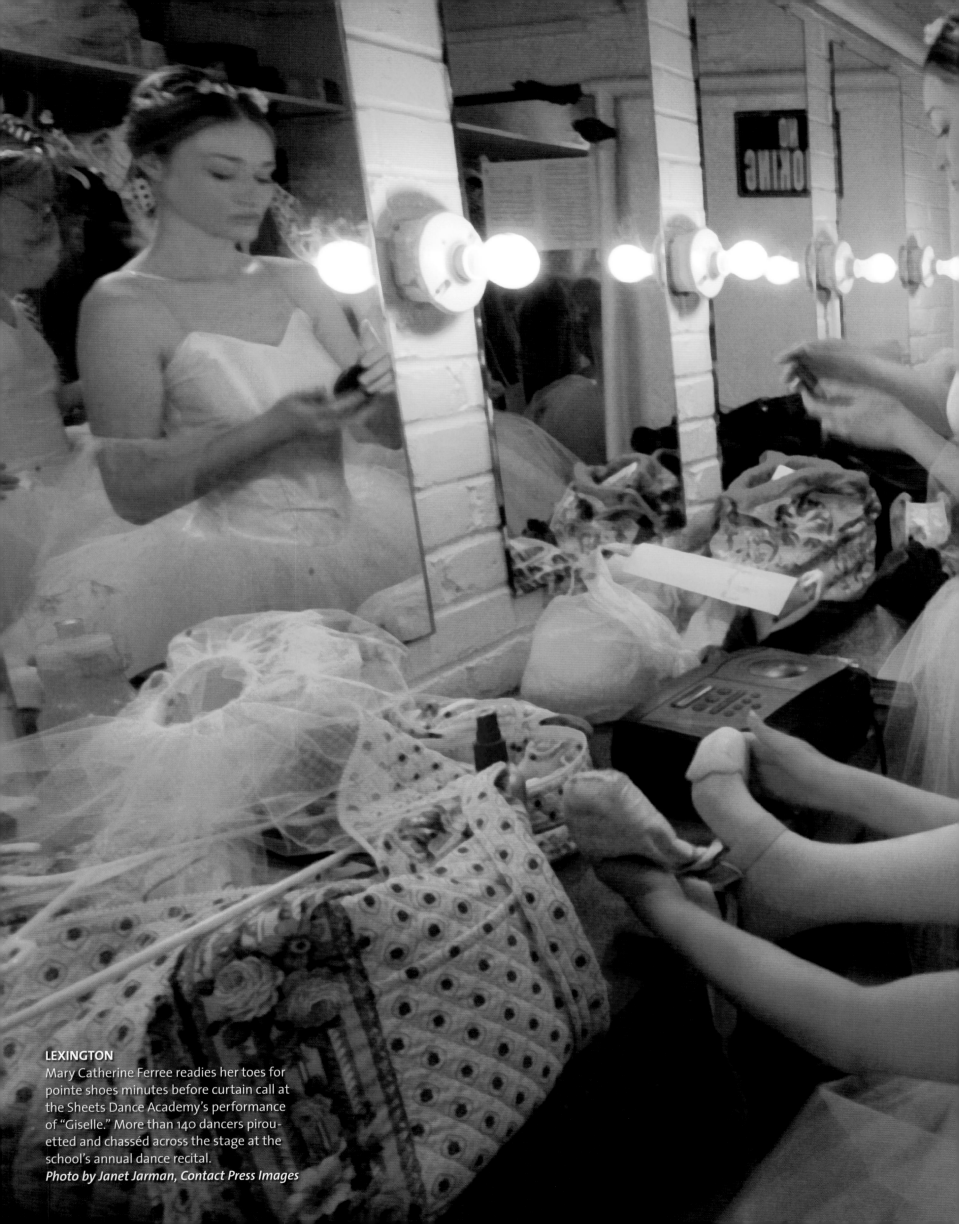

LEXINGTON
Mary Catherine Ferree readies her toes for pointe shoes minutes before curtain call at the Sheets Dance Academy's performance of "Giselle." More than 140 dancers pirou-etted and chasséd across the stage at the school's annual dance recital.
Photo by Janet Jarman, Contact Press Images

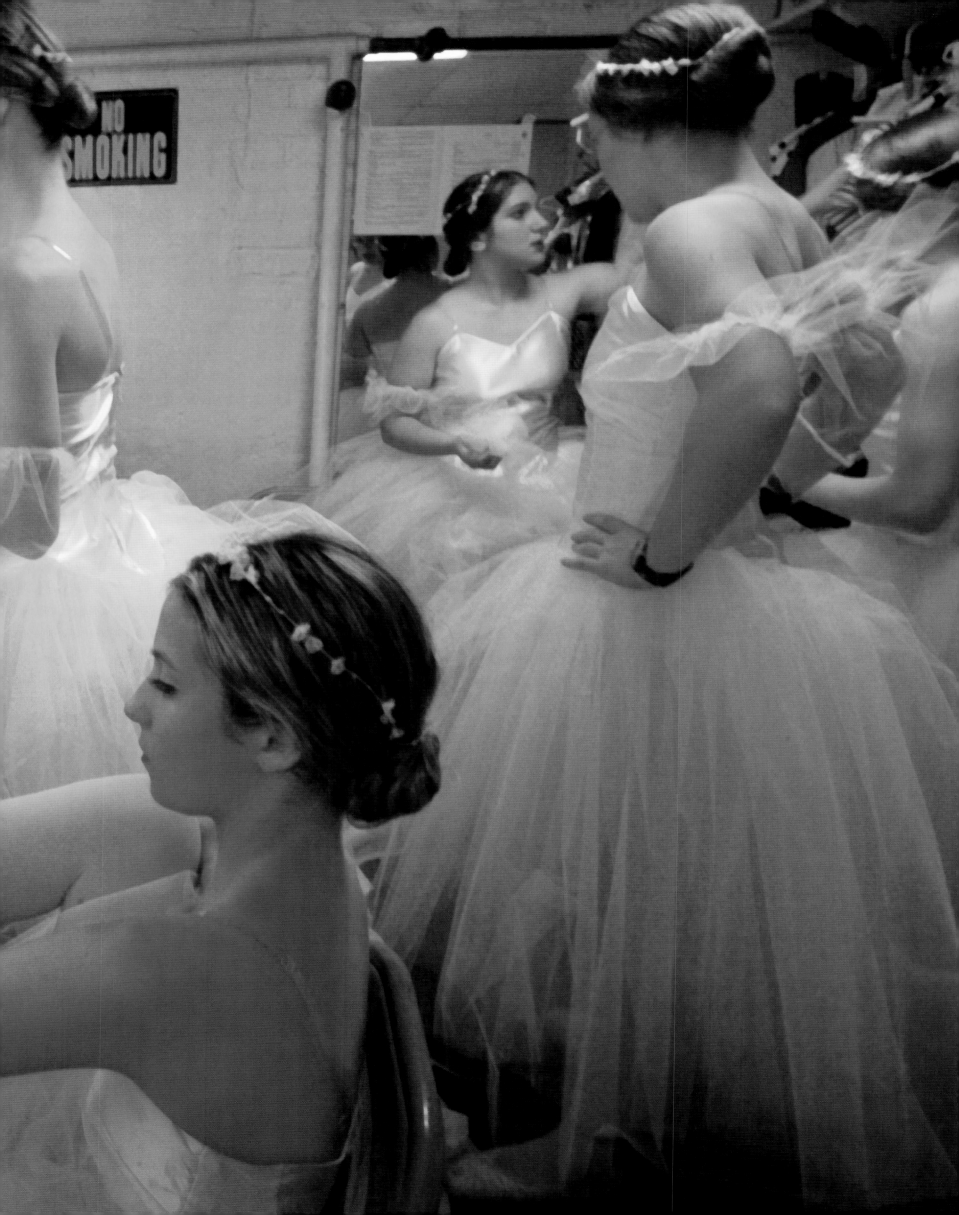

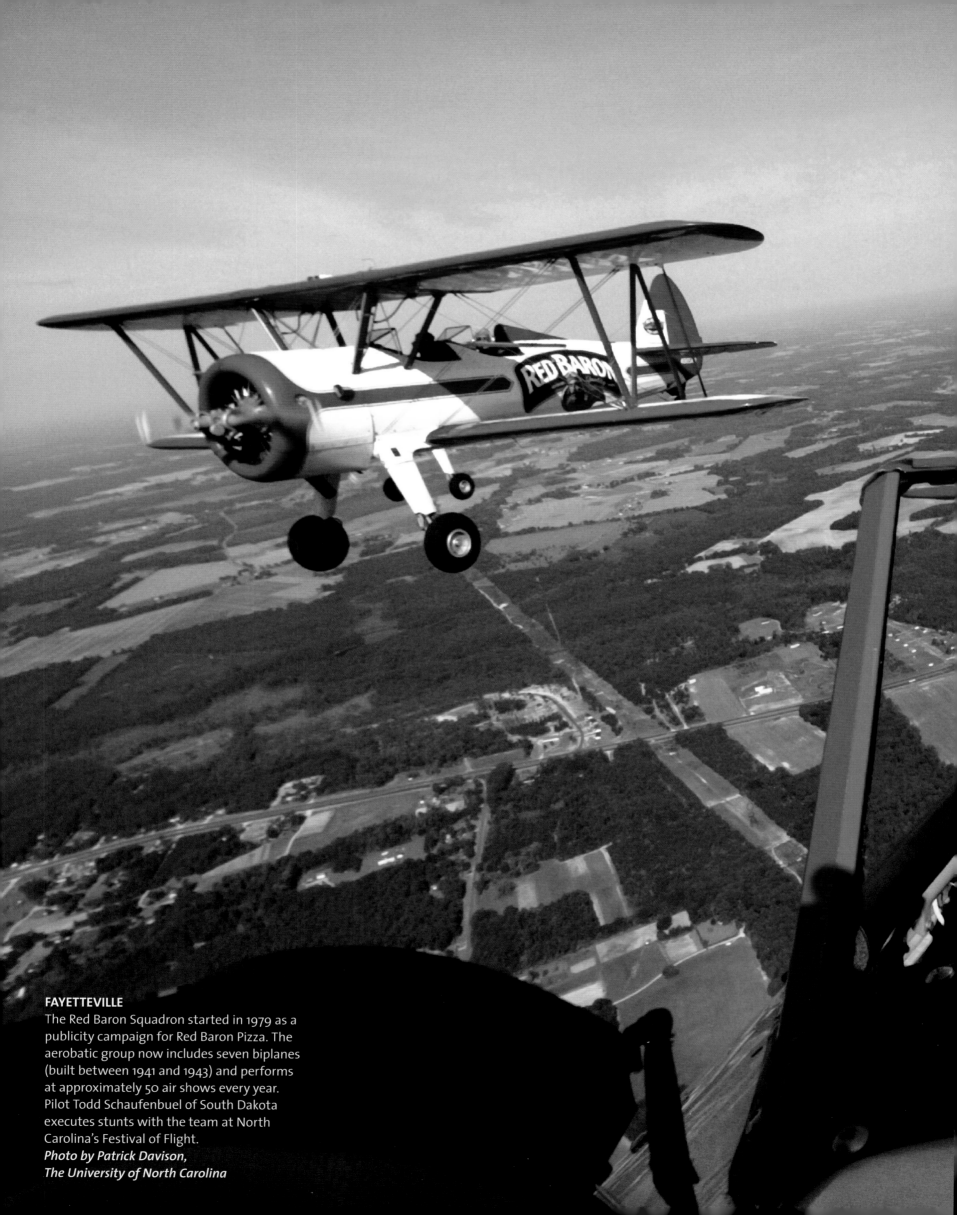

FAYETTEVILLE
The Red Baron Squadron started in 1979 as a publicity campaign for Red Baron Pizza. The aerobatic group now includes seven biplanes (built between 1941 and 1943) and performs at approximately 50 air shows every year. Pilot Todd Schaufenbuel of South Dakota executes stunts with the team at North Carolina's Festival of Flight.
Photo by Patrick Davison,
The University of North Carolina

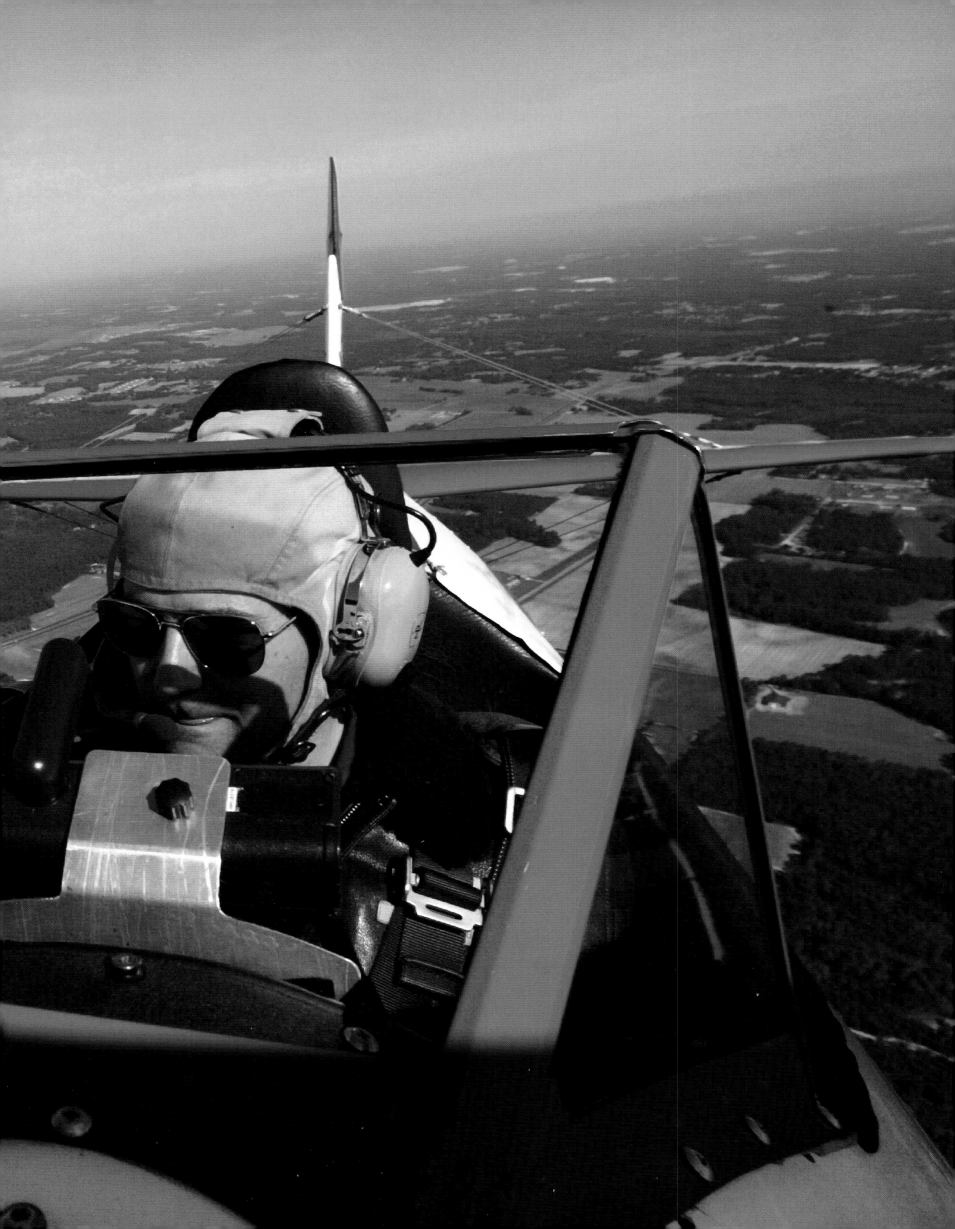

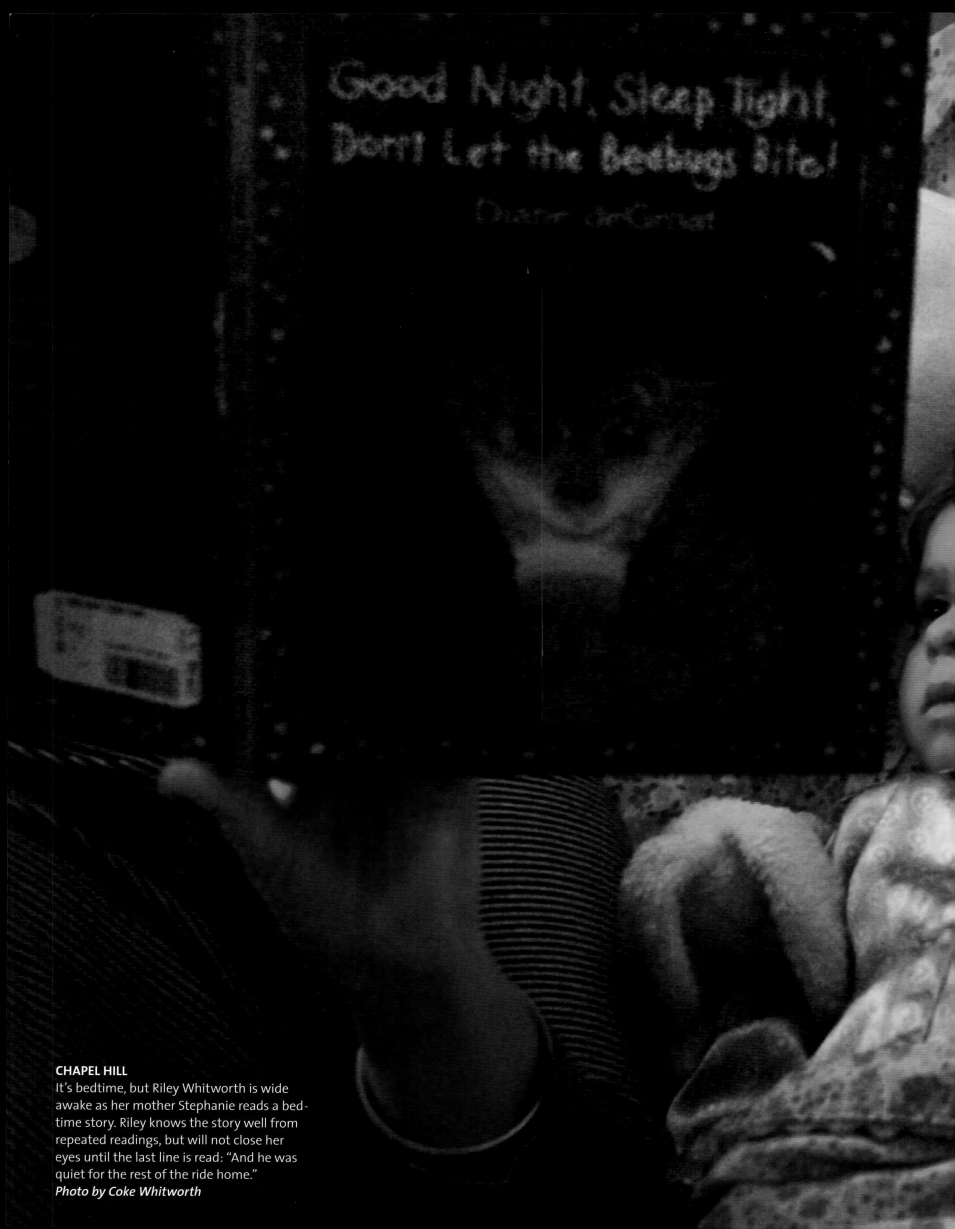

CHAPEL HILL
It's bedtime, but Riley Whitworth is wide awake as her mother Stephanie reads a bedtime story. Riley knows the story well from repeated readings, but will not close her eyes until the last line is read: "And he was quiet for the rest of the ride home."
Photo by Coke Whitworth

Hearth & Home

Brotherly love: Ethan and Quinn Schneider have always been affectionate with one another, says their father Patrick. Holding hands on the drive to preschool is typical for the pair.
Photos by Patrick Schneider,
The Charlotte Observer

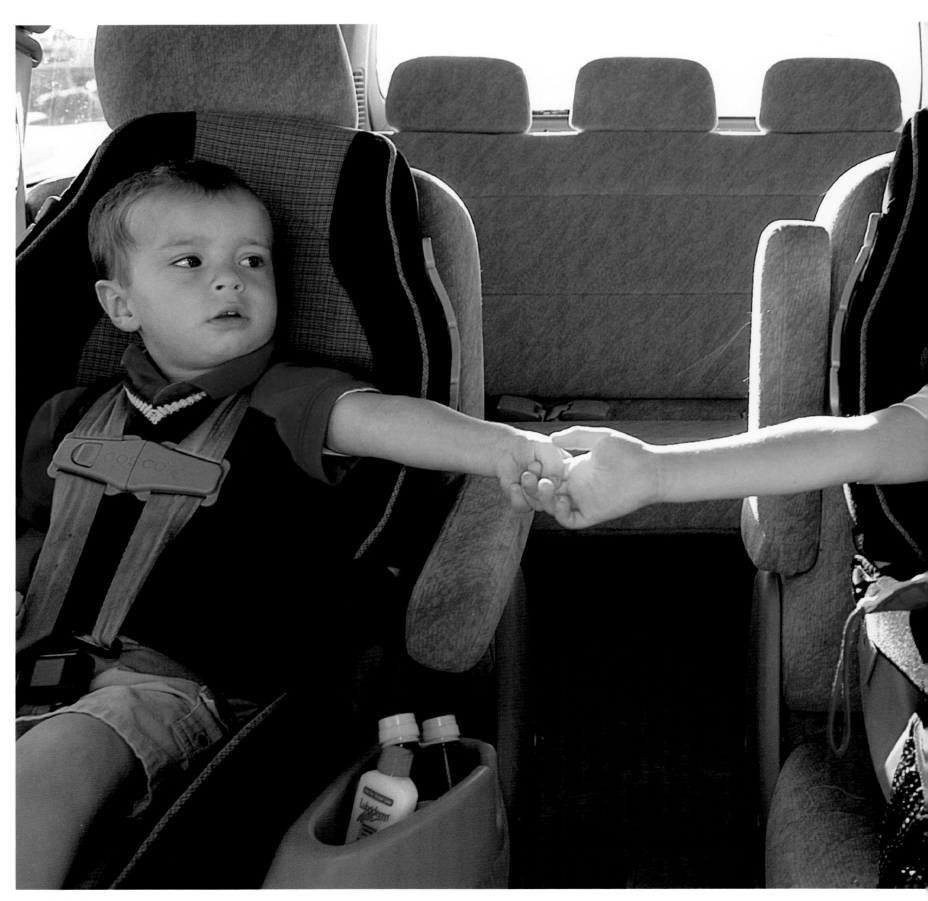

HUNTERSVILLE

Routine reigns at the Schneider home. From 7:14 to 7:16, Lore Postman Schneider, a freelance business writer, enforces the laws of dental hygiene. At 7:30, husband Patrick drives them to breakfast at Bob Evans Restaurant, while Lore begins work at her home office. At 8:15, Patrick delivers the boys to preschool, and heads to work at *The Charlotte Observer*.

HUNTERSVILLE

The routine continues into the evening. At 6:15, Ethan and Quinn get baths. At 7:15, their parents read two books to the boys together, then two more books to Ethan in his room, and then two chapters from another book to Quinn in his room. Lights out at 8. Good night, sleep tight!

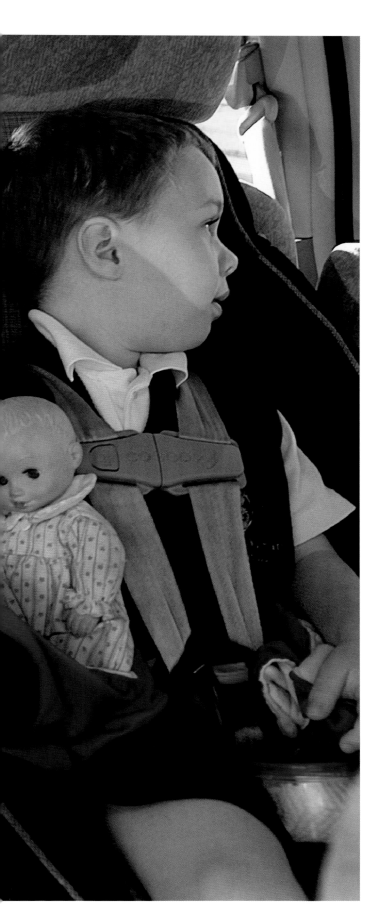

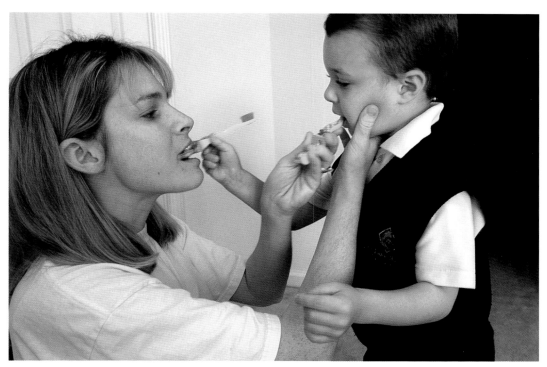

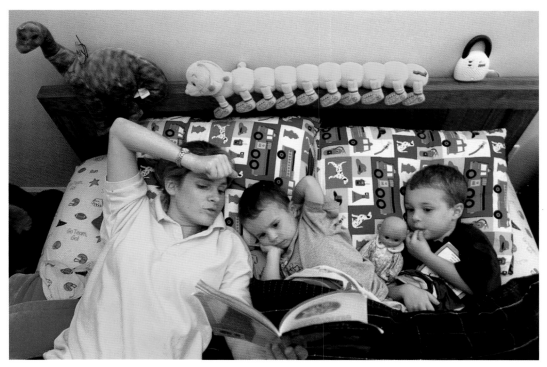

WARRENSVILLE
Aspiring shepherd Matthew Hoffman carries a
one-week-old lamb to pasture on his family's
47-acre farm. The Hoffmans moved to Warrens-
ville from Asheville two years ago to resurrect
their grandfather's orchard, which hadn't been
farmed in 25 years. Now fine yarn spun from the
wool of sheep and angora goats is the primary
product sold at the new Hoffman farm.
Photos by Ted Richardson, Winston-Salem Journal

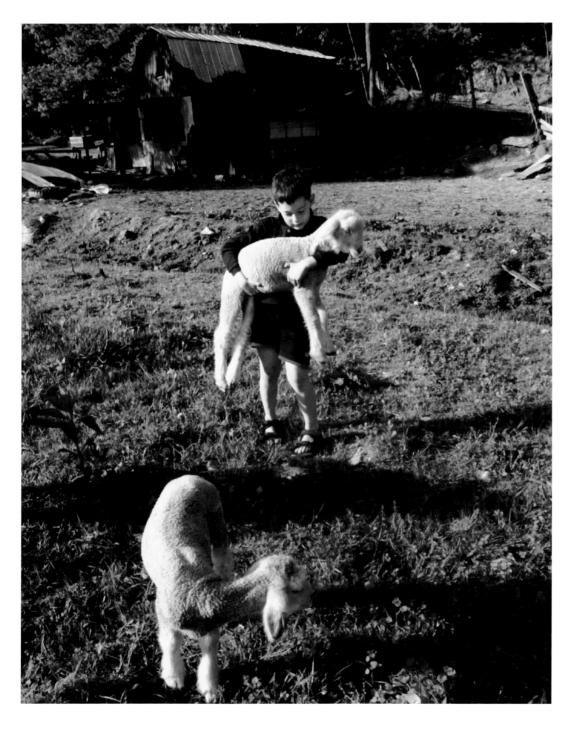

WARRENSVILLE

Goat on a hot tin roof: Sugar Cube, the daredevil goat, has never suffered from vertigo. In fact, she's so fond of heights that her owner, Nancy Hoffman (left), had to construct a barrier to prevent her from seeking even higher ground.

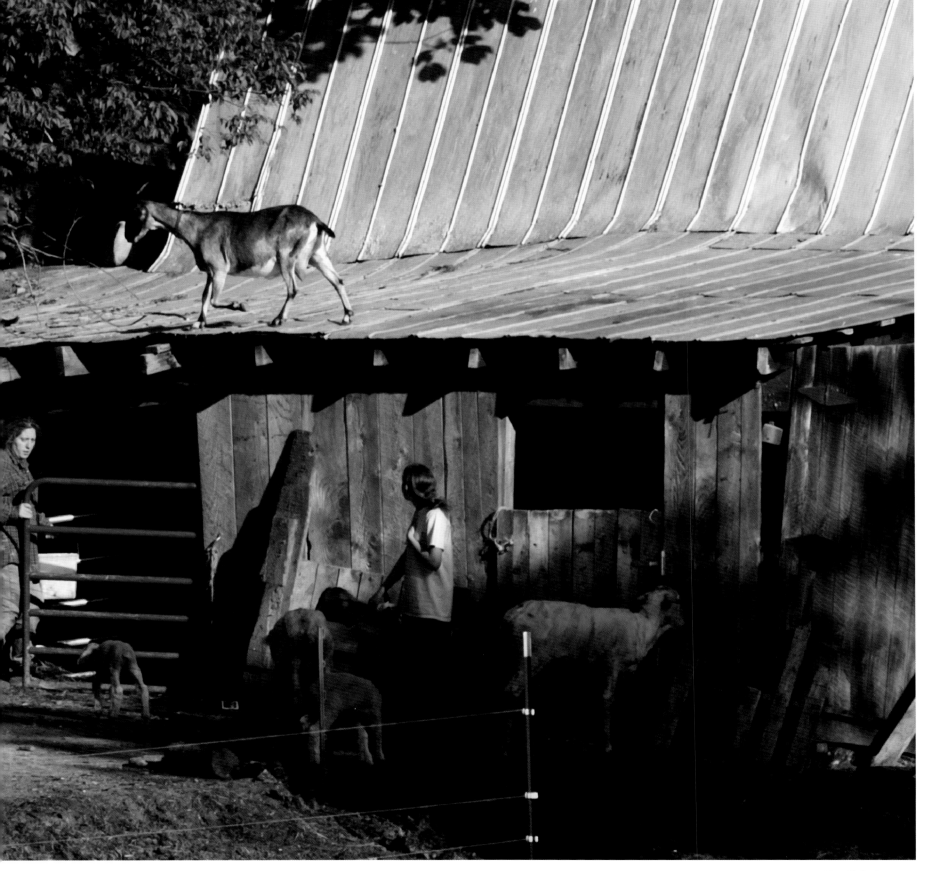

WINSTON-SALEM
"She knows every nook, corner, and cranny of
my house," says Irene Smith (right) of Mamie
Caldwell, her assistant of 47 years. Three children
and two busy careers motivated the Smiths to
hire Caldwell as a housekeeper in 1956. Since then
she's also become one of the family's closest
friends and confidantes. "She's one in a million,"
says Smith.
Photo by Ted Richardson, Winston-Salem Journal

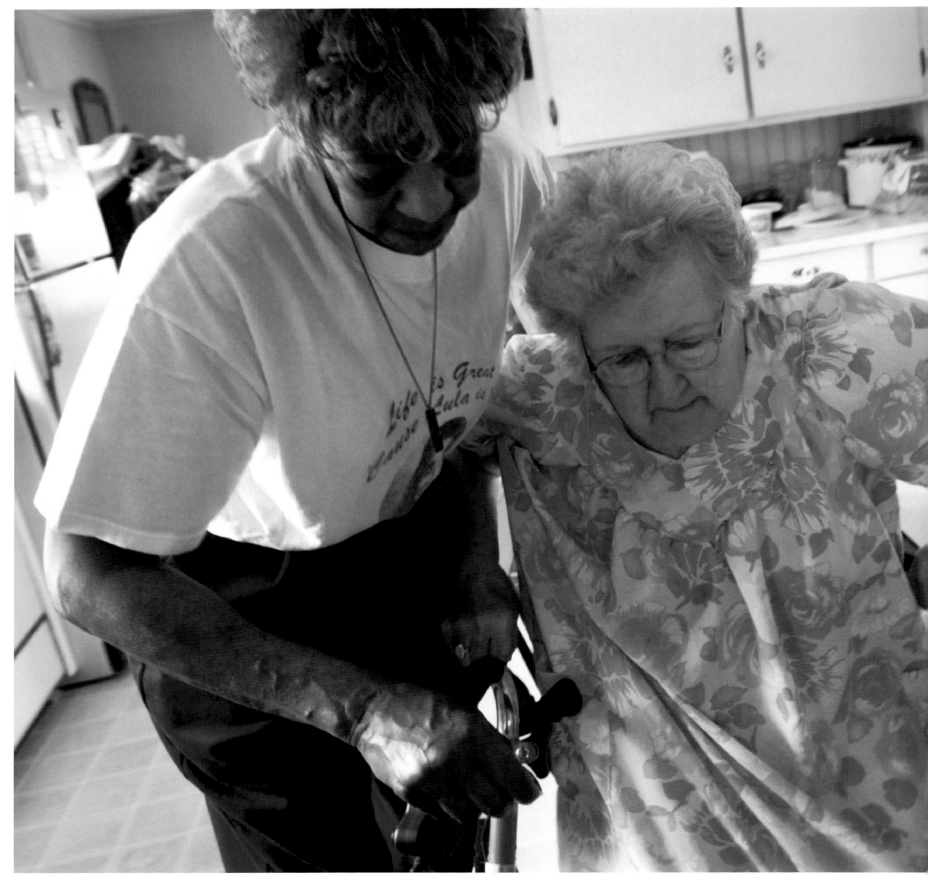

MOCKSVILLE

Pretty in pink: Ruth Carroll dawdles around her winter home at the Lake Myers RV Park with her bichon frise, Danielle Steele.

Photo by Ted Richardson, Winston-Salem Journal

KNIGHTDALE

Songbirds Denie Allen, Mary Tyler, and Annie Ruth Ray electrify the Wellington Nursing Center with a rendition of "Girls Just Wanna Have Fun." At the end of their number, the boa-clad trio threw their bras into the audience—a flourish that earned them first place in the center's annual Gong Show competition.

Photo by John L. White

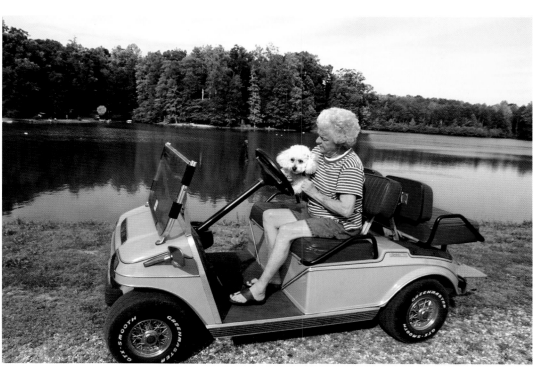

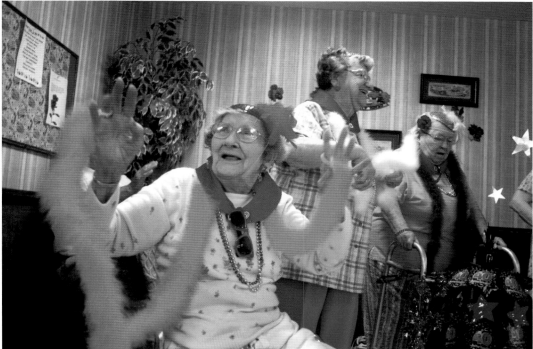

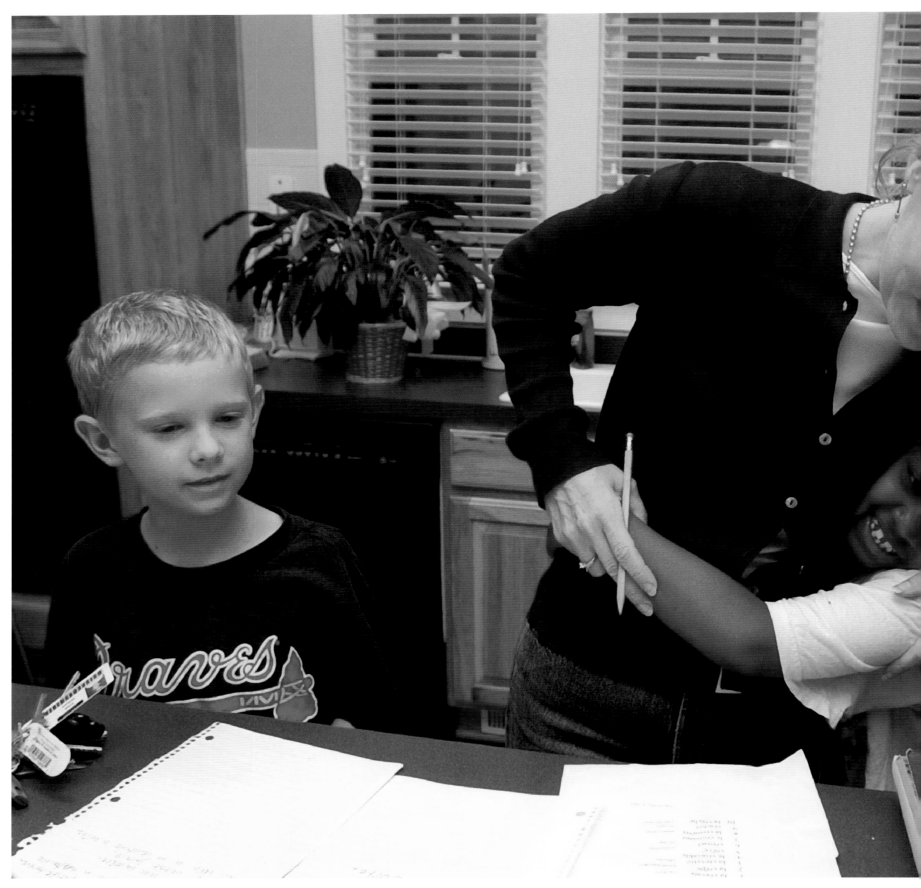

CHARLOTTE

Unique Simpson (right) gets a hug from her mentor, Trish Hobson, after doing well on a French quiz. Through Habitat for Humanity of Charlotte, Hobson has mentored the eight-year-old since 1998. Unique has become a regular in the Hobson household; she often spends afternoons studying and eating—and squabbling—with Ross, 8, and Helen, 6.

Photos by Gayle Shomer Brezicki

CHARLOTTE
Tubbing buddies Unique and Helen scrub up after dinner.

CHARLOTTE
One night a week, Helen makes room for Unique in her queen-size bed. After prayers Trish turns out the light, but the girls always talk and giggle well into the night.

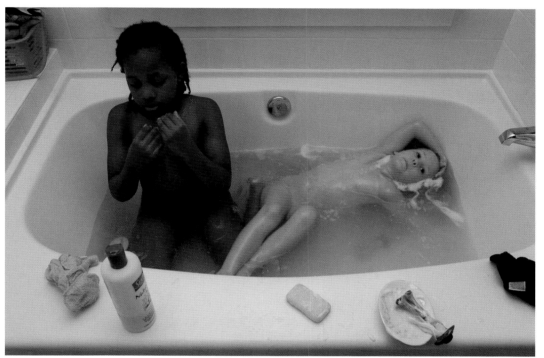

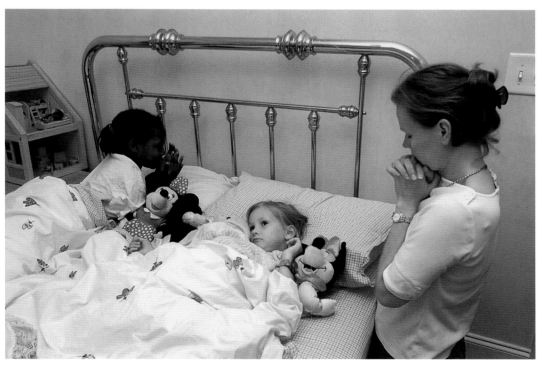

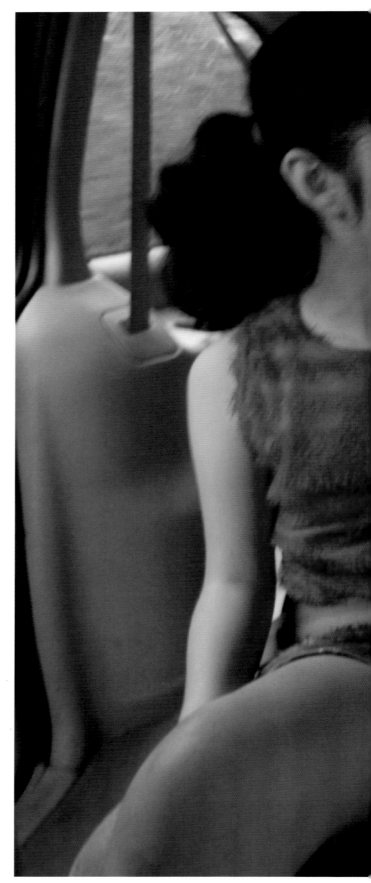

DURHAM

Emiko Davison sends her daughter Mariko off to school. Another mother drives the carpool in the morning; Emiko has the afternoon duty. Born in Japan, Emiko came to America in 1985 to attend the University of Missouri, where she met her husband. They followed employment to five states before moving to North Carolina in 2001.
Photos by Patrick Davison,
The University of North Carolina

DURHAM

Hanna Davison, 8, practices on her violin. That's sister Hope, 5, curled up behind her. The two girls and their 10-year-old sister Mariko attend Orange, a K–8 charter school in Hillsboro. Hanna is learning to play the violin as part of the school's Strings program.

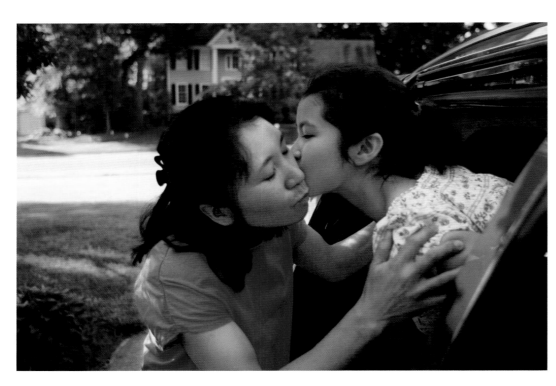

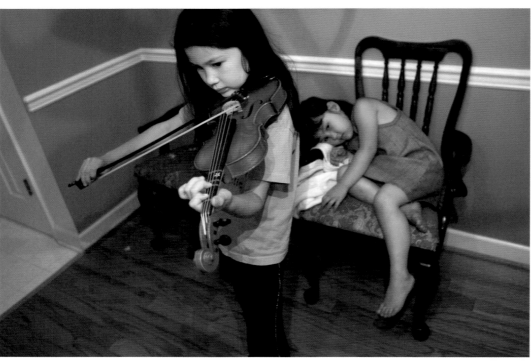

DURHAM

The Davison girls—Mariko, Hanna, and Hope in the back—head to Hanna's ballet recital in Chapel Hill. Though today is Hanna's day, Mariko celebrates her new year-long scholarship. The "Young Strings of the Triangle" award entitles her to free lessons during the year and the chance to perform with the North Carolina Symphony.

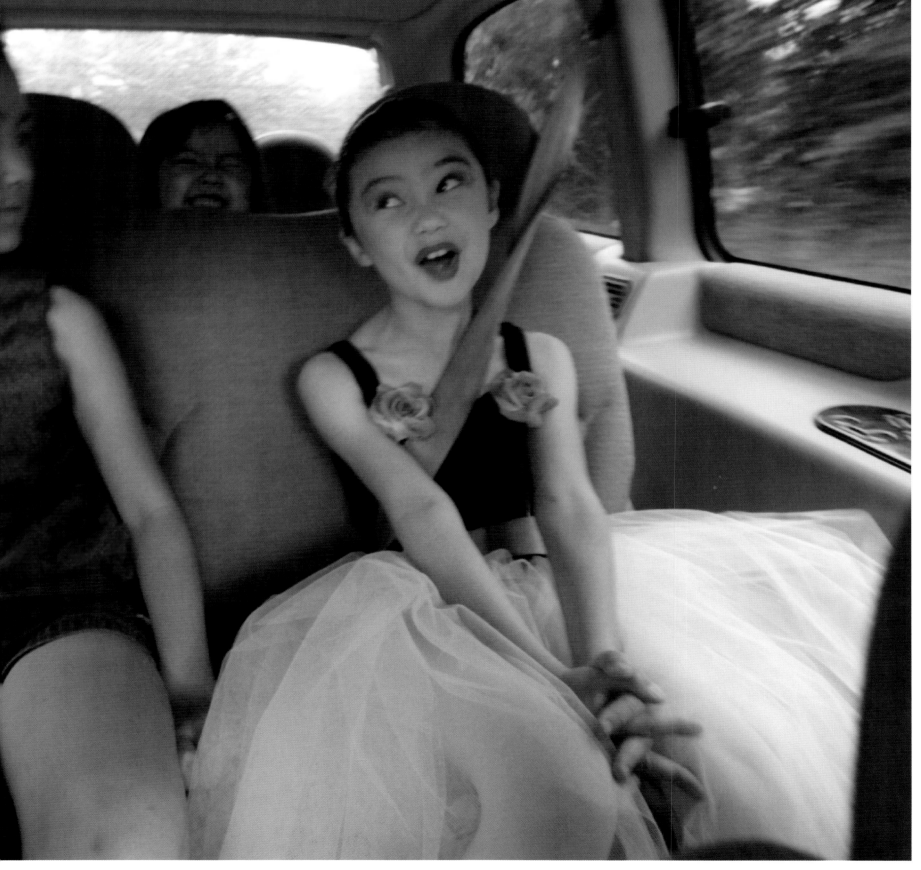

"I brush 'em and shine 'em," says Frank Taylor
Wright about his collection of 39 pairs of shoes.
Photos by Corey Lowenstein

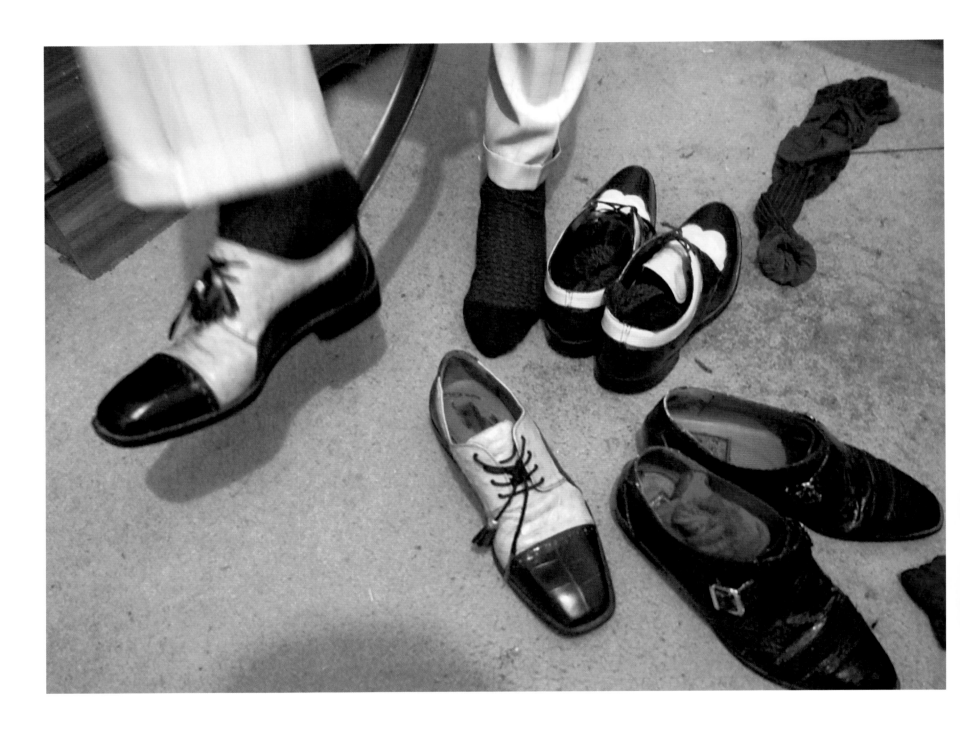

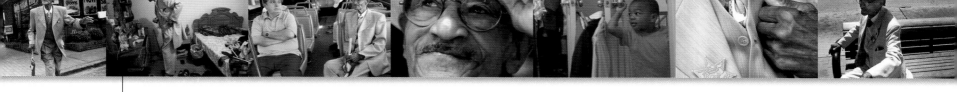

DURHAM

Wright says his mother gave him his first suit when he was 6, and he's dressed up ever since. Every day but Sunday, Wright carefully chooses matching shoes, suit, and hat, and then hops the bus to Chapel Hill. A well-known fixture in town, he spends the day walking about and socializing.

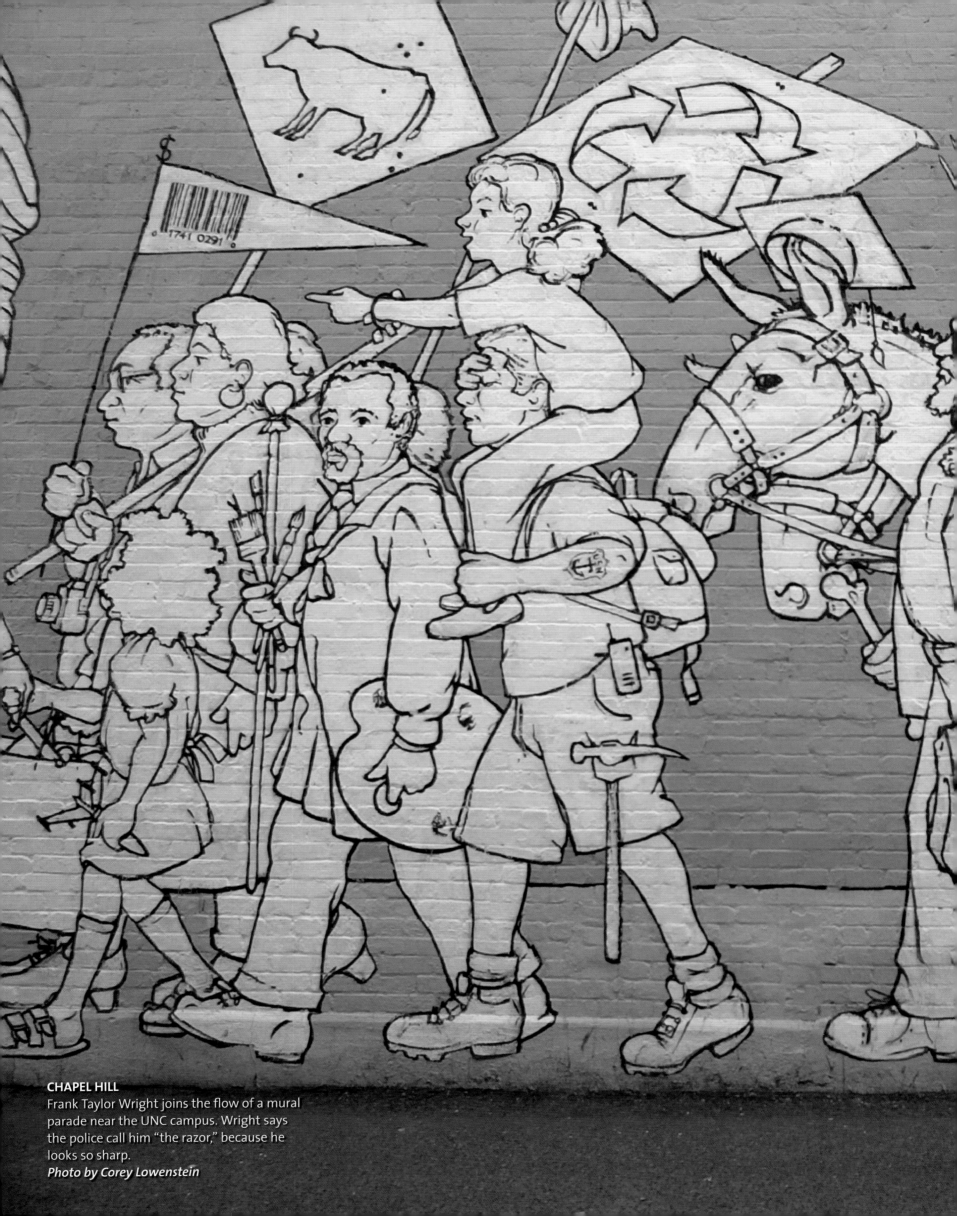

CHAPEL HILL
Frank Taylor Wright joins the flow of a mural parade near the UNC campus. Wright says the police call him "the razor," because he looks so sharp.
Photo by Corey Lowenstein

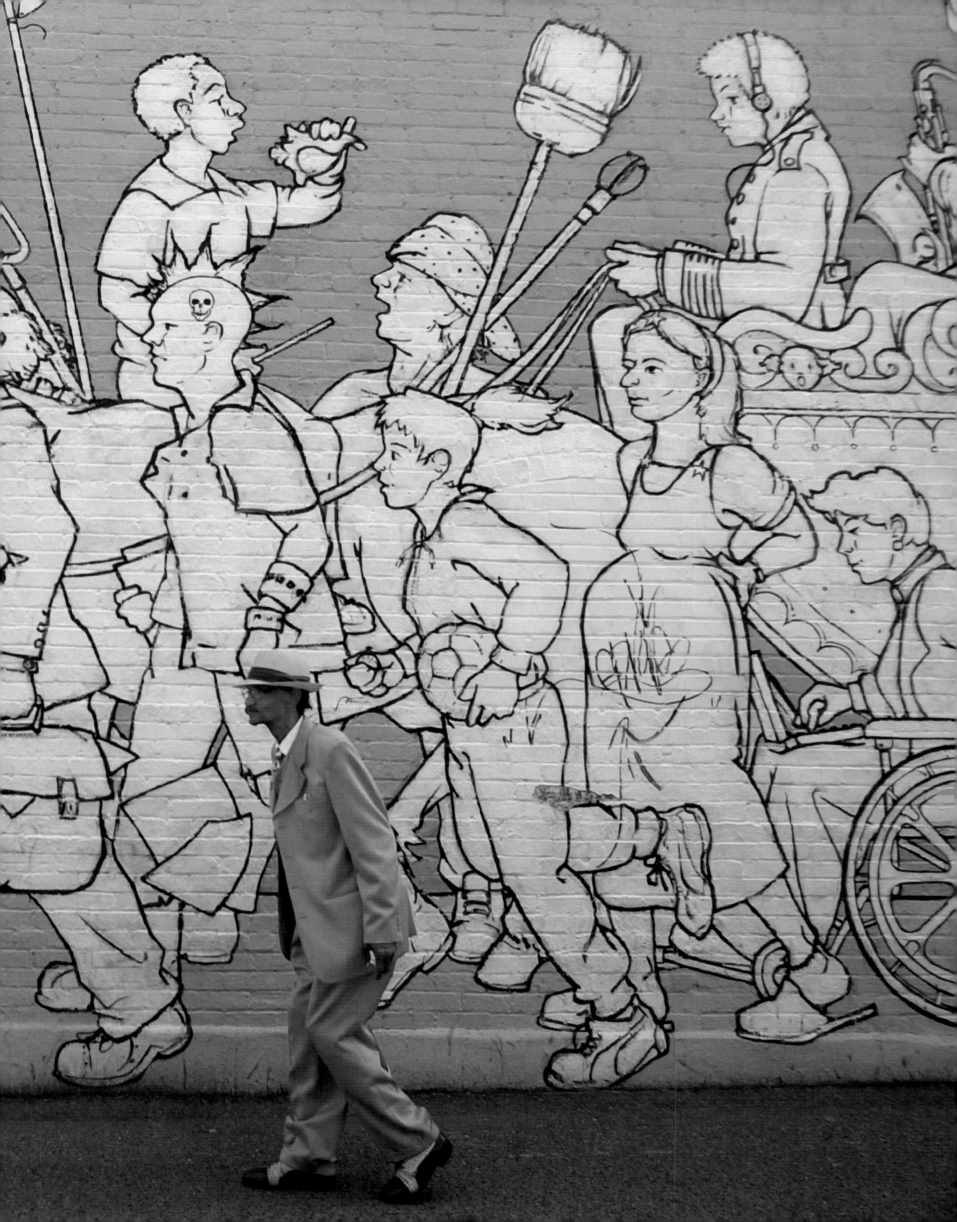

RALEIGH

Matthieu Bushiri prepares his daughter's break-fast before heading to work at MCI. Bushiri immigrated to America from the Republic of Congo in 1989 to escape the dictatorship of President Mobuto and get an education. "Many Americans take this country for granted," he says. "They don't know how bad it can be in other places."
Photo by Scott Lewis

HUNTERSVILLE

Big brother Quinn Schneider, 4, kisses his 2-year-old brother Ethan after walking him to his classroom at Lake Norman Day School, a Montessori school.
Photo by Patrick Schneider,
The Charlotte Observer

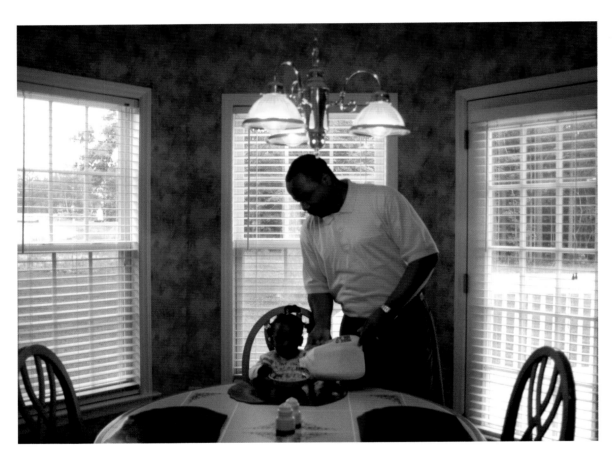

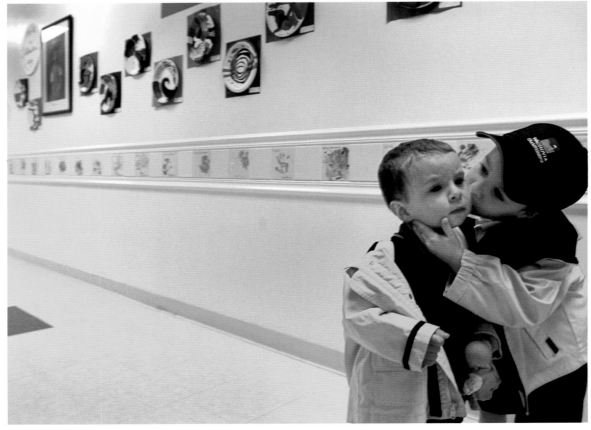

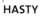

HASTY

Andrea Pauley knights her favorite leading man, dad Michael Pauley, during a break from gathering hay on a neighbor's farm.

Photo by Ted Richardson, Winston-Salem Journal

MANTEO

After a long day of hauling tuna, shark, and bluefish at the Willie R. Etheridge Seafood Co., Chris Miller settles into quiet time with son Brandon. "I hope my boys don't go into the fish house business," says Miller. "There's no money in it—I'd like them to go to college instead."

Photo by Janet Jarman, Contact Press Images

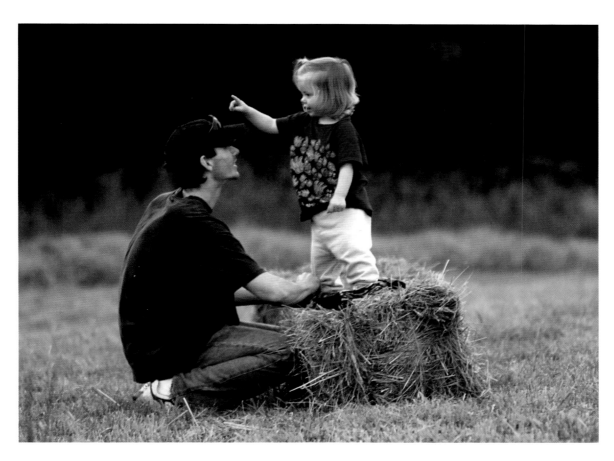

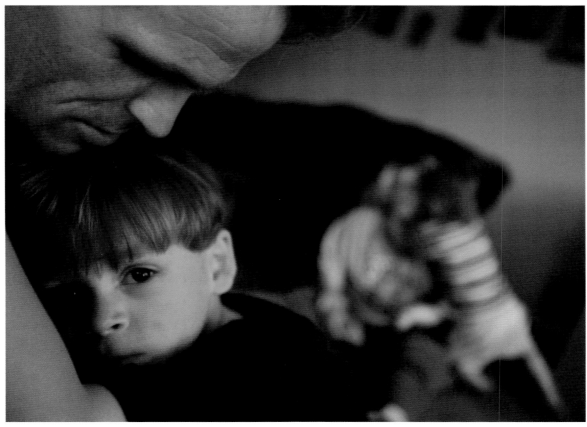

The year 2003 marked a turning point in the history of photography: It was the first year that digital cameras outsold film cameras. To celebrate this unprecedented sea change, the *America 24/7* project invited amateur photographers—along with students and professionals—to shoot and, via the Internet, submit digital images. Think of it as audience participation. Their visions of community are interspersed with the professional frames throughout this book. On the following four pages, however, we present a gallery produced exclusively by amateur photographers.

WASHINGTON Grad students Wade Layton and Adam Sebastian pose with an 82-pound amberjack. "Fun to catch, but not fun to eat," Sebastian says. "It's half filled with worms." *Photo by Adam Sebastian*

FAYETTEVILLE Tom Morris's 5-year-old grandson Austin wears his Spiderman Halloween costume whenever he's in a Spidey mood. *Photo by Thomas Morris*

a view: Bridget O'Donoghue, 17, dives into the Winchester Cr... ns west of Asheville. *Photo by Lorraine Williams*

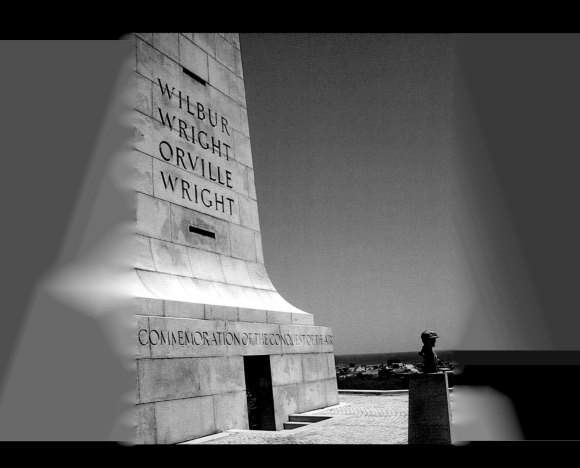

WILBUR
WRIGHT
ORVILLE
WRIGHT

COMMEMORATION OF THE CONQUEST OF THE AIR

t atop Big Kill Devil Hill marks the spot where in 1903, after pa... s Wilbur and Orville Wright launched the alpha of human fligh...

FAYETTEVILLE The long and short of it: Angel is part beagle (stubby legs) and part collie (elongated trunk). Tom Morris found the dog when she was 3-months-old. *Photo by Thomas Morris*

MANSON With an Asheville chef raving about frog leg mousse and a restaurant in Raleigh serving frog legs, pet

RALEIGH Rescued kitten becomes cantankerous. Owner Teri Saylor says Squeak has bitten so many friends and strangers, (and her, too), that the feline now wears an "I bite!" collar. *Photo by Teri Saylor*

DURHAM Adoptees Buster, Josie, and Trapper sit patiently in anticipation of breakfast. *Photo by Fred Brown*

CHAPEL HILL
Elaine Thomas adds cilantro to a serving of
fried catfish and jasmine rice at The Lantern.
When it opened in 2002, the pan-Asian
eatery was named best new restaurant by
The News & Observer. It is one of several
independent businesses that have helped
revitalize Chapel Hill's West Franklin Street.
Photo by Susie Post Rust, Aurora

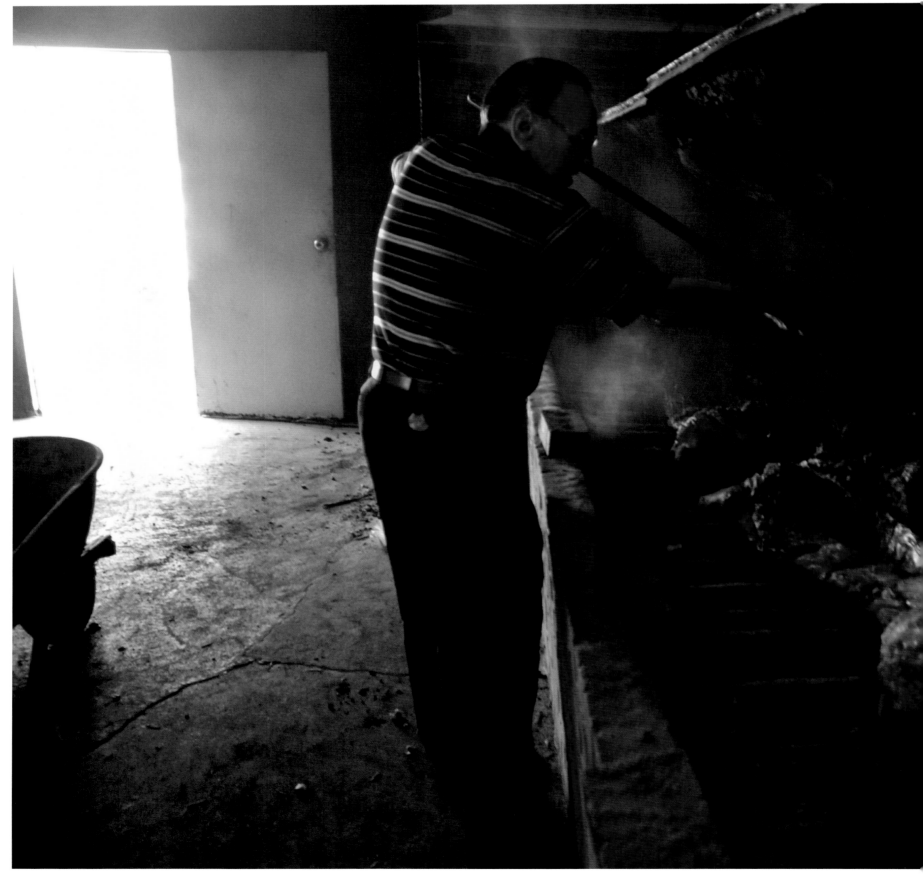

AYDEN

As perfected in 1947 at his Skylight Inn, Pete Jones barbecues the whole hog for 15 hours over red-hot hickory and oak coals, seasons it with vinegar and hot sauce, then serves it with corn bread and slaw. "It's not barbecue if it isn't cooked over wood," he says.

Photo by Scott Sharpe

BOONVILLE

Piping hot tortillas emerge from the Milpa de Oro factory. Opened in 2002, the company supplies North Carolina's Latino grocery stores with the south-of-the-border staple. The *tortilleria* makes its product the old way—with hand-picked maize washed with volcanic rocks and milled into masa.
Photo by Ted Richardson, Winston-Salem Journal

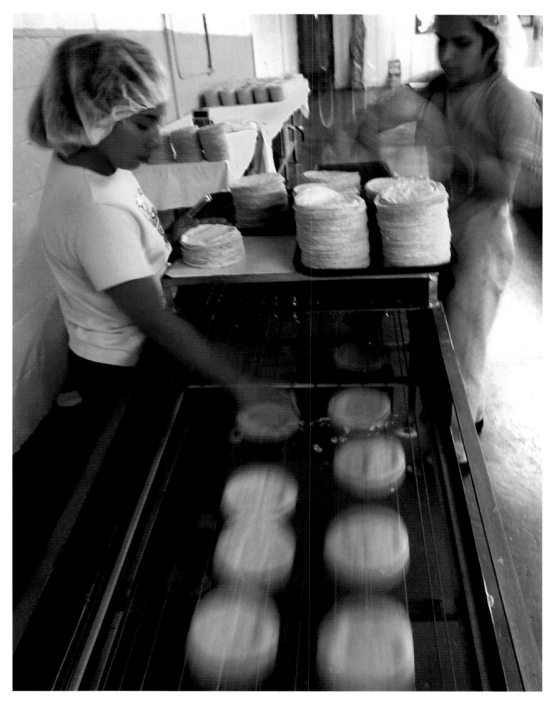

POPE AIR FORCE BASE
First Sergeant Dale Perez, jumpmaster with the
Army's 82nd Airborne Division, checks a doorway
in a mock aircraft structure as part of a jump re-
hearsal. The jumpmaster is responsible for the
paratroopers in his group from initial manifest
through landing in the drop zone.
Photos by Ethan Hyman

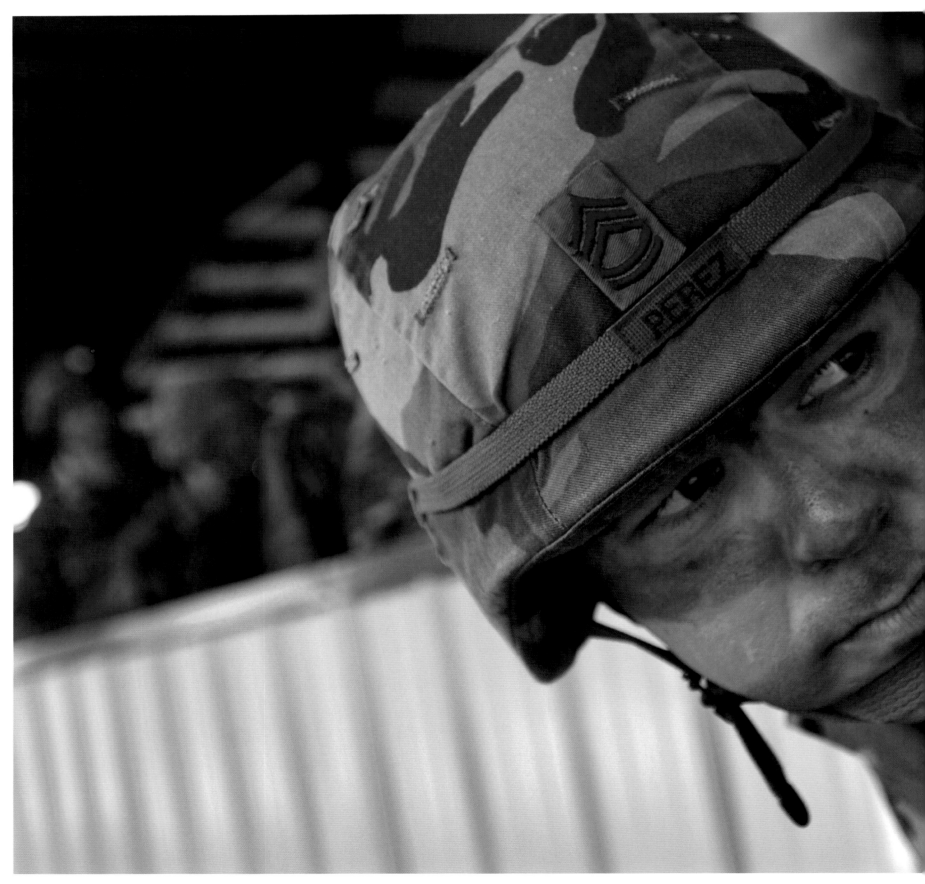

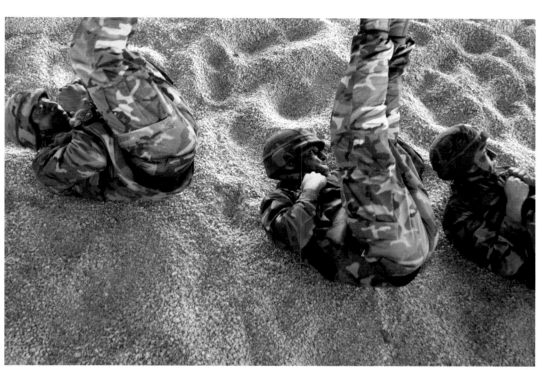

POPE AIR FORCE BASE
Paratroopers practice parachute landing falls from a 3-foot platform. The goal is to use five points of contact to land safely: feet, calf, thigh, buttocks, and chest muscle.

POPE AIR FORCE BASE
Members of the 82nd Airborne Division All American Chorus head for Rock Shed to don their parachutes. The chorus's mascot—a stuffed pink pig—accompanies the singing paratroopers to all jumps and performances. The 26-member group performs at college campuses, professional base-ball games, and special events.

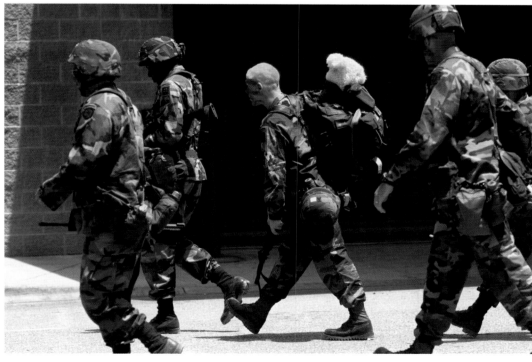

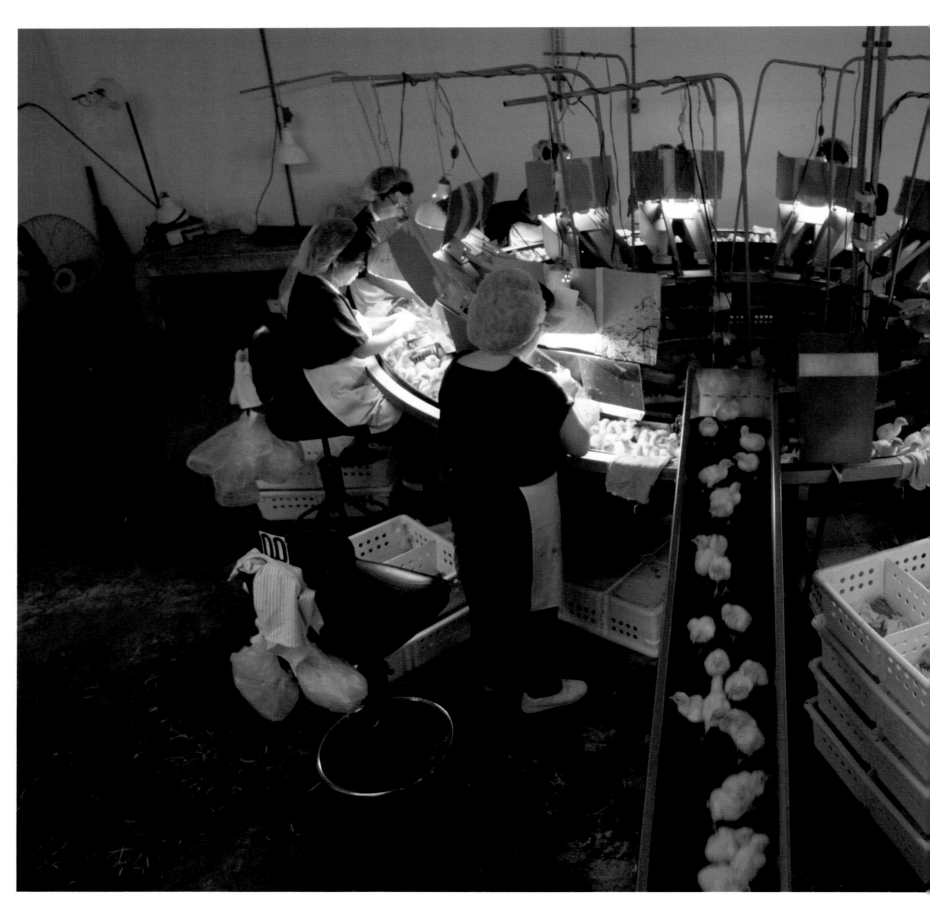

Prestage Farms Turkey Hatchery employs
nine Korean-American women for a very
specific task: to determine the sex of
12,000 chicks per hour. In South Korea,
where there are chickens but very few
turkeys, women spend years learning the
delicate skill, which involves manipulating
the tiny balls of fluff in such a way that
the sex is made apparent.
Photos by Janet Jarman, Contact Press

CLINTON

North Carolina, the top turkey producing state in the country, supplies America's Thanksgiving tables. Growing demand for white meat helped many of the state's struggling tobacco farmers transition into the poultry production business. These recently hatched and sorted pullets are among the 45.5 million birds that North Carolina farmers raise and sell to processors each year.

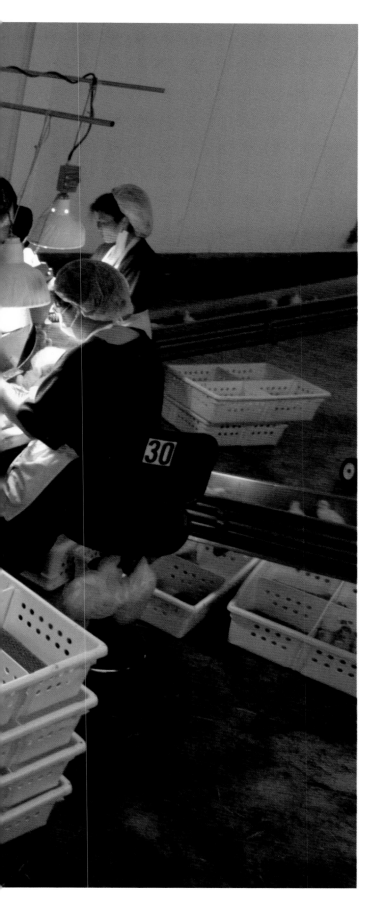

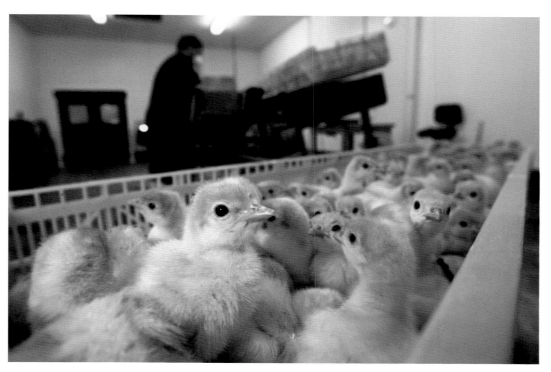

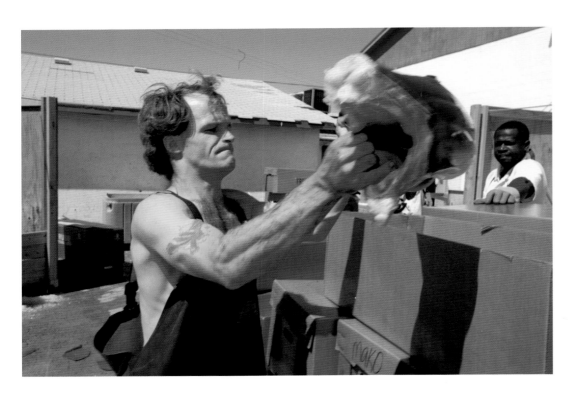

WANCHESE

Chris Miller loads a 10-pound section of mako shark into a packing box at the Willie R. Etheridge Seafood Company. Northwest Atlantic Ocean shark populations have collapsed over the past 15 years, creating competition between commercial and recreational fishermen for the increasingly rare predator.

Photo by Janet Jarman, Contact Press Images

MARSHALLBERG

Zack Davis, 19, who has owned his own boat since he was 12, shrimps from 7:30 in the evening to 7:30 in the morning, then sells his catch to a local fish market. He figures the days of independent commercial fishermen are numbered, so he's also a freshman at University of North Carolina at Wilmington.

Photo by Coke Whitworth

MT. OLIVE

The Mt. Olive Pickle Company, located at the corner of Cucumber and Vine, has been making pickles since 1926. It employs 450 full-time workers, with an additional 350 seasonal workers, all of whom go through 10 minutes of hand and wrist exercises before a shift. "This reduces repetitive motion problems, especially in the packing department," says company nurse Lori Tillman.
Photos by Ethan Hyman

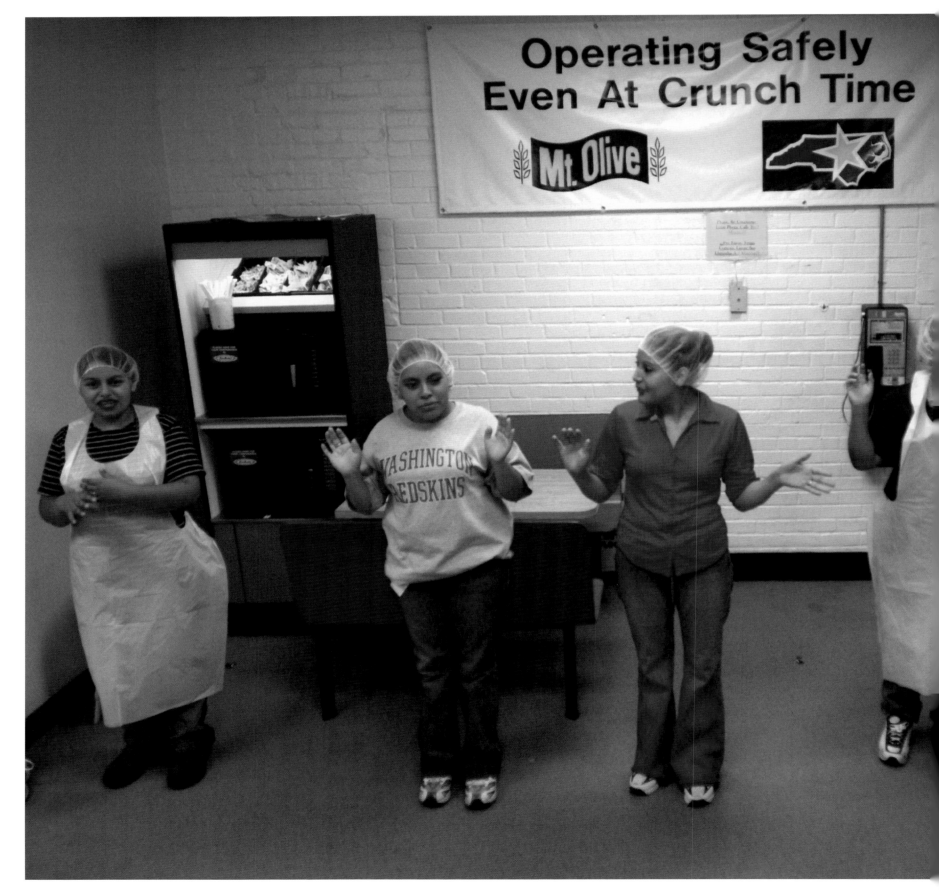

MT. OLIVE

Glass inspector Rebecca Outlaw checks each jar for flaws as it passes through a special light on its way to being filled with dill pickles. Mt. Olive Pickle Company is the largest independent pickle company in America—packing 70 million jars of pickles, peppers, and relishes a year.

MT. OLIVE

On its journey to becoming a pickle, the average cucumber ferments between six and nine months in one of Mt. Olive's 1,200 fiberglass and plastic brine vats. Wooden headers laid across the top of the vats keep the notoriously buoyant "cucs" submerged. The entire inventory of 40 million cucumbers turns over once a year.

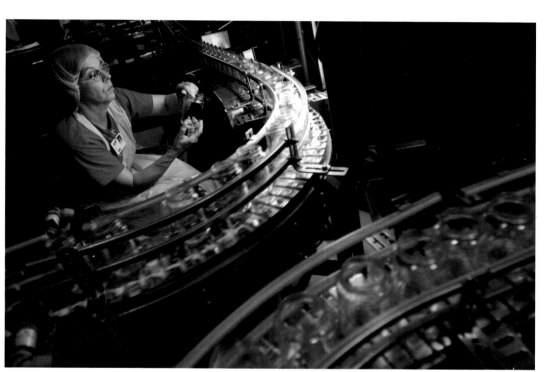

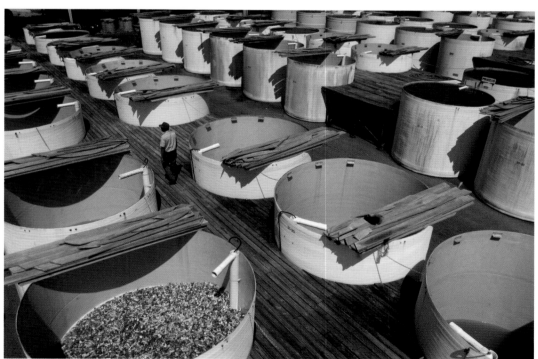

SWANNANOA

Repaving 15 miles of Highway 70, Mark Gaimari adjusts the controls on a "digger." The truck has a row of metal teeth underneath that chews up 2 inches of the old road's surface. The chewed up material is then mixed with new asphalt and hot adhesives, set on the road, and paved into place with heavy rollers.

Photo by Melody Ko

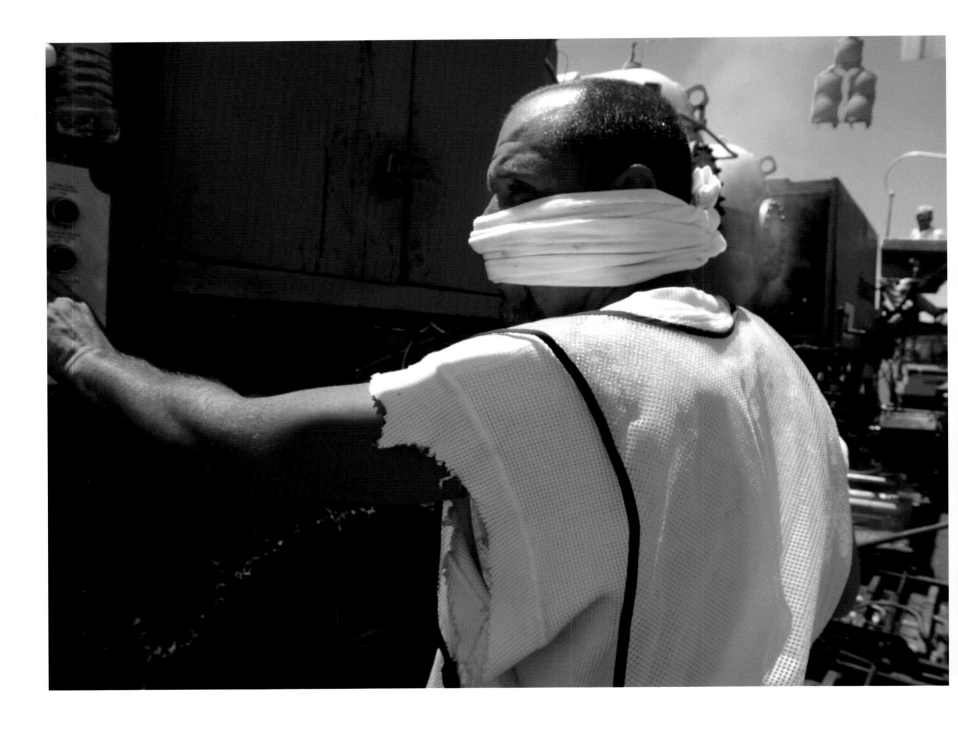

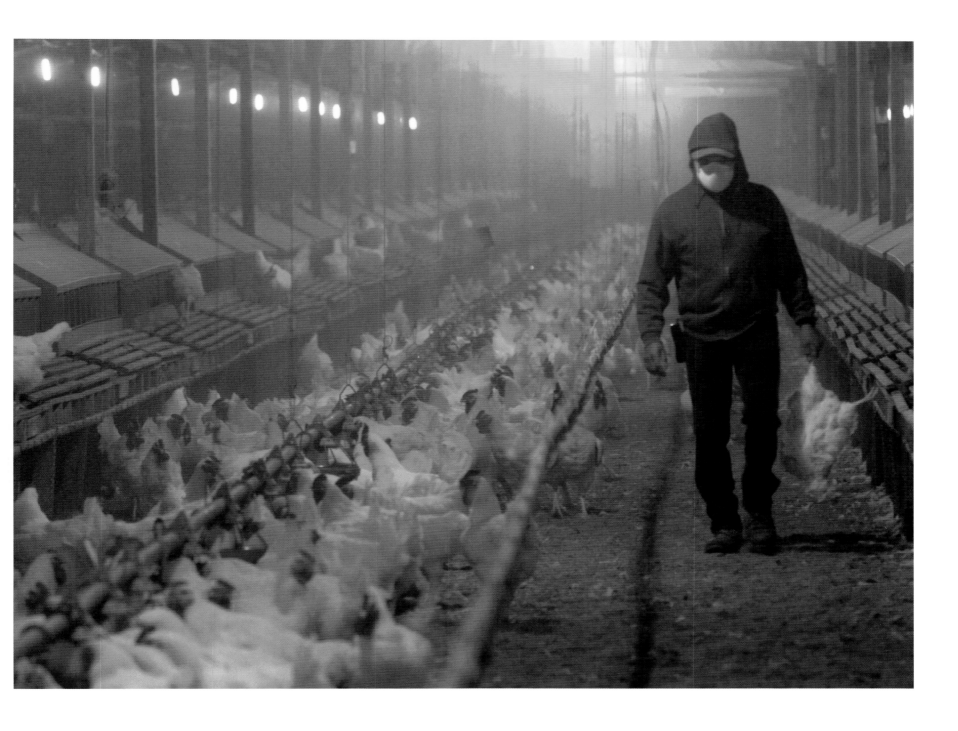

MOUNT AIRY

Migrant laborer Esteban Garcia protects his eyes and lungs from the dust and fumes rising from 15,000 mating chickens at Radford Farms, which produces 735 million broilers per year.

Photo by Ted Richardson, Winston-Salem Journal

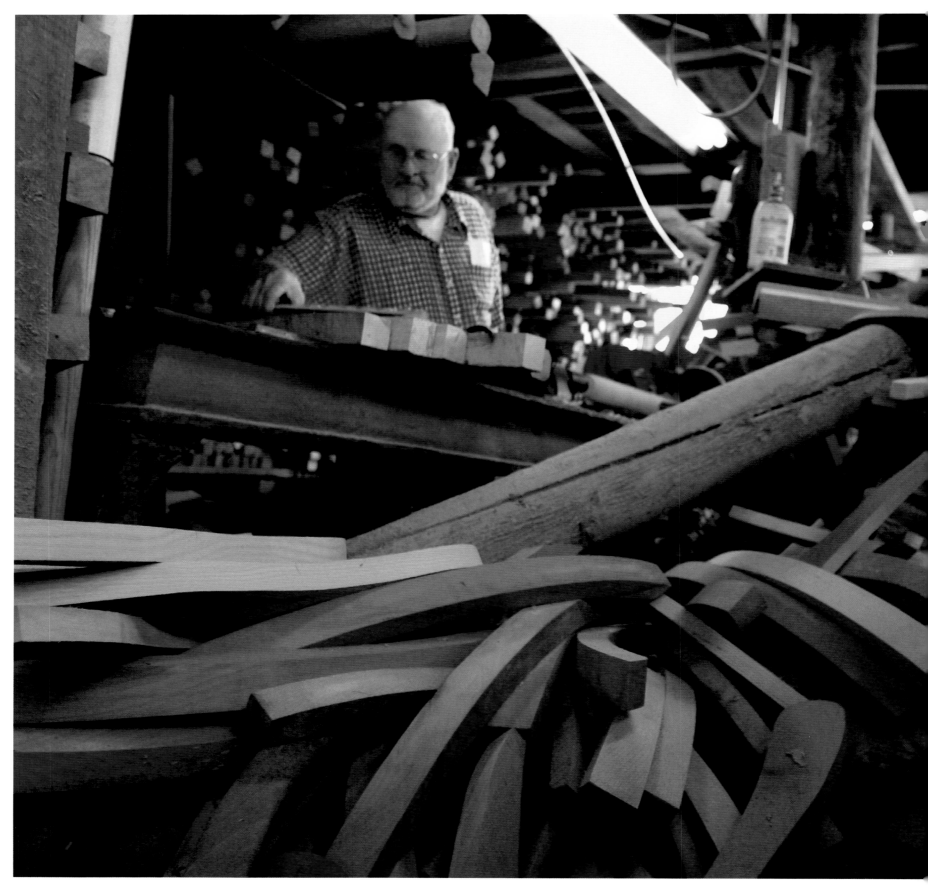

MARION

Chair maker Max Woody, 74, is surrounded by his medium: maple, cherry, oak, and black walnut. Woody's chairs are completely handmade and custom fitted to the customers' measurements. He hopes his youngest son will eventually leave his corporate job with Thomasville Furniture and come back to Marion to keep the family business going.

Photo by Melody Ko

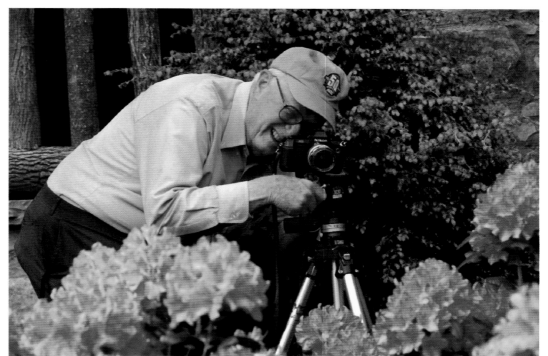

LINVILLE

Hugh Morton, 82, takes aim at the rhododendrons on Grandfather Mountain (elevation 5,964 feet), which he inherited in 1950 from *his* grandfather. Morton built roads, a mile-high swinging bridge, and nature trails, and transformed the land into a beloved nature preserve. An amateur photographer for 60 years, Morton recently published *Hugh Morton's North Carolina*, a photographic valentine to his native state.

Photo by Christopher Record

ROBERSONVILLE

Scattered Farms' famous *fresas* await sorting and packing. Migrant laborer Florencio Velasquez of Guanajuato, Mexico, handpicks the delicate crop during the fruit's short spring harvest.

Photo by Janet Jarman, Contact Press Images

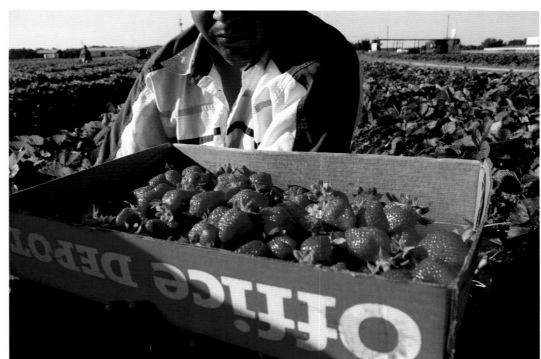

LAUREL SPRINGS

Before they're covered with ornaments, tinsel, and lights, the Fraser firs grown at Laurel Springs Christmas Tree Farms get regular trims throughout their 12-year growth cycle. Careful shaping ensures that the saplings develop into symmetrical, 6-foot cones.

Photo by Ted Richardson, Winston-Salem Journal

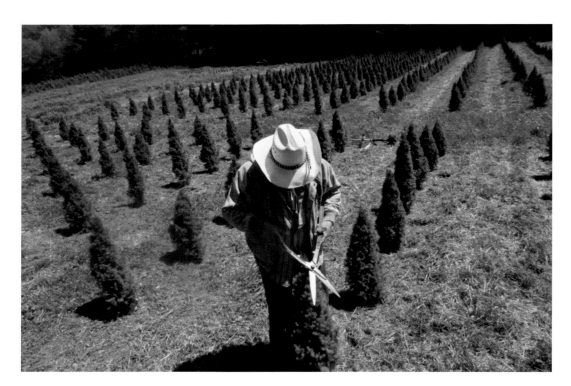

ASHE COUNTY
Fraser firs grow well in the higher elevations of northwestern North Carolina, making the state the second-largest Christmas tree producer in America after Oregon. The New River Tree Co., which sells 100,000 Christmas trees a year, has more than one million Fraser firs growing on 700 acres. The company's typical 8-footer takes 15 years from seed to sale.
Photo by Melody Ko

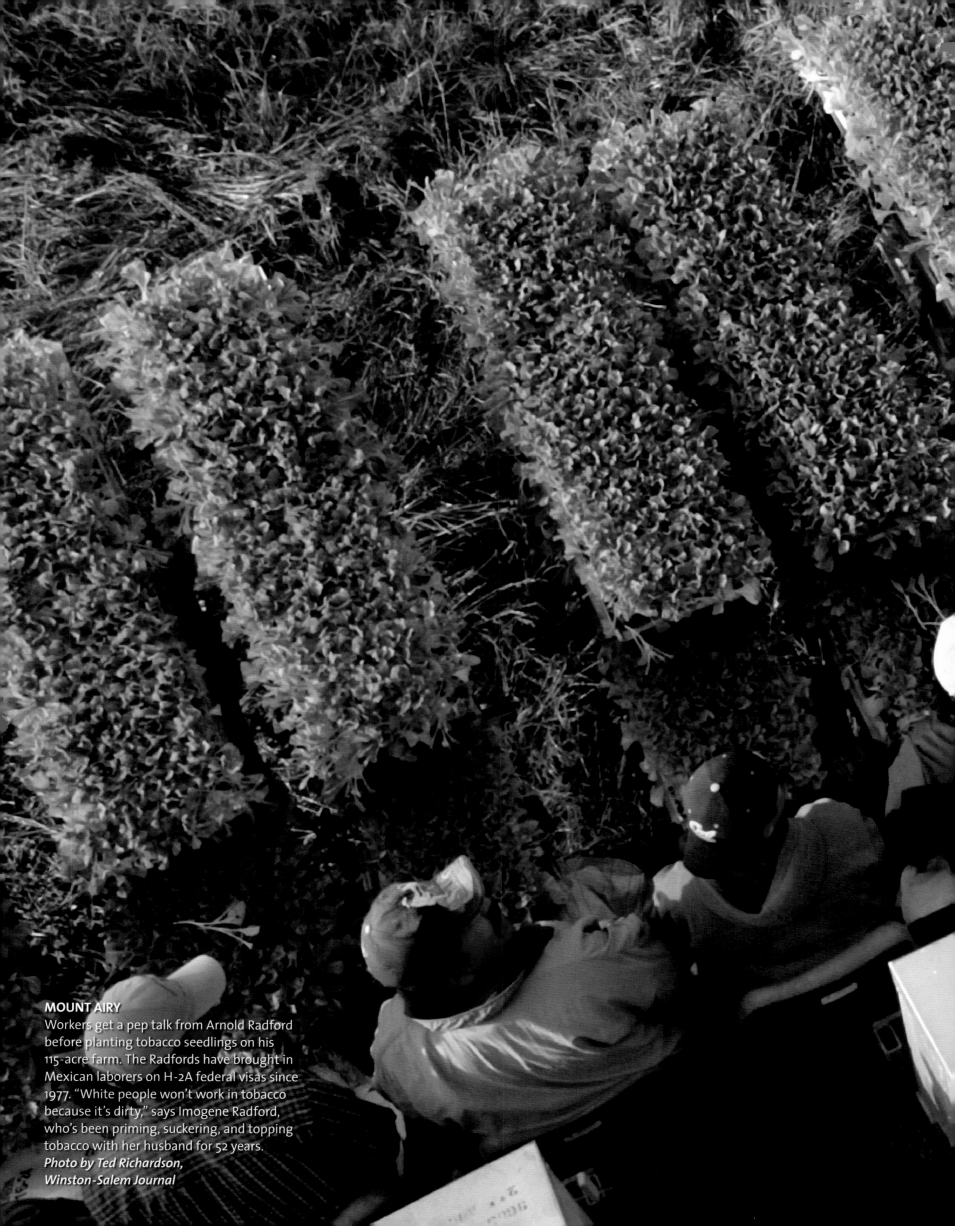

MOUNT AIRY
Workers get a pep talk from Arnold Radford before planting tobacco seedlings on his 115-acre farm. The Radfords have brought in Mexican laborers on H-2A federal visas since 1977. "White people won't work in tobacco because it's dirty," says Imogene Radford, who's been priming, suckering, and topping tobacco with her husband for 52 years.
Photo by Ted Richardson,
Winston-Salem Journal

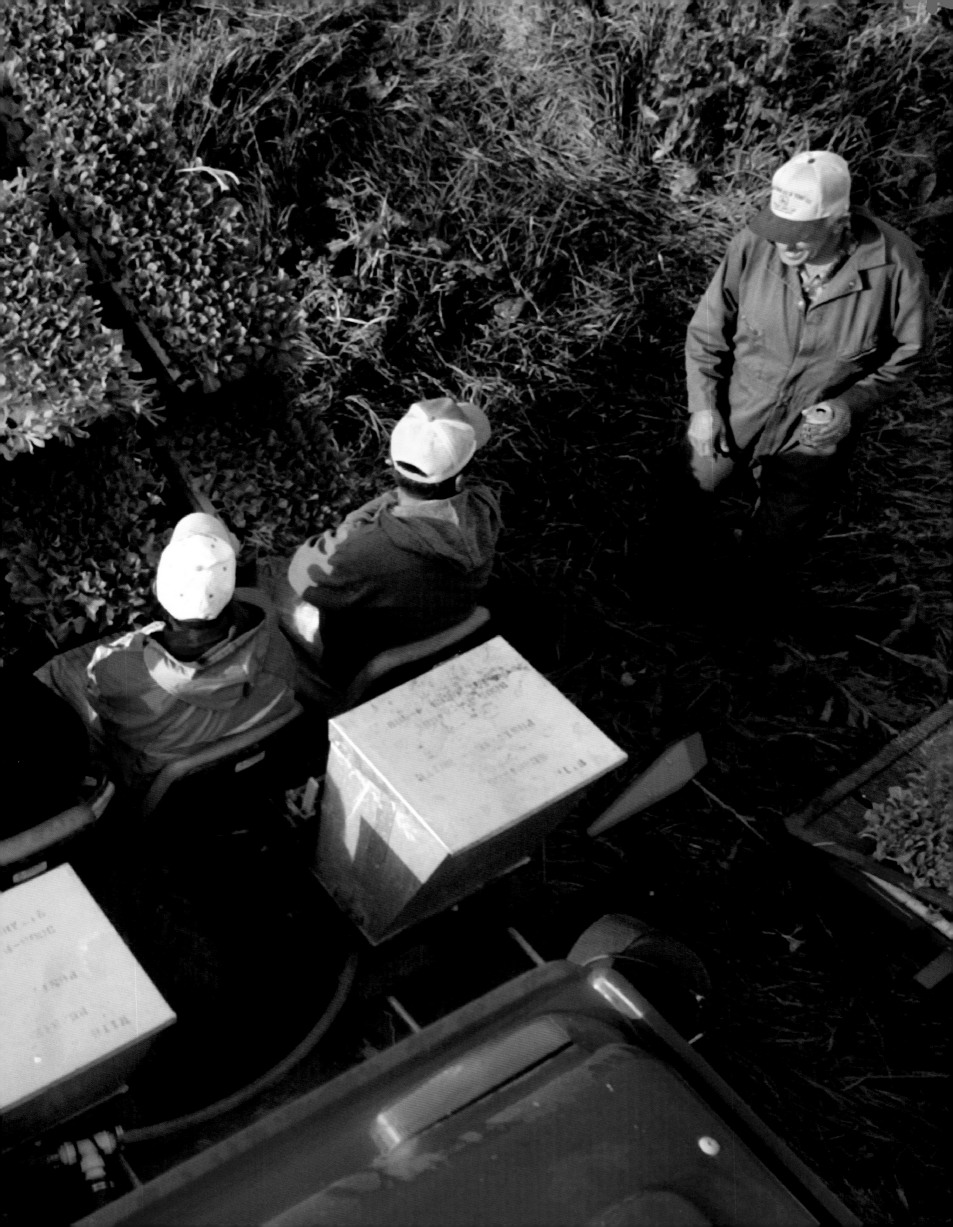

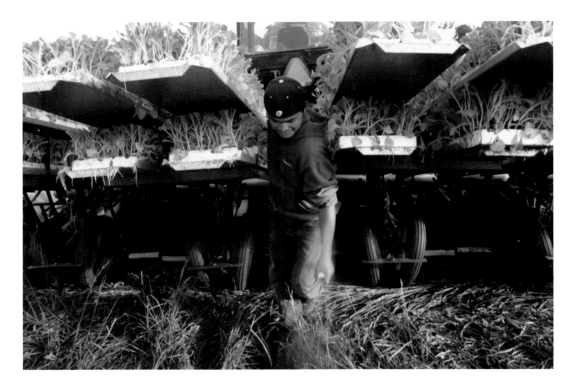

MOUNT AIRY

Tobacco seedlings raised in the Radfords' green-house are planted in early spring and harvested during the long, hot days of North Carolina's Indian summers. When plants reach a height of 6 feet, laborers cut, cure, bundle, and ship the leaves to a processing plant where they're made into Marlboros and Virginia Slims for the Philip Morris Company.

Photos by Ted Richardson, Winston-Salem Journal

MOUNT AIRY

The sun is setting on North Carolina's tobacco growers. Declining cigarette consumption, hikes in state and federal taxes, and lawsuits against the big tobacco companies have gutted demand for the crop and reduced its market value. "We don't have a fine home and we never took vacations, but we made a living," says Imogene Radford. "We just don't make money like we used to."

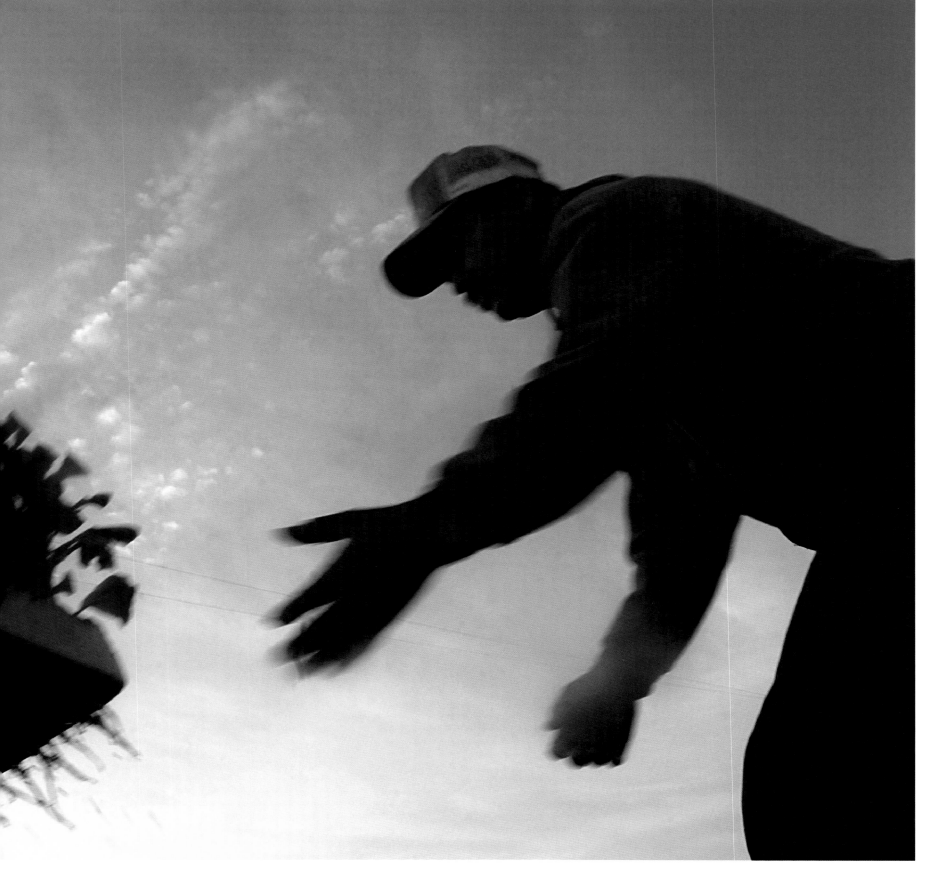

PLYMOUTH
Headwaitress Katie Blair, 24, puts in an hour's work cleaning up after her shift at a branch of Andy's Cheesesteaks and Cheeseburgers. She earns $7 an hour before tips, well above the state's minimum wage of $2.13 for employees who receive tips.
Photo by Janet Jarman, Contact Press Images

RALEIGH

Earning his stripes. Jesse Oates, a student at Harris Barber College, neatens customer Walter Rogers with clippers. The school opened in 1937 across the street from Shaw University, one of the South's oldest black colleges. The barbershop offers 20 services, including a regular haircut ($4), an Afro ($5), and a men's relaxer wave ($17).
Photo by Corey Lowenstein

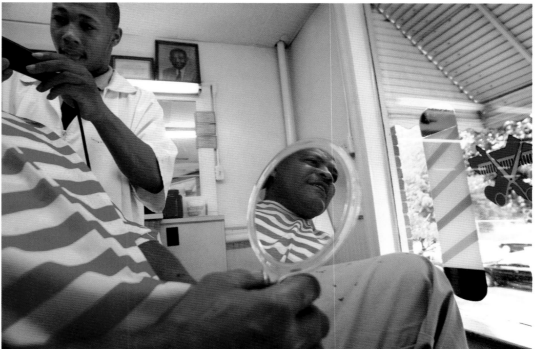

SWANNANOA

When US Highway 70 needed to be repaved between Oteen and Black Mountain, Texas-based Remixer Inc. got the job. So, Willie Clark of Tyler, Texas, relocated to the Motel 6 in Black Mountain for five months. As chief of traffic control on the project, Clark has been yelled at and cussed at. "Now, whenever I get delayed by a road crew," he says, "I keep my mouth shut."

Photos by Melody Ko

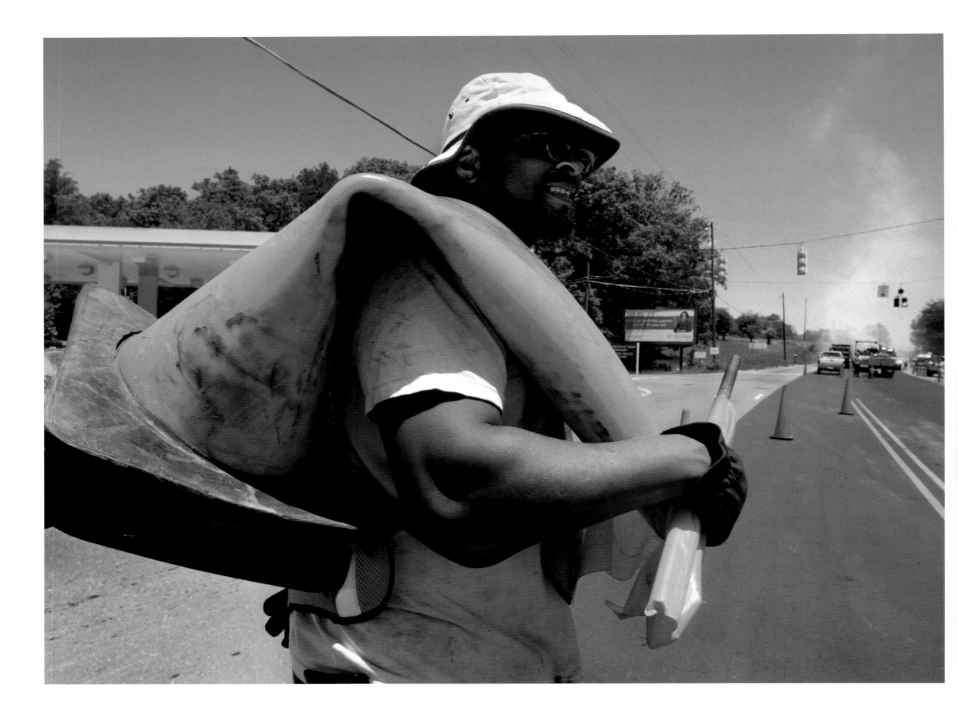

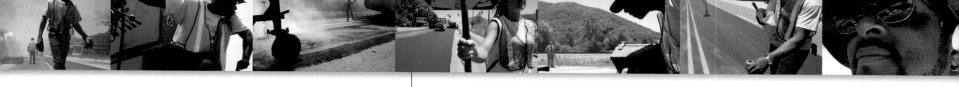

SWANNANOA

Ashley McGhee, 18, was one of just two women on the Highway 70 repaving project. She took the job—her first on a road crew—for the money and flexible hours. She worked 10 hours a day, three days a week during her summer break from McDowell Technical Community College, where she is studying to be a registered nurse.

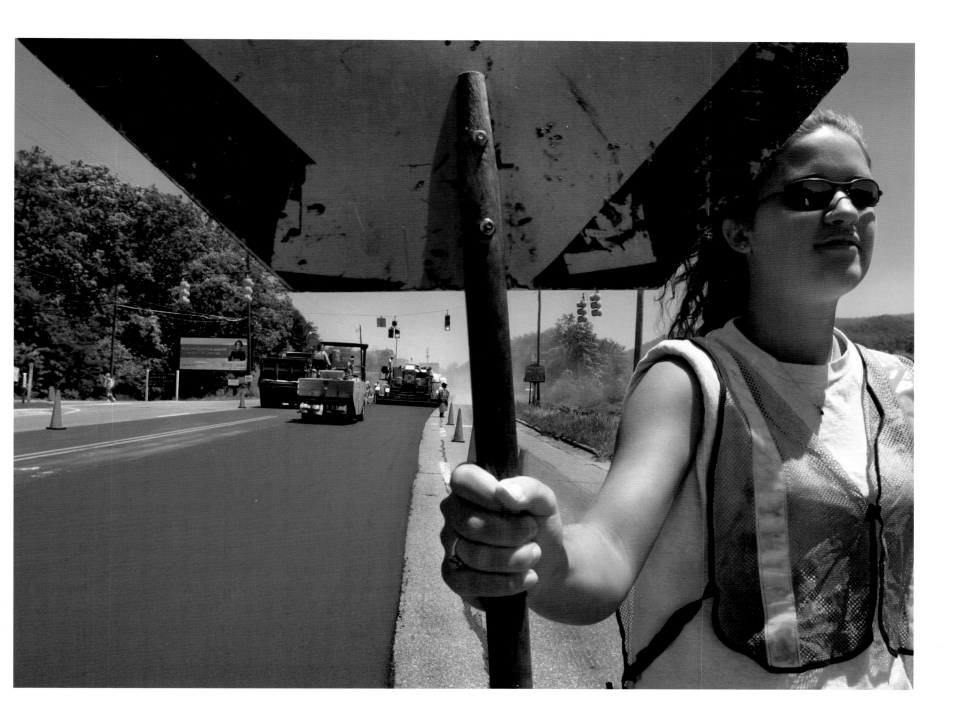

PINEHURST
Caddy Greg Parker's jaw goes slack as Dave Abdo sinks a birdie putt on the No. 2 course at Pinehurst Resort. Reading yardages, raking sand bunkers, and carrying golf bags are just part of a caddy's job. "We're here to make golfing easy and enjoyable," Parker says.
Photos by Christopher Record

PINEHURST

This ain't no *Caddy Shack*. Course No. 2 at Pinehurst is considered the second-best public golf course in America (after California's Pebble Beach). The U.S. Open was held on this course in 1999 and will be again in 2005.

PINEHURST

In the break room, caddies Donnie Miller and Gerry Williams deal with downtime by playing Spades. Pinehurst's 120 caddies make $29 a bag; it's the tips that make all the difference— $25 to $150 per player, depending on how well the round goes.

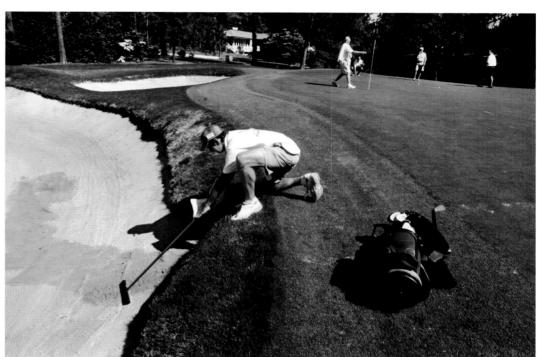

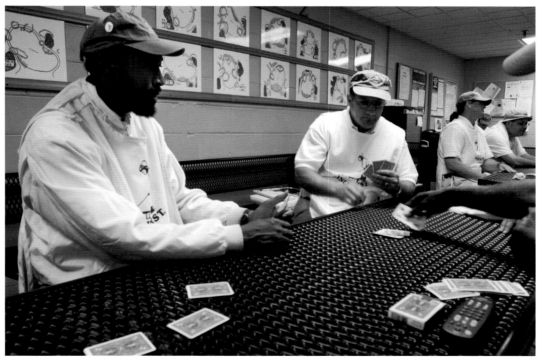

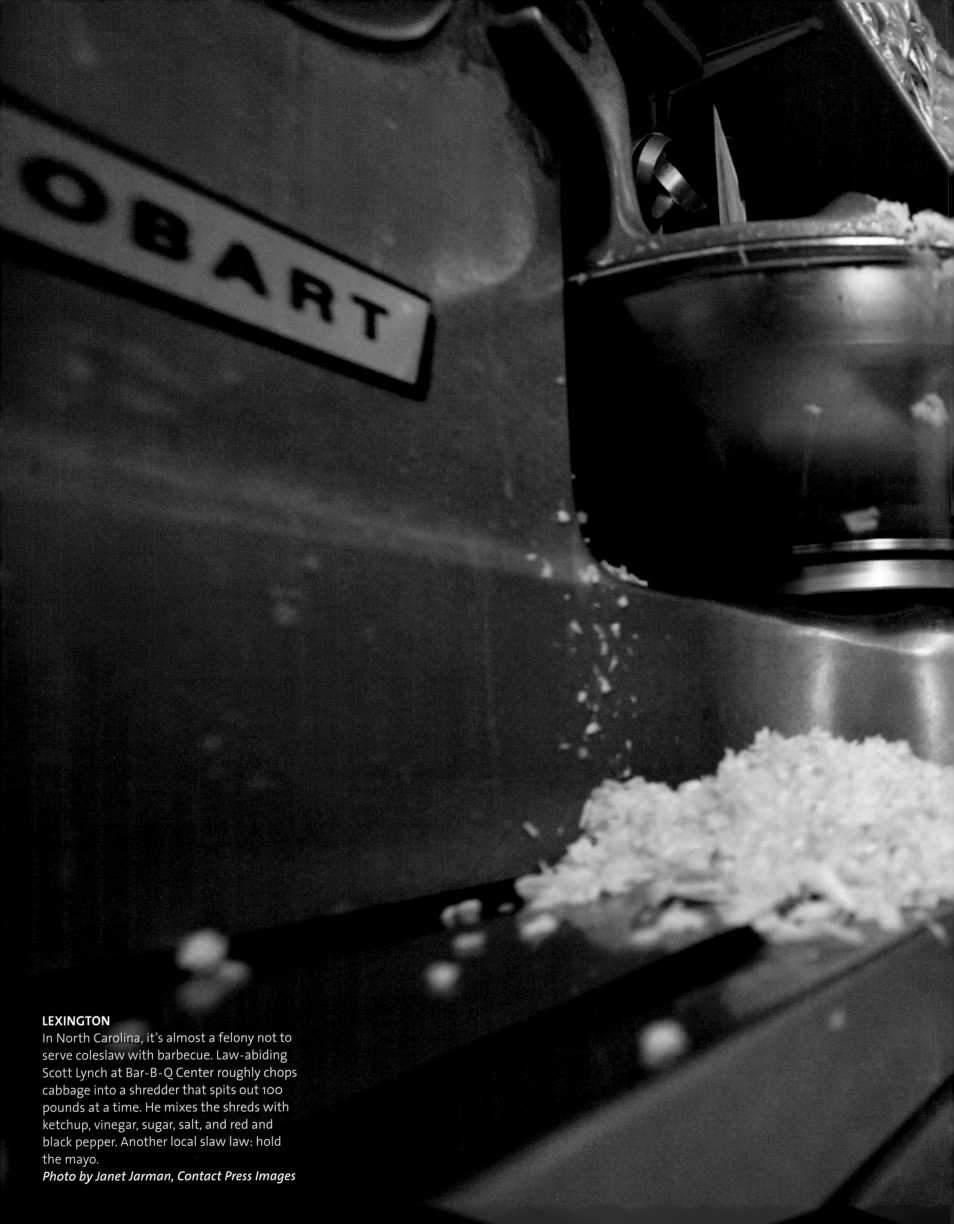

LEXINGTON
In North Carolina, it's almost a felony not to serve coleslaw with barbecue. Law-abiding Scott Lynch at Bar-B-Q Center roughly chops cabbage into a shredder that spits out 100 pounds at a time. He mixes the shreds with ketchup, vinegar, sugar, salt, and red and black pepper. Another local slaw law: hold the mayo.
Photo by Janet Jarman, Contact Press Images

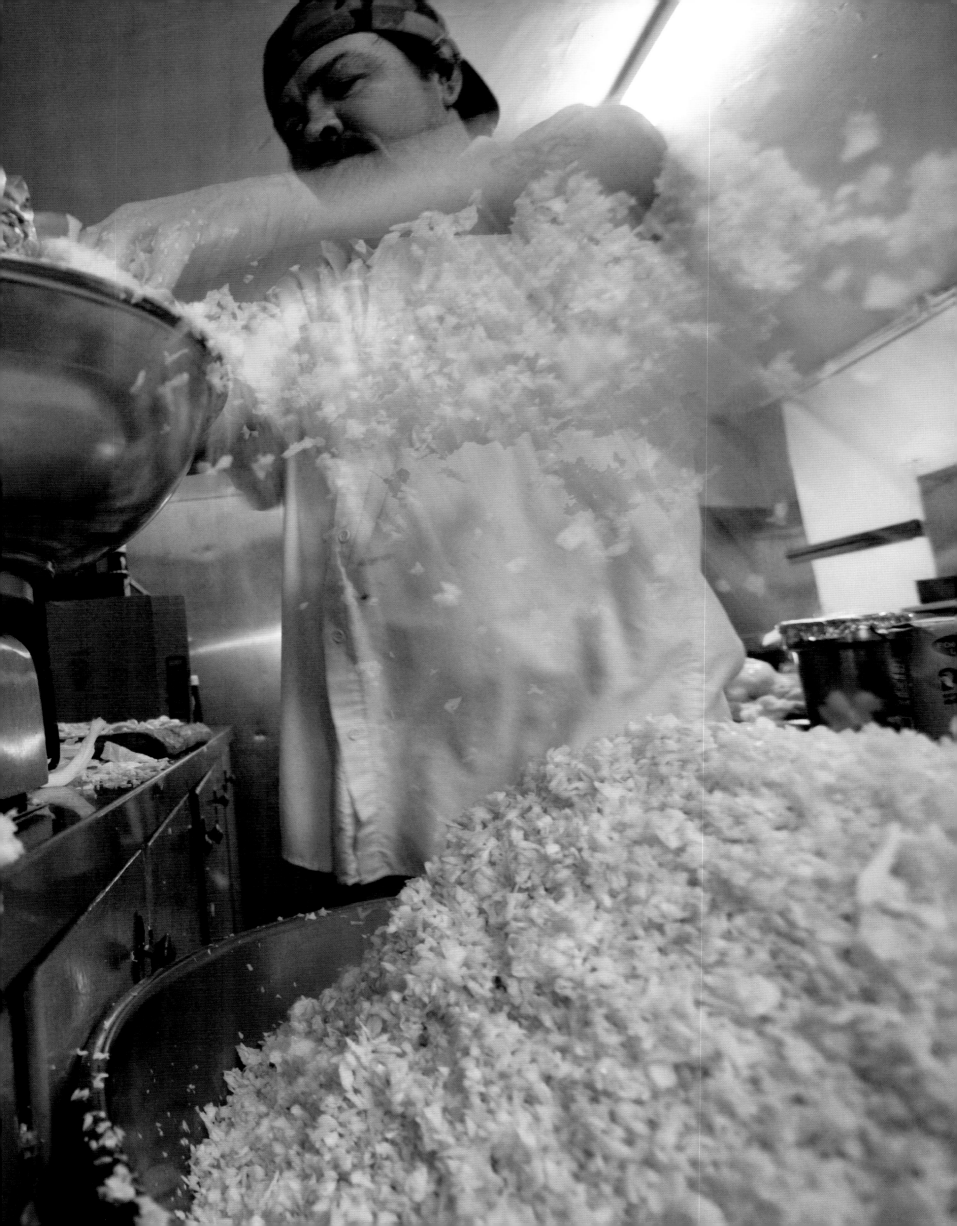

FAYETTEVILLE
Cool under pressure. Neurosurgeon Dr. Carol Wadon
consults with another doctor over the phone while
repairing a ruptured lumbar disc at the Cape Fear
Valley Medical Center. Brain and spinal chord
surgeries can last up to 14 hours, but Dr. Wadon
rarely notices. "You're so involved in what you're
doing that time just flies by," she says.
Photo by Cindy Burnham, Nautilus Productions

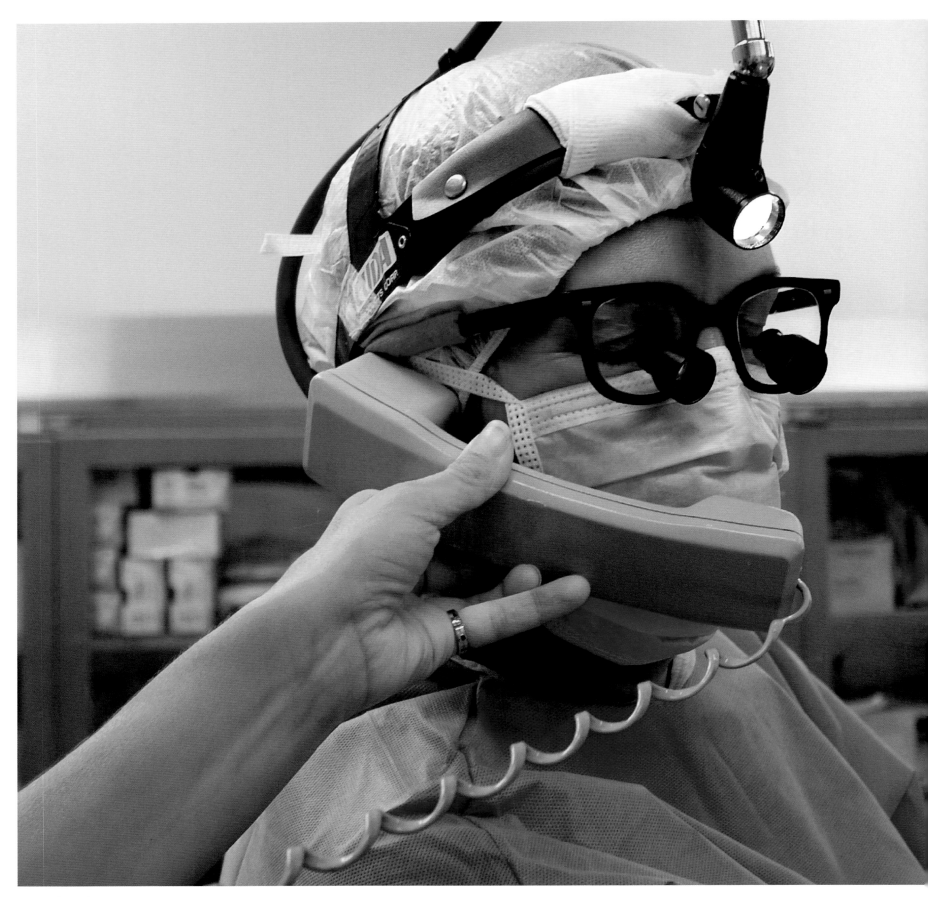

RALEIGH

The intricacies of the double helix are revealed in Susan Pando's genotyping experiments at the GlaxoSmithKline facility in Research Triangle Park. Pando's lab studies the genetic underpinnings of hereditary diseases and tests the efficacy of new drugs on DNA targets.

Photo by Bruce DeBoer

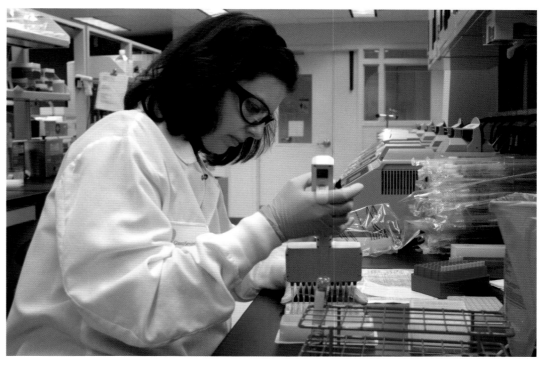

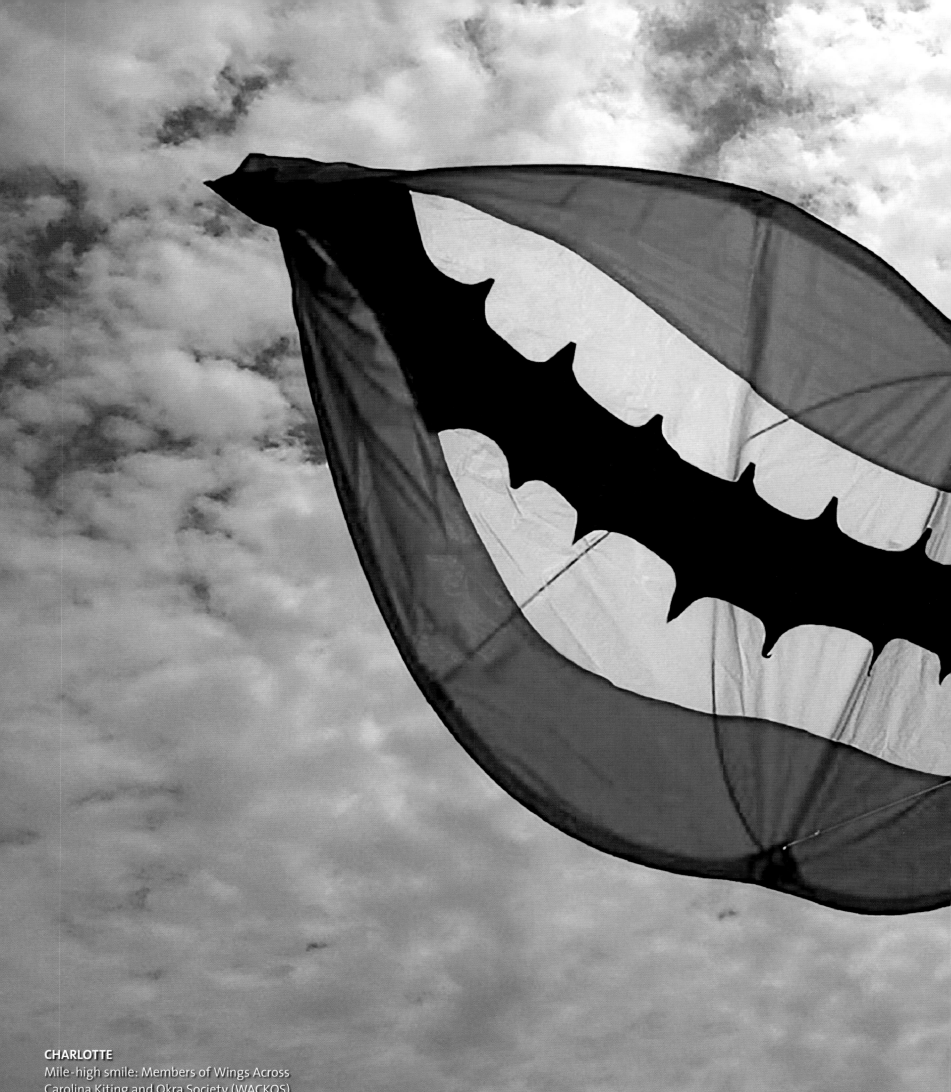

CHARLOTTE
Mile-high smile: Members of Wings Across
Carolina Kiting and Okra Society (WACKOS)
chipped in to buy fellow member Jim Martin
this set of flying chops for his 40th birthday.
The loose-knit group meets twice a month
for socializin' and flyin' at Frank Liske Park.
Photo by Gayle Shomer Brezicki

North Carolina At Play

WRIGHTSVILLE BEACH

Bobby Cox carries a freshly caught Spanish mackerel to his cooler on Johnnie Mercer's Pier. In 1939, a local fisherman bought the structure (at the time called Atlantic View Pier) and humbly renamed it after himself.
Photo by Logan Mock-Bunting

ATLANTIC BEACH

On vacation south of Morehead City, Acey Adams of Winston-Salem is one determined and upbeat fisherman. "My wife and I used to go fishing together, but she has passed away, so now my daughter just rolls me up here and I can pretty much do the rest by myself." Adams began using a wheelchair after a recent hip replacement.
Photo by Coke Whitworth

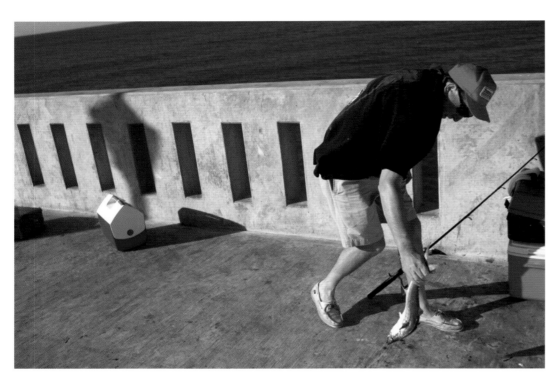

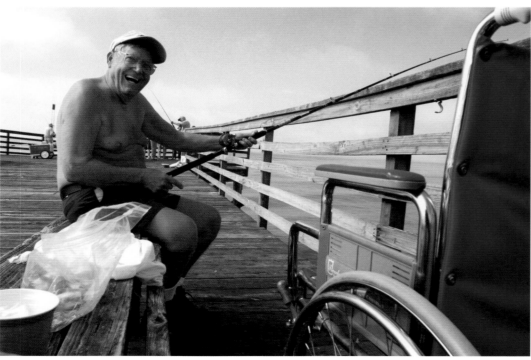

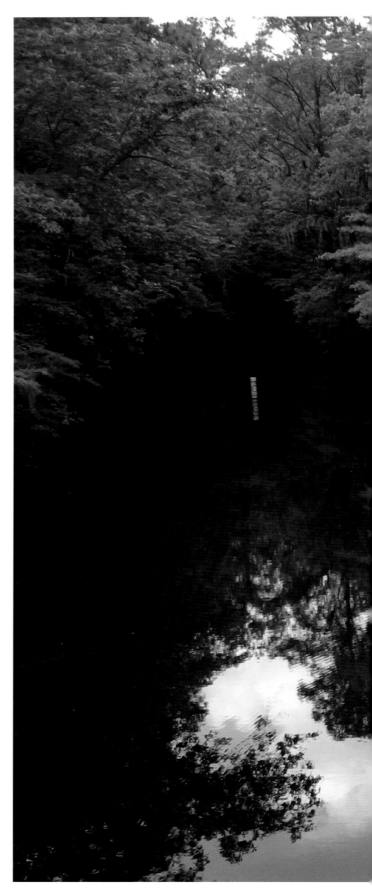

HAVELOCK
Early one evening along a tributary of the Neuse River in the Croatan National Forest, fisherman Dennis Smith casts his line for mullet, or maybe croakers.
Photo by Coke Whitworth

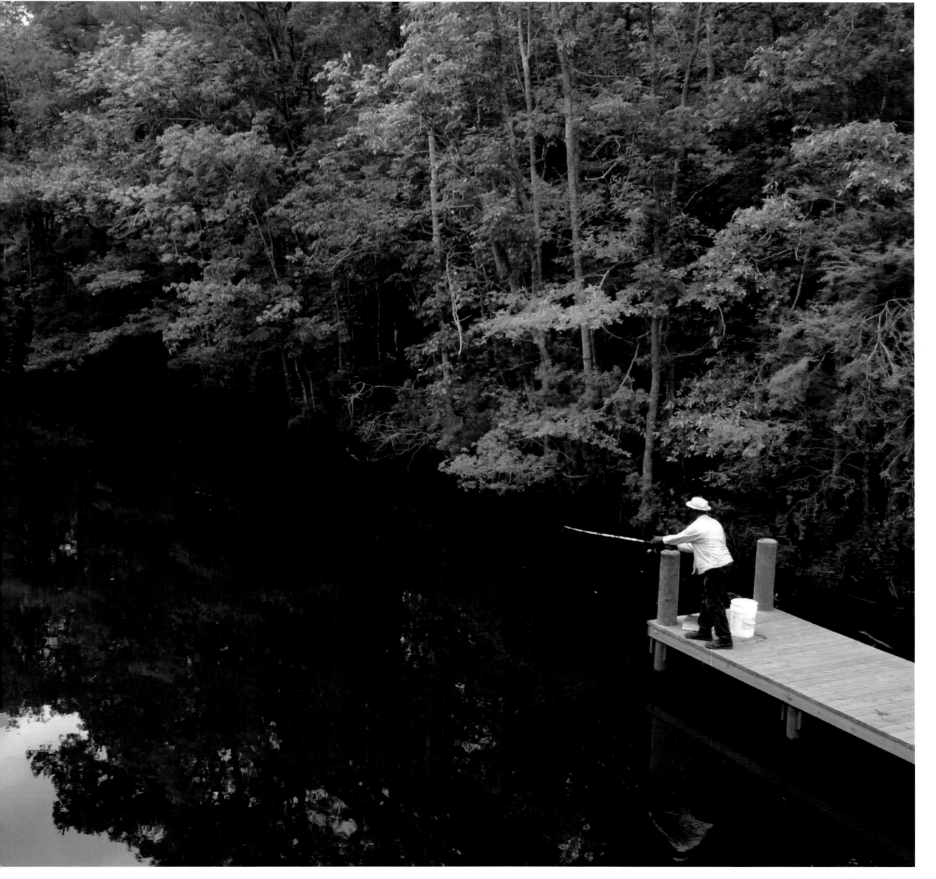

BOONE

In extreme tubing, the cheaper the raft and rougher the river—the bigger the rush. Will Hagna hangs on for dear life on the wily Watauga near the Tennessee border. During the winter months he pulls equally risky snowboard stunts on the frozen stuff.
Photo by Jason Arthurs

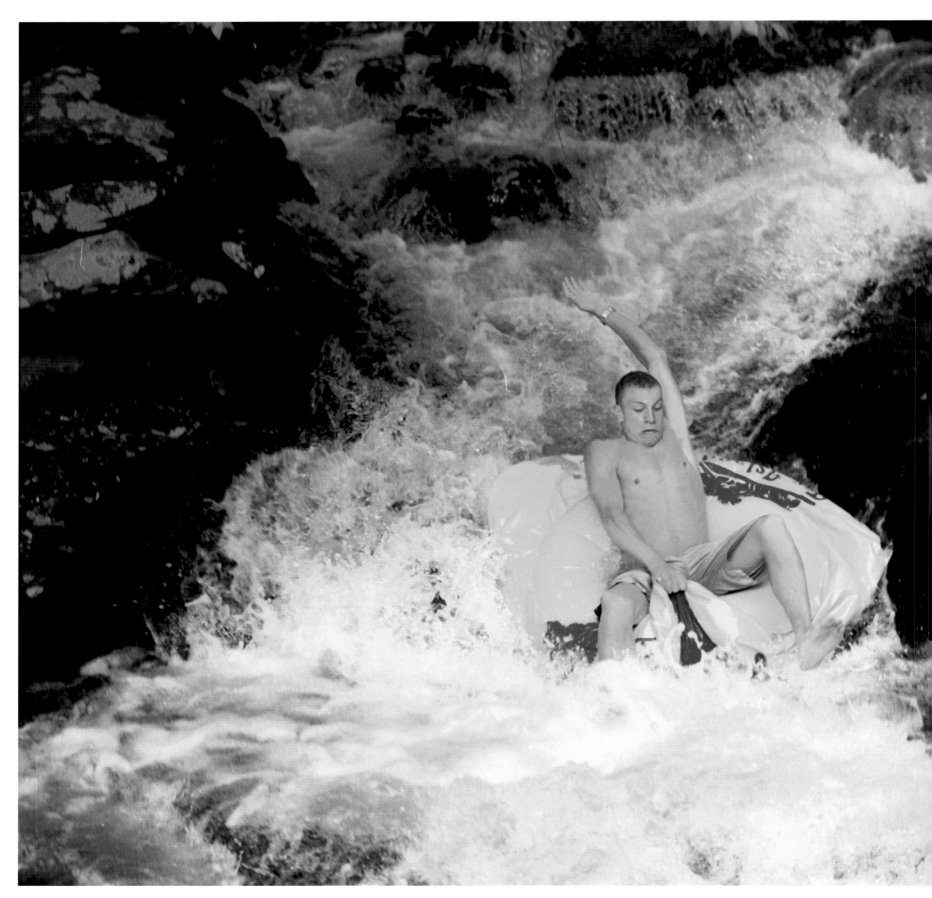

WRIGHTSVILLE BEACH
Wes Corder, 23, prefers his 9 foot 2 inch longboard when riding the waves on Wrightsville Beach. "Surfing is the only time I can go out someplace and be alone," he says.
Photo by Logan Mock-Bunting

EMERALD ISLE
New York City resident Jennifer Manzella, 30, cools off while visiting friends on Emerald Isle. Manzella says one of the highlights of her trip—her first to North Carolina—was the annual Blackbeard Fest in Beaufort and Morehead City. The notorious pirate was killed in a battle in nearby Ocracoke Inlet in 1718.
Photo by Susie Post Rust, Aurora

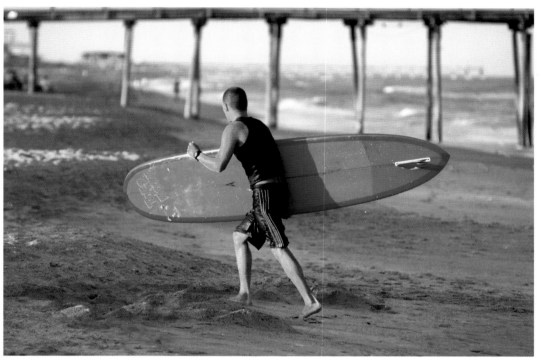

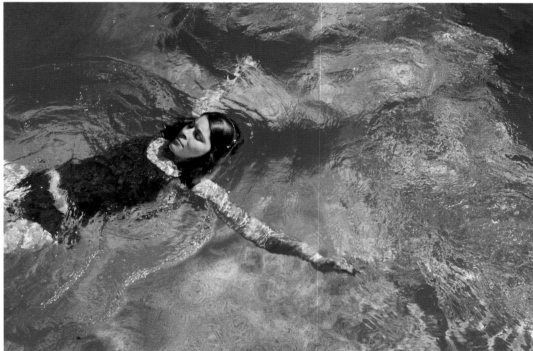

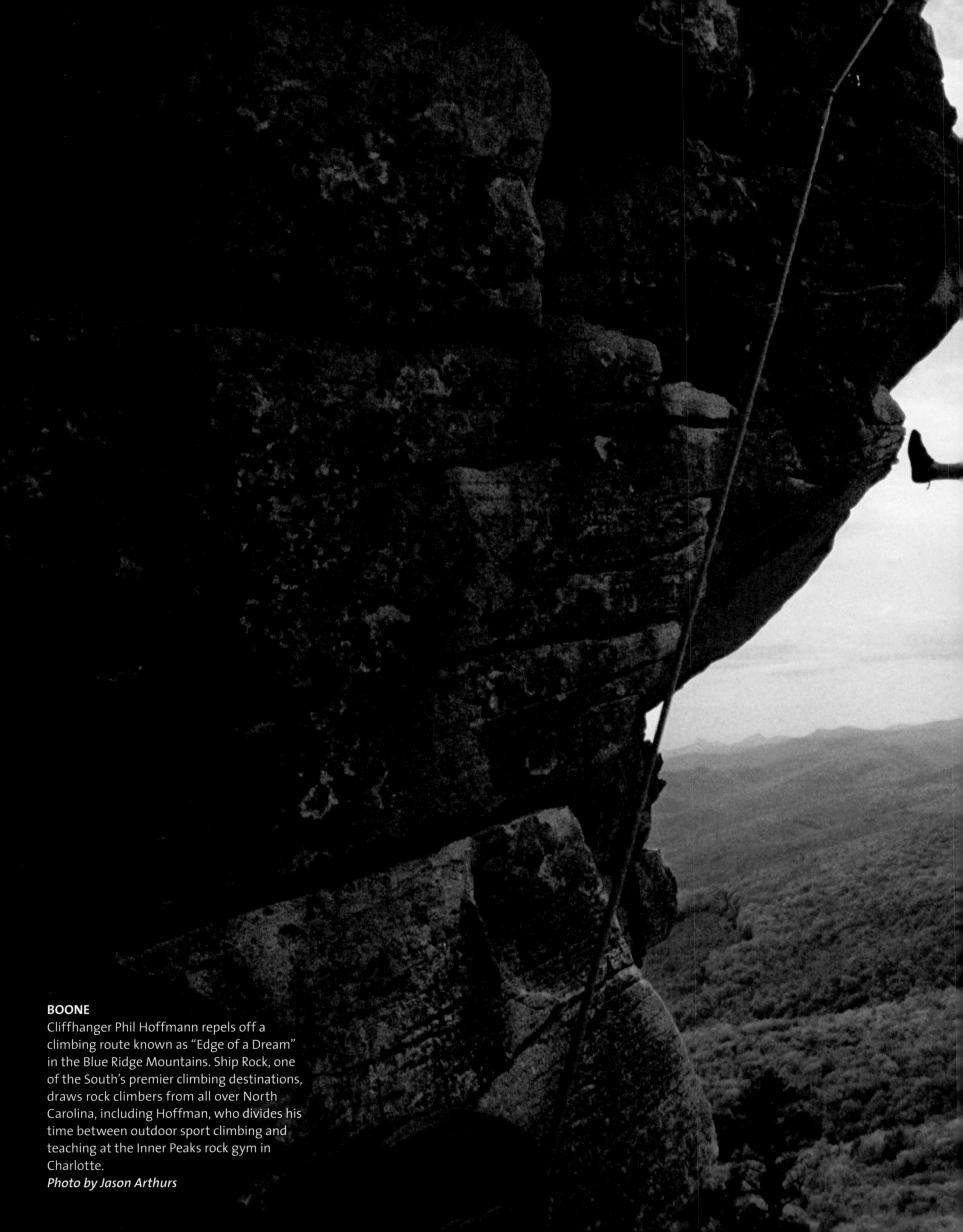

BOONE
Cliffhanger Phil Hoffmann repels off a climbing route known as "Edge of a Dream" in the Blue Ridge Mountains. Ship Rock, one of the South's premier climbing destinations, draws rock climbers from all over North Carolina, including Hoffman, who divides his time between outdoor sport climbing and teaching at the Inner Peaks rock gym in Charlotte.
Photo by Jason Arthurs

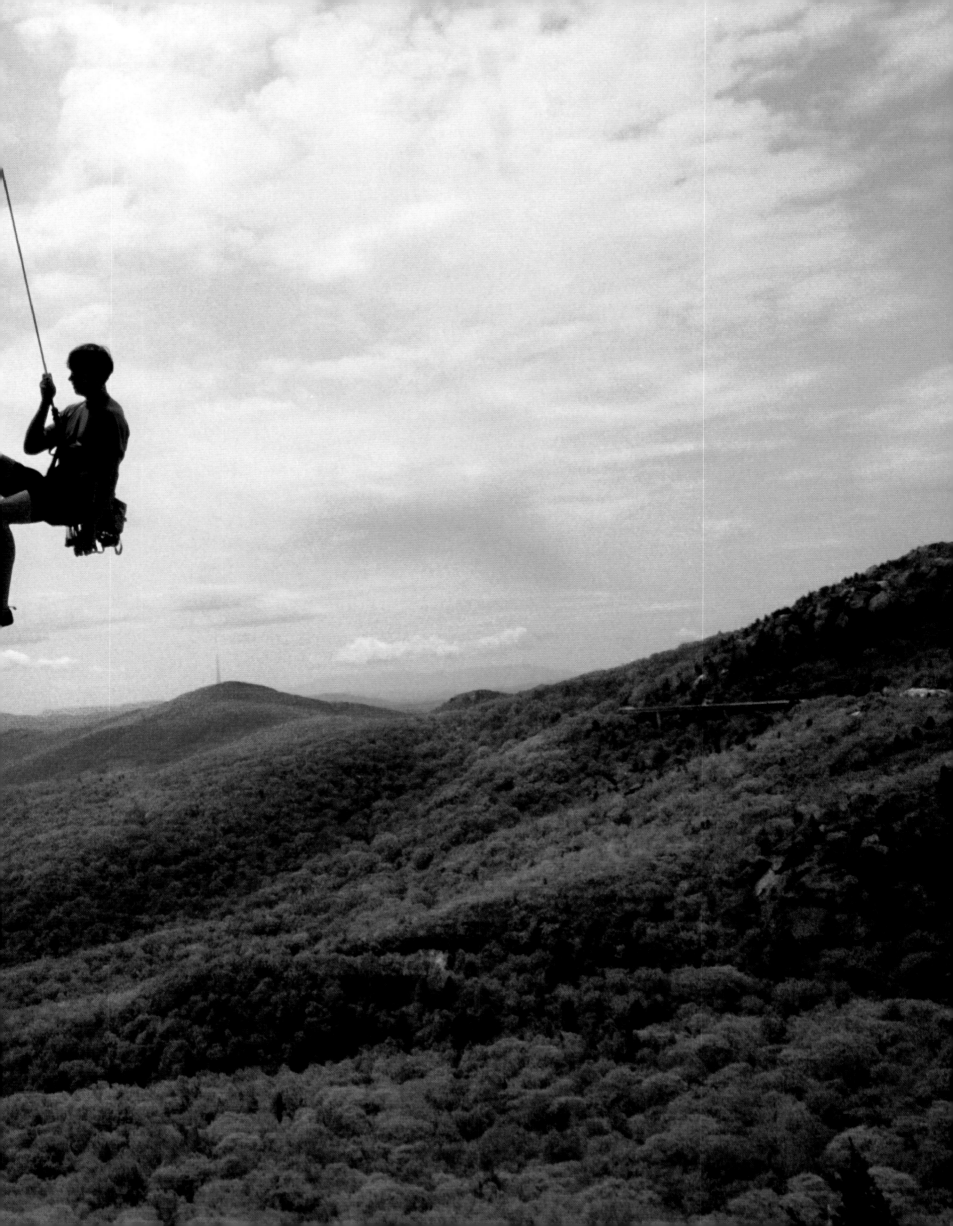

Ladies' night: The Bunko Babes of Raleigh's Riverside subdivision get together to play the dice game once a month. Dawn Lazzara gets ready to roll the dice as opposing teammates high-five their last move.
Photos by Scott Lewis

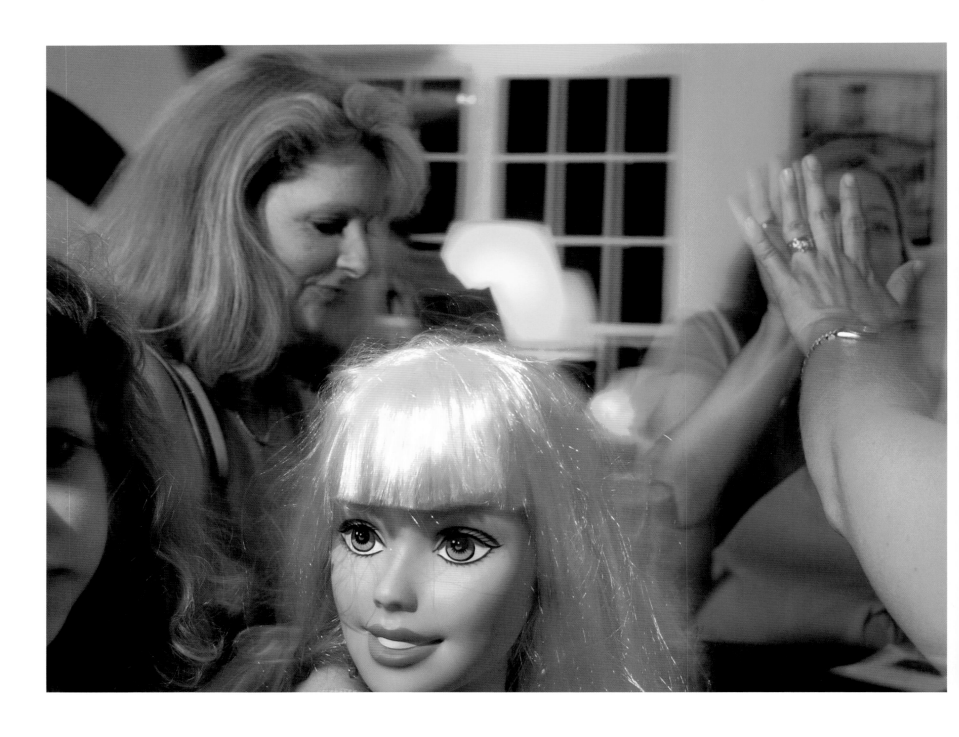

RALEIGH

In Bunko, teams can score on every turn. Though the rules vary, the Raleigh women start by rolling for ones, then twos, up through sixes. This roll would score if the team were on threes or fives. If not, the dice must go to the next team. A bunko (three-of-a-kind) also racks up extra points. A score of 21 ends the game.

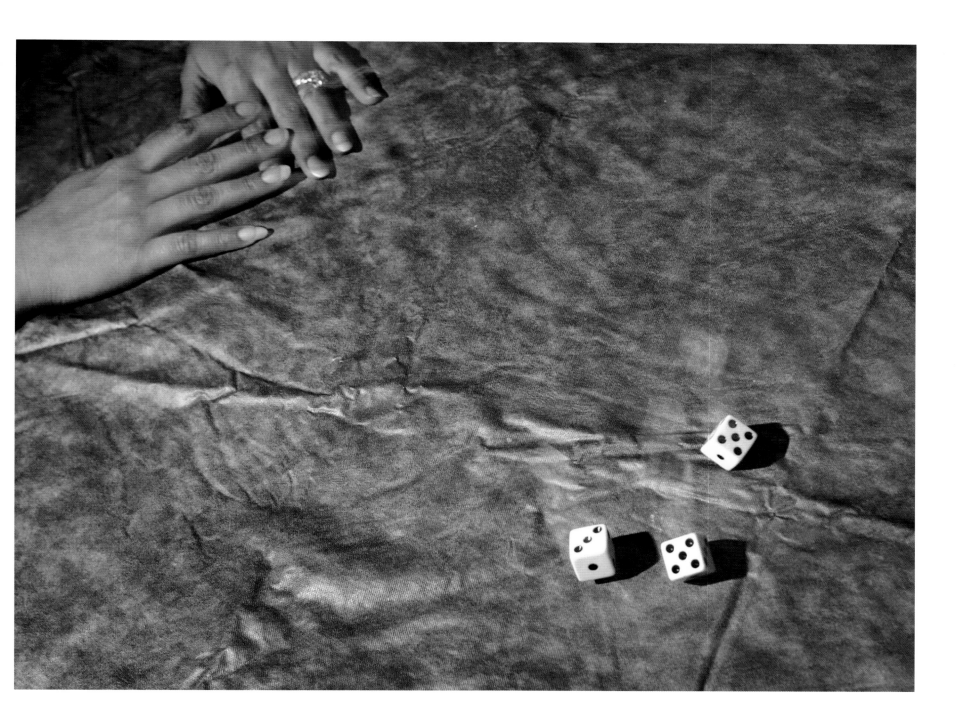

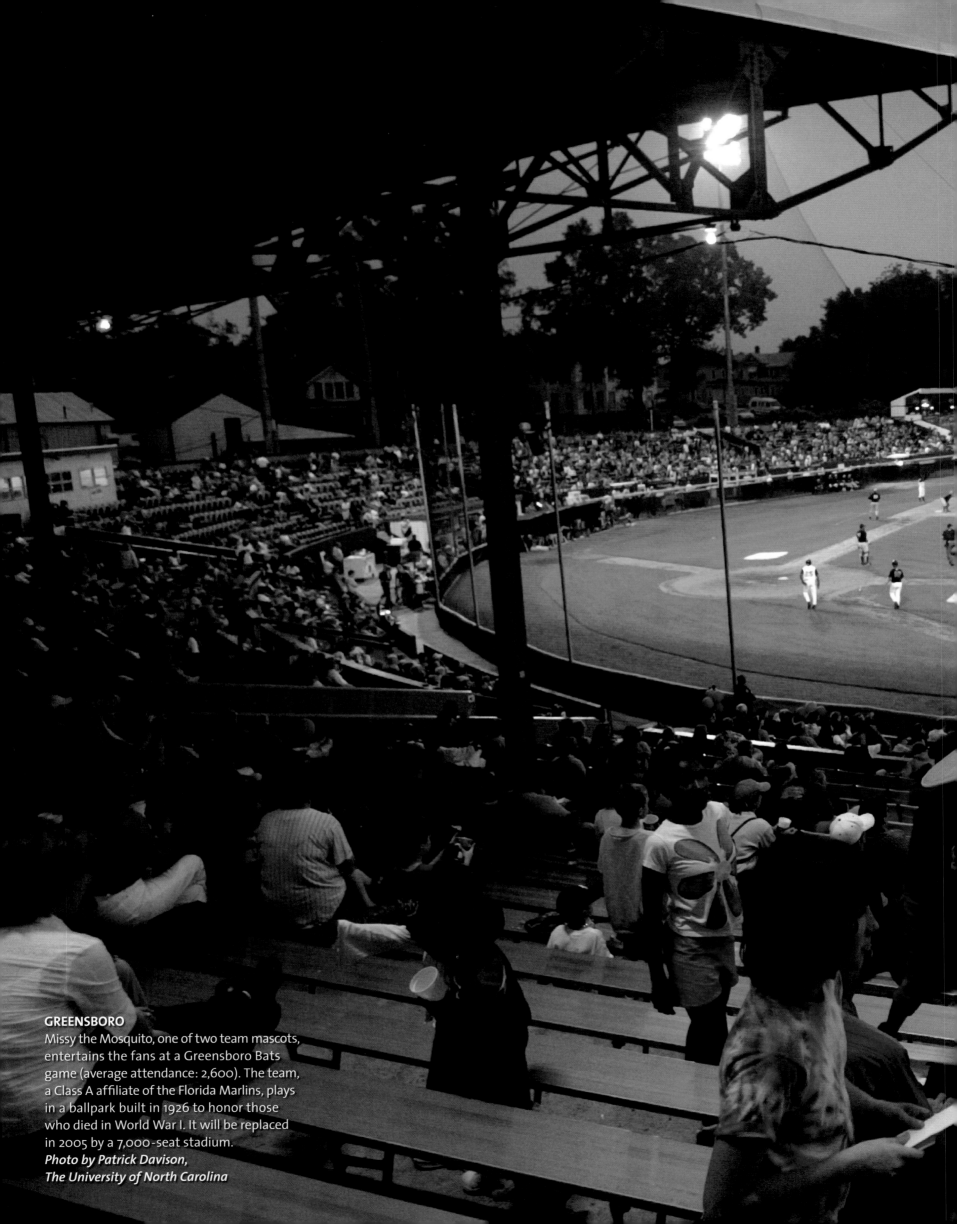

GREENSBORO
Missy the Mosquito, one of two team mascots, entertains the fans at a Greensboro Bats game (average attendance: 2,600). The team, a Class A affiliate of the Florida Marlins, plays in a ballpark built in 1926 to honor those who died in World War I. It will be replaced in 2005 by a 7,000-seat stadium.
Photo by Patrick Davison,
The University of North Carolina

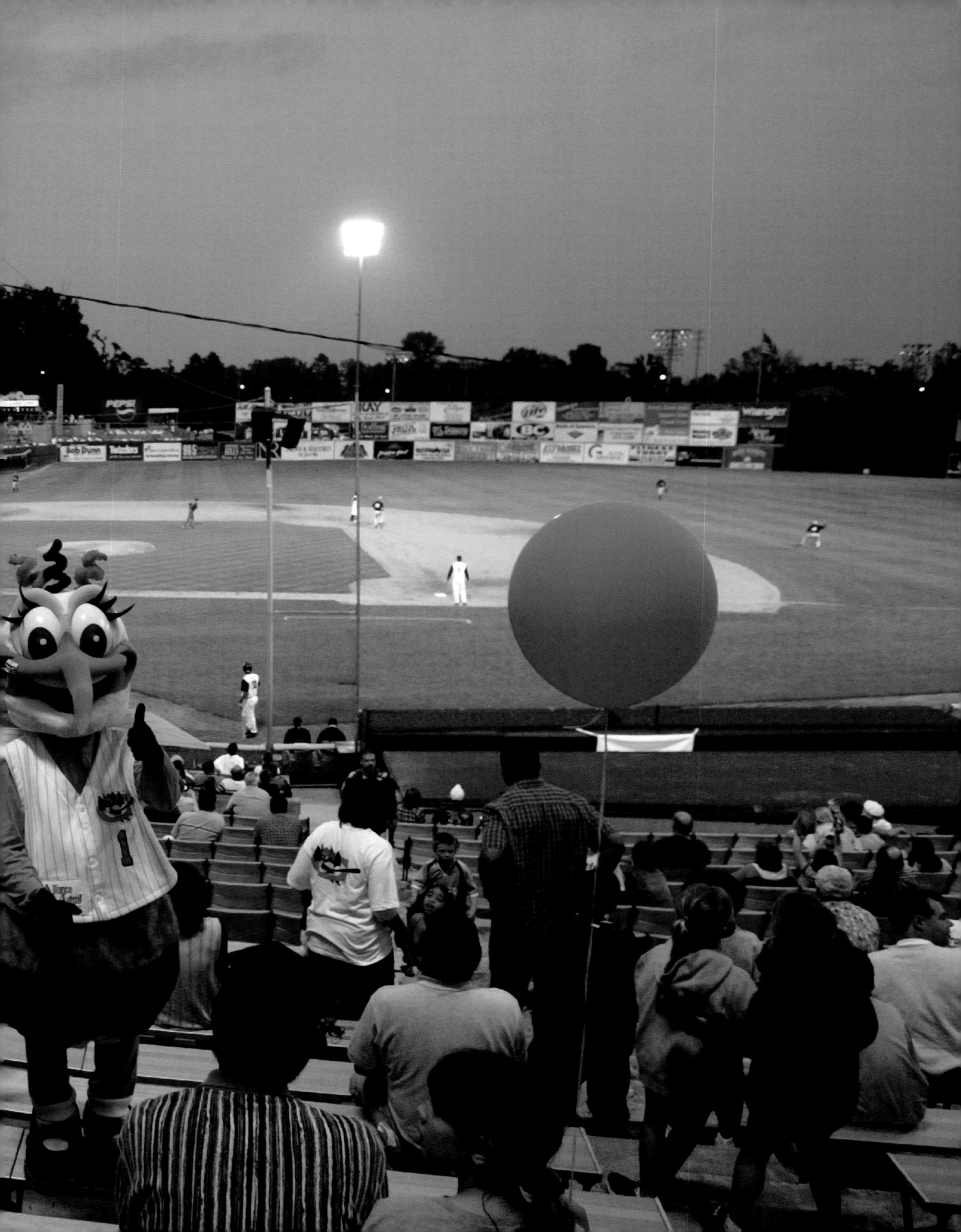

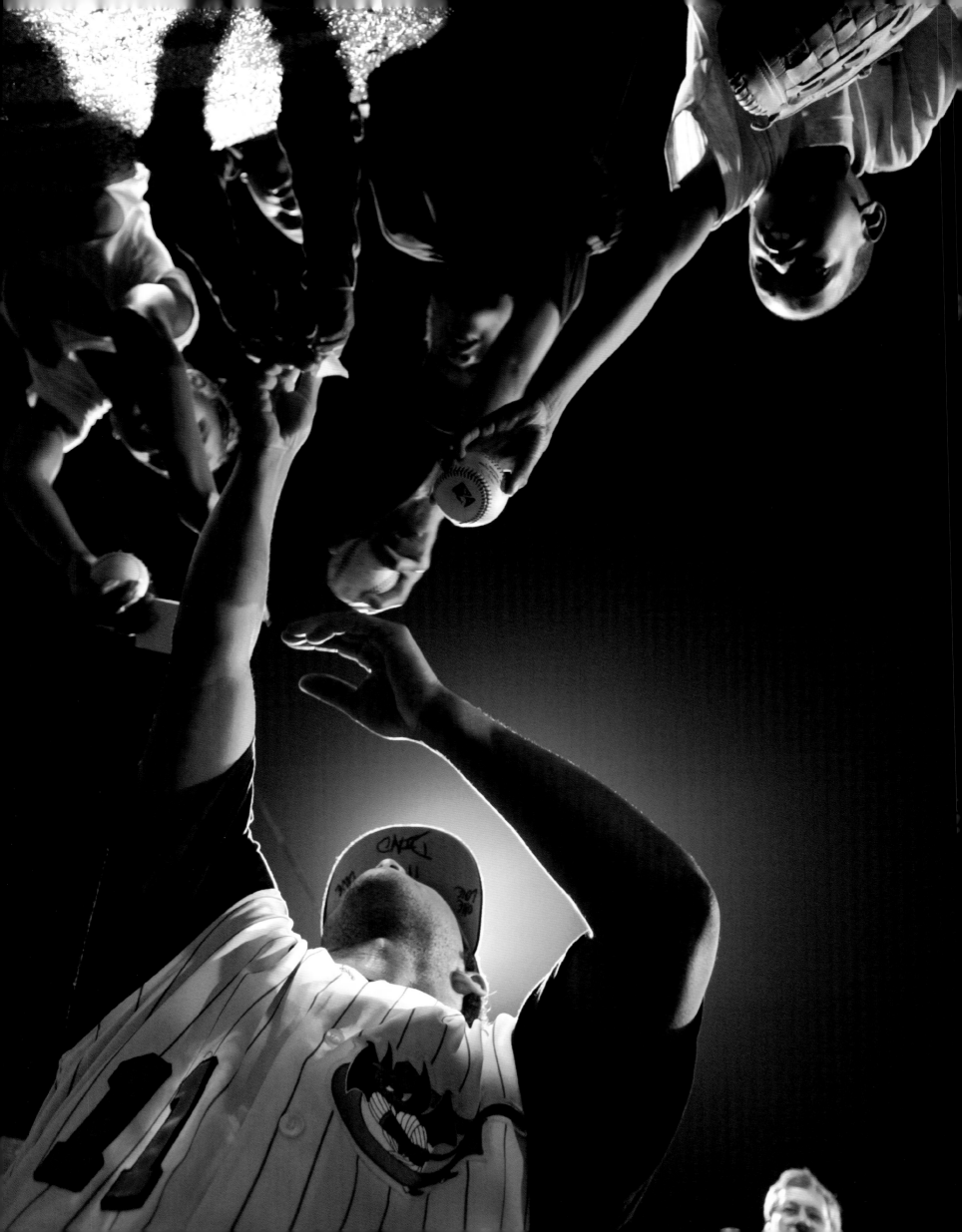

GREENSBORO

Shortstop Robert Andino, 19, signs balls for adoring fans after his Greensboro Bats beat the Hickory Crawdads 14–8. Picked in the 2002 Amateur Draft, Andino opted to play for the Bats, a Class A Florida Marlins farm club, instead of pursuing a college career.
Photos by Patrick Davison,
The University of North Carolina

GREENSBORO

To keep their muscles loose and avoid injuries, players do a half-hour of warm-ups every day before practices and games. Bats trainer Steve Miller puts the players through their paces. In a given year, about 50 athletes will cycle through the 25-man squad.

GREENSBORO

Fan Aaron Blackburn tries to one-hand a ball tossed into the stands between innings. Although he missed the catch, his 4-year-old daughter Lila was able to keep the ball.

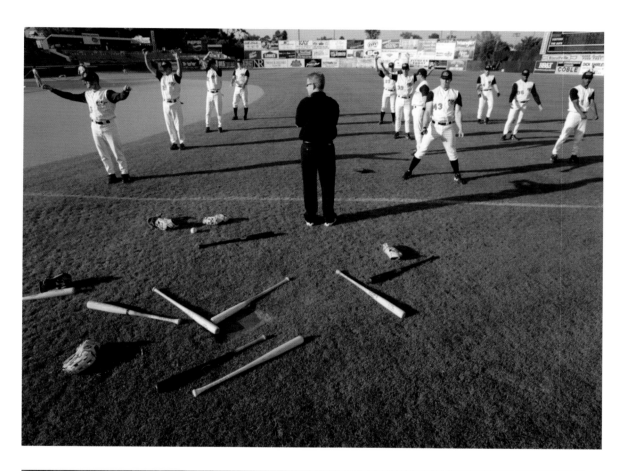

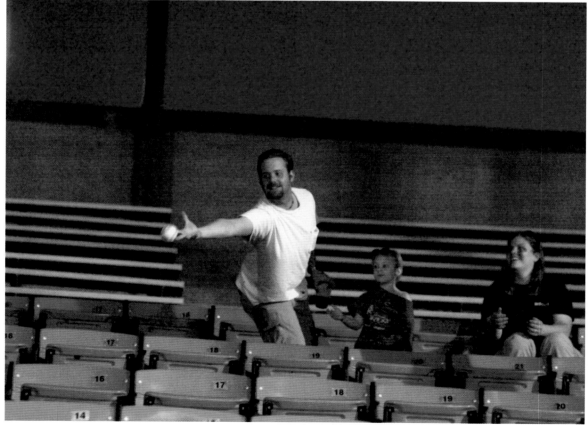

GREENSBORO

Hailing from Wichita Falls, Texas, pitcher James Demontel, 23, was the Marlins' 12th-round draft pick in 2002. He is known for his fastball, which clocks in at about 92 mph.

Photos by Patrick Davison,
The University of North Carolina

GREENSBORO

The Florida Marlins franchise has kept catcher Angel Molina busy. Since becoming a Marlin property in 2001, the Puerto Rican native has played on affiliate teams in the Gulf Coast league, the Midwest league, and the New York Penn league. He was part of the Greensboro Bats—a South Atlantic league team—lineup for 2003.

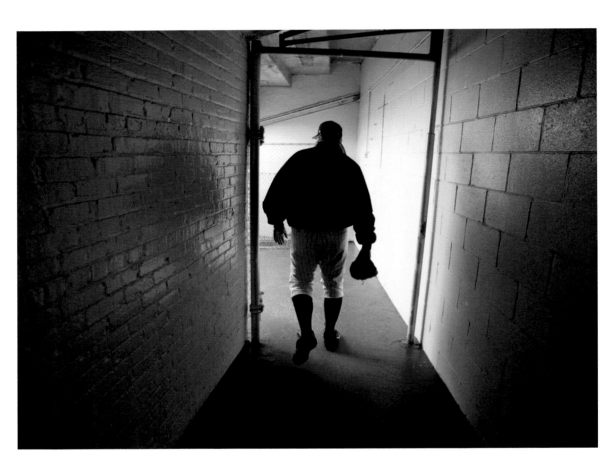

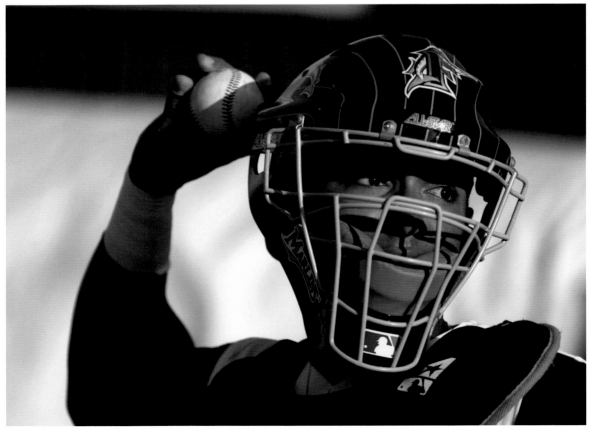

China produces 80 percent of the world's baseballs; however, all of the balls pitched in the pros are made at a Rawlings factory in Costa Rica. This bag of practice balls represents a small percentage of the 3,000 balls used by the Greensboro Bats every year.

Paul Mildren, collecting his thoughts before a game, is the only Australian player in the entire Marlins franchise system. Just 19, he almost made the Australian Olympic team but was a late cut. A lefty, Mildren's best pitch is his curveball, and he is often compared to current Major League hurler Tom Glavine.

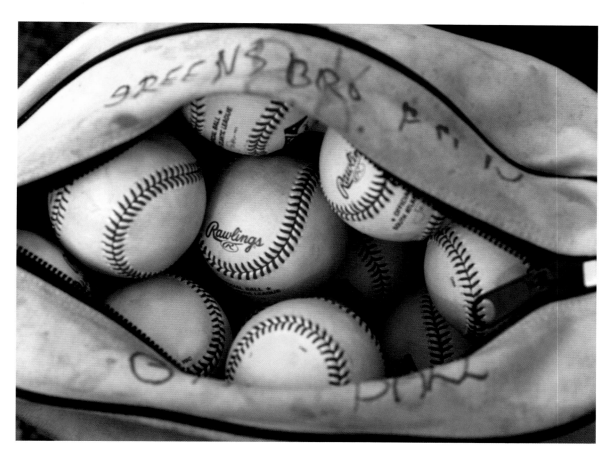

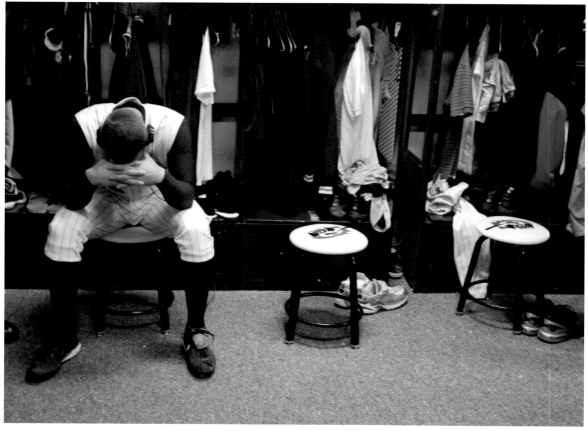

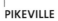

PIKEVILLE

The dirt—North Carolina red clay dirt—of Wayne County Speedway indicates where this stock car spent Friday night. Track owner Ed Radford and his son Eddie opened the facility in 1989. The first track was dirt. The Radfords paved it, but then reverted to dirt for more excitement. The family-friendly business is one of 75 dragways, dragstrips, raceways, and speedways in the state.
Photos by Corey Lowenstein

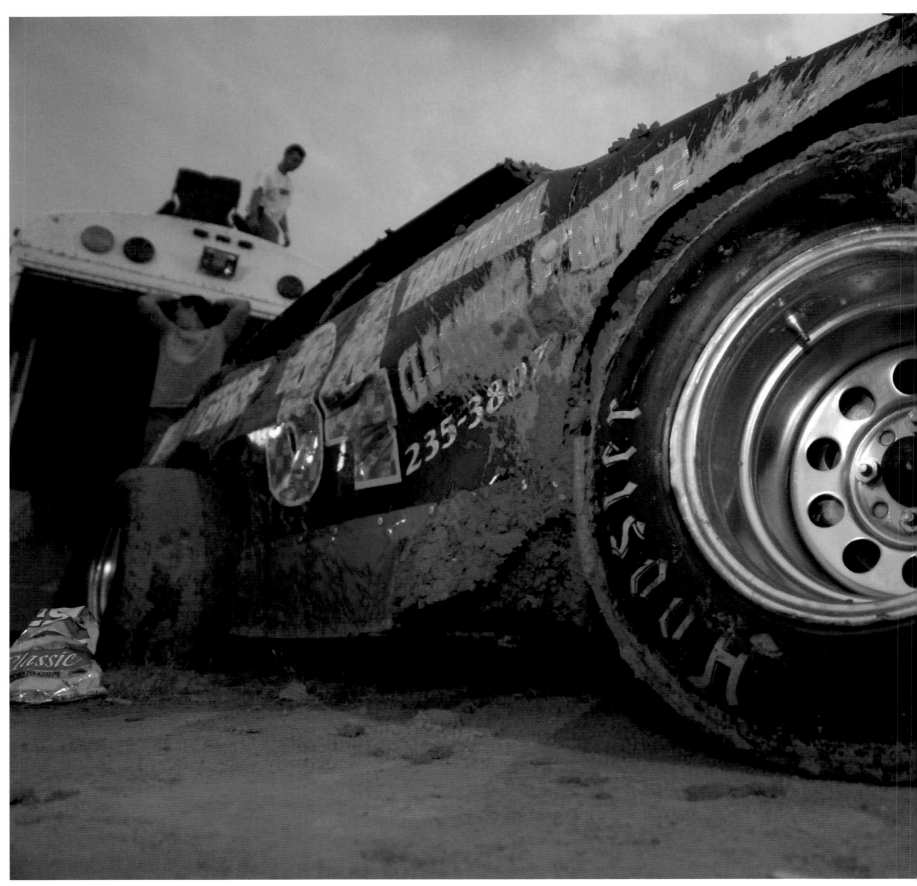

PIKEVILLE

Marty Lee of Stantonsburg adjusts the valves on Ol' Maybelle, the 1976 Camaro he rebuilt. "You're pushing about 450 horses," he figures. Lee, who owns six race cars with his wife Darlene—that's her name tattooed on his forearm—now leaves driving to younger men. "They have no fear." As for the race that night? "We won."

PIKEVILLE

Like father, like son: Eleven-year-old Dustin O'Neal and his father Jim (right) of Louisburg talk car talk with Tom Stone of Rocky Mount.

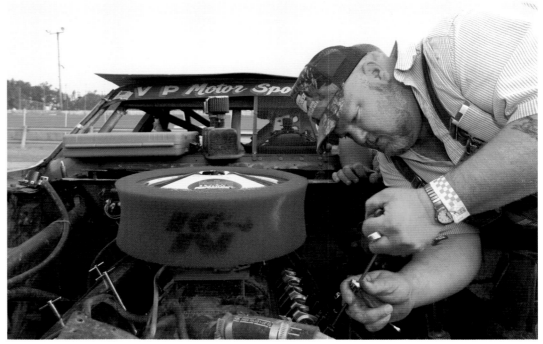

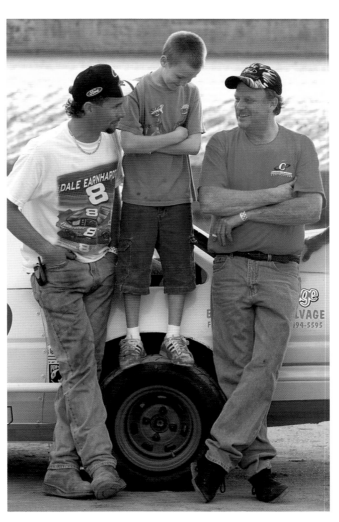

CONCORD
Todd Millard, crew member for NASCAR driver
Matt Kenseth, checks the pressure on tires Kenseth
will use during The Winston at Lowe's Motor
Speedway. In 2003, Kenseth's racing wins totaled
$9.5 million.
Photos by Patrick Schneider,
The Charlotte Observer

CONCORD

During qualification runs for The Winston, crew members for driver Michael Waltrip go through a four-tire pit stop. Tire changes are phenomenally fast—13 to 14 seconds. Each team member has a specific job. One man jacks up the car, two men carry the tires, and two change them.

CONCORD

Crew members for driver Brett Bodine push his car down pit lane before the Winston Open, a preliminary race leading to The Winston. The engine is so finely tuned that driving it even a short distance would affect its performance.

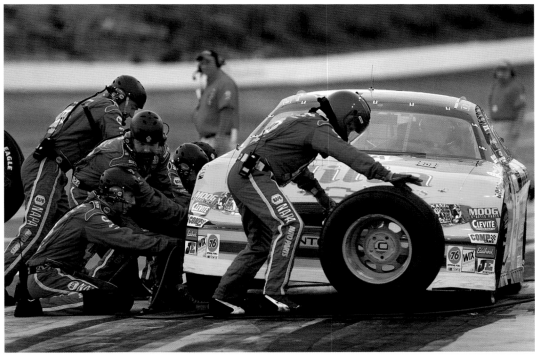

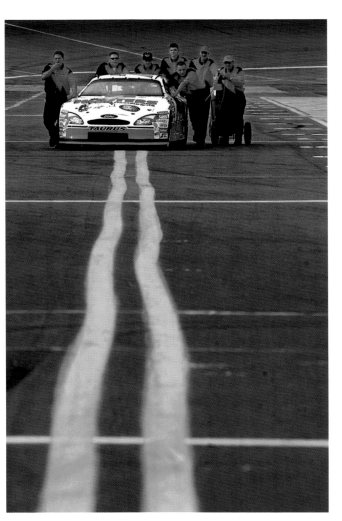

CONCORD

NASCAR drivers race off the fourth turn at Lowe's
Motor Speedway during the running of the
Winston Open.
Photos by Patrick Schneider,
The Charlotte Observer

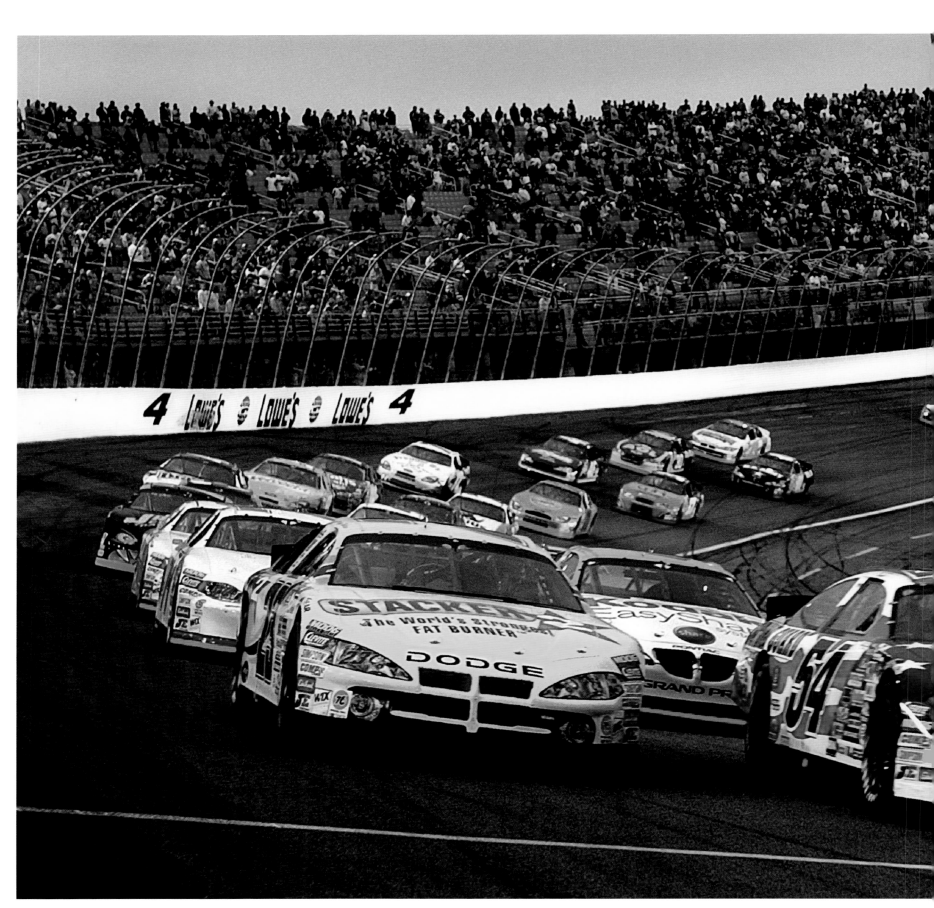

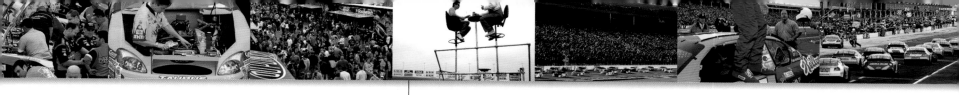

CONCORD

Mark Delany and John Allen sit 23 feet up in the infield to watch The Winston qualifying races. Their perch is a makeshift scaffolding set on an old church bus. NASCAR claims 75 million of the most loyal sports fans in America.

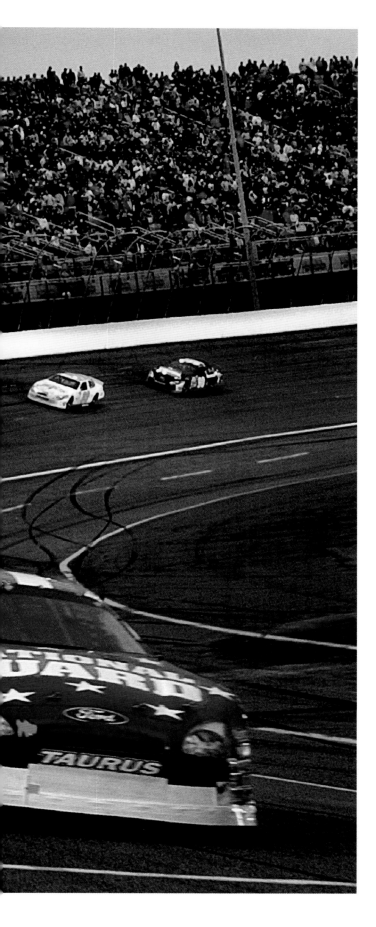

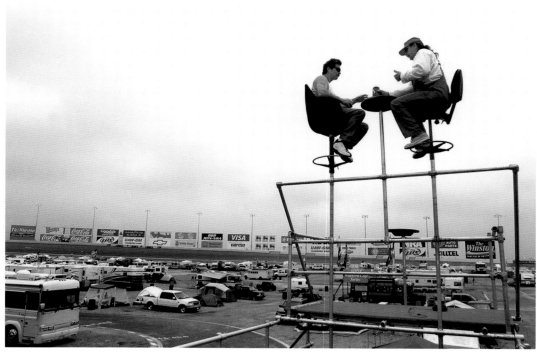

DREXEL
Outfitted with a National thumb pick and
two 225 Dunlop finger picks, Raymond
"Joe Joe" Patton of Morganton plays banjo
regularly with friends in Drexel. Patton, who
plays what he calls "Scruggs style," met banjo
great Earl Scruggs in the 1960s and still
remembers his advice: "Don't try to learn
too much at one time."
Photo by Scott Sharpe

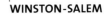

ASHEVILLE

Jim Kelley takes the lead at Nelia Hyatt's weekly gathering. Music lovers started showing up here 50 years ago, drawn by the instruments—guitars, fiddles, and stand-up basses—made by Hyatt's husband. He has since passed on, but the musicians still come. They take turns choosing songs, and everyone else dances (Aunt Jenny, 93, still clogs). Folks head home around midnight.
Photo by Melody Ko

WINSTON-SALEM

The blues brought Macavine Hayes, 59, to North Carolina. Born in Tampa, Florida, Hayes heard some pickers when he was 20 and followed them to Winston-Salem. He plays unadorned Juke Blues and is one of 100 artists supported by the Music Maker Relief Foundation. The group provides housing, food, and other necessities to aging Southern blues musicians.
Photo by Patrick Davison,
The University of North Carolina

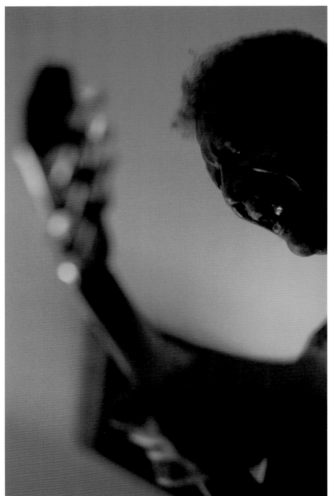

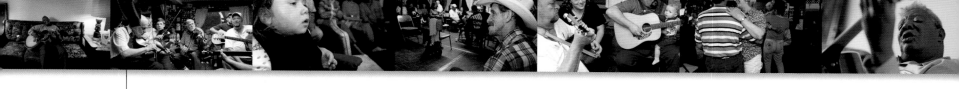

ASHEVILLE

Max Woody, Cliff Wright, a fiddler who stopped by, Chad Farmer, and Barry Hollingsworth join in on a bluegrass song at Ms. Hyatt's Thursday night jam. Drop-ins have come from as far away as Russia and Sweden. One local, Bryan Sutton, who sat in a few times has gone on to play with Dolly Parton and Ricky Skaggs.

Photo by Melody Ko

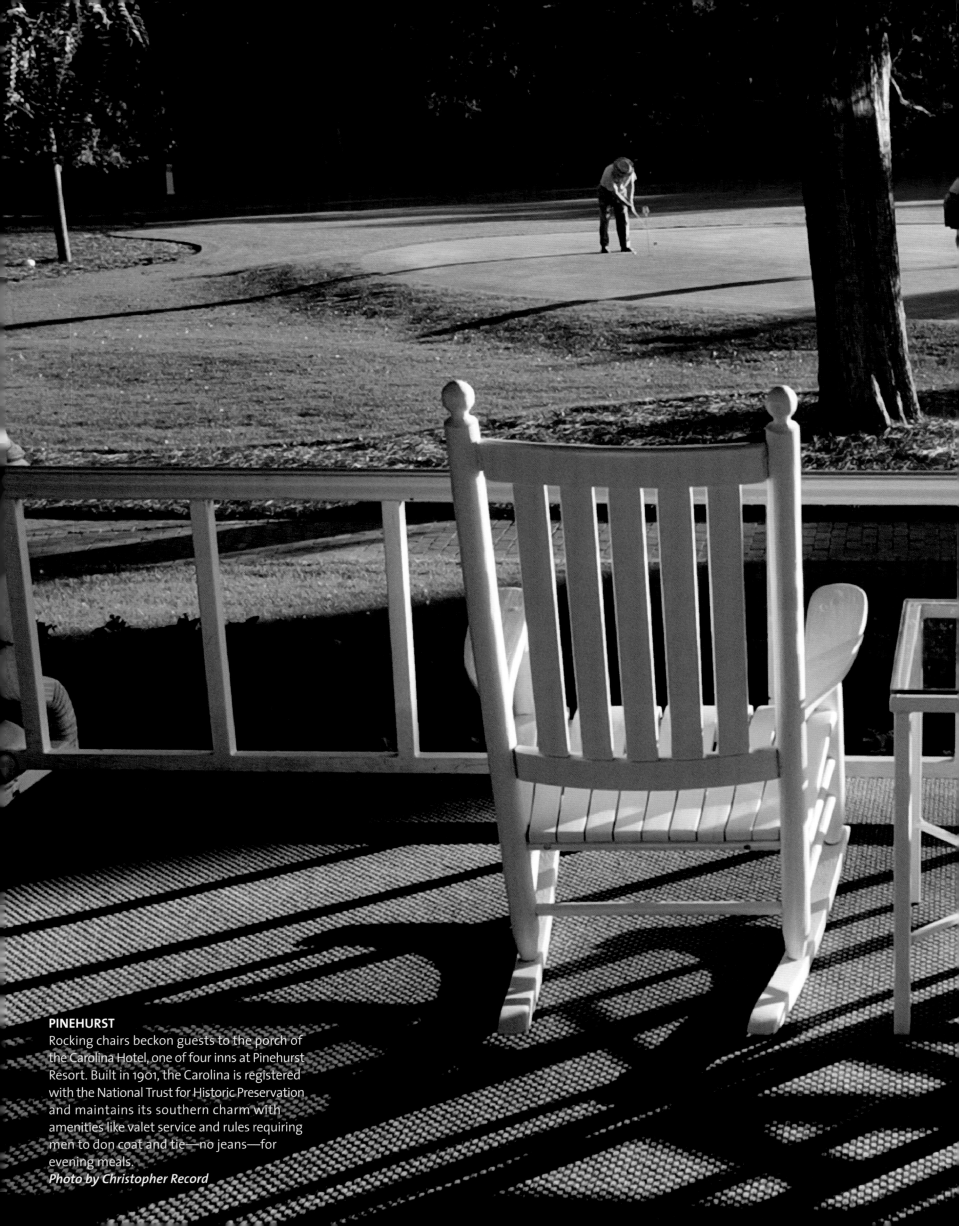

PINEHURST
Rocking chairs beckon guests to the porch of
the Carolina Hotel, one of four inns at Pinehurst
Resort. Built in 1901, the Carolina is registered
with the National Trust for Historic Preservation
and maintains its southern charm with
amenities like valet service and rules requiring
men to don coat and tie—no jeans—for
evening meals.
Photo by Christopher Record

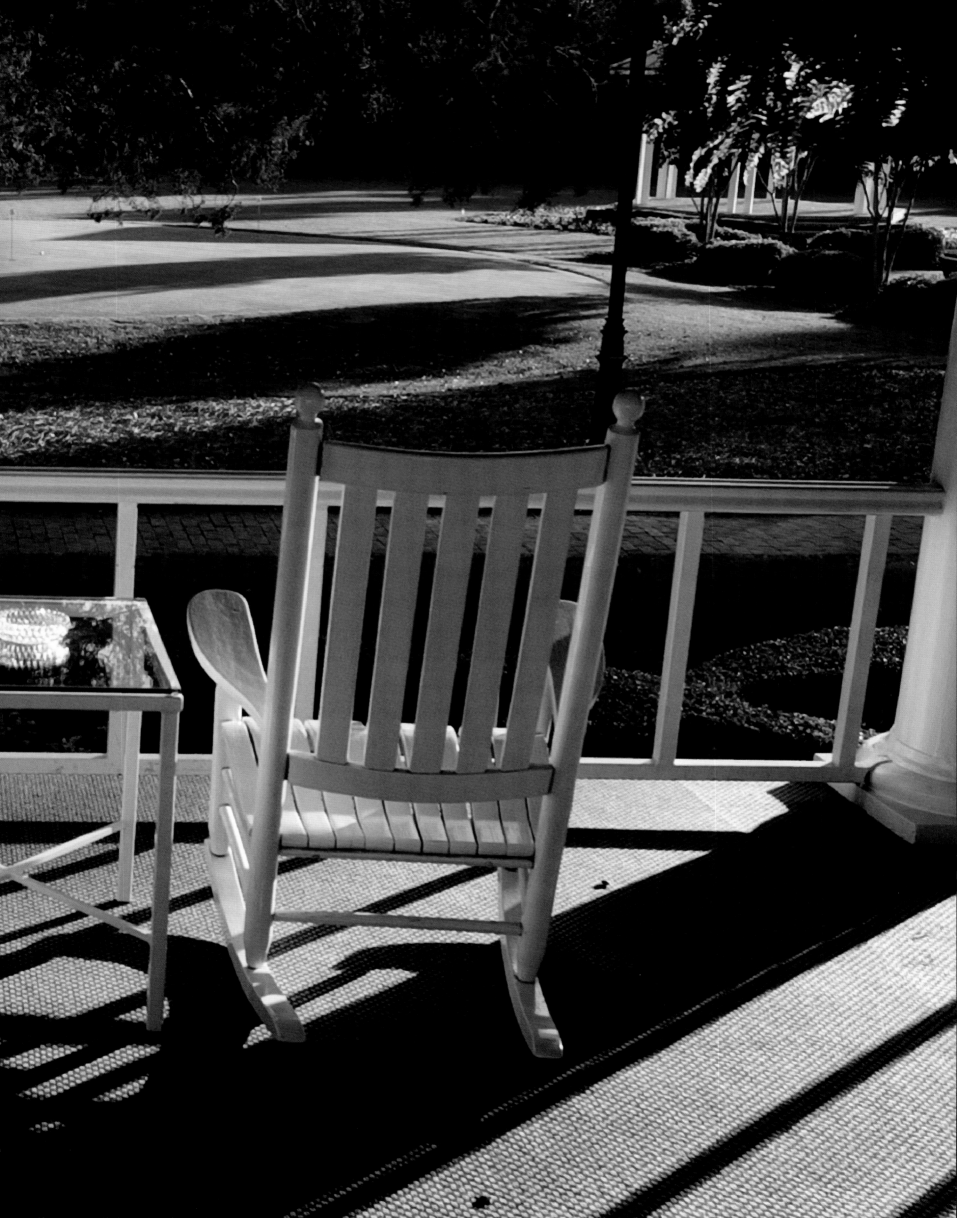

PINEHURST

Joe Coleman may have retired, but his competitive drive hasn't. The former high school soccer and basketball coach is an ace lawn bowler who competes in local and national tournaments. Coleman says the highlight of his post-retirement career, so far, was officiating at the 1996 Atlanta Paralympic Games.
Photos by Christopher Record

PINEHURST

Al Conolly, 82, moved here from New Jersey 15 years ago to spend his retirement playing golf and tennis. When his legs started to give out a couple of years ago, he switched to croquet.

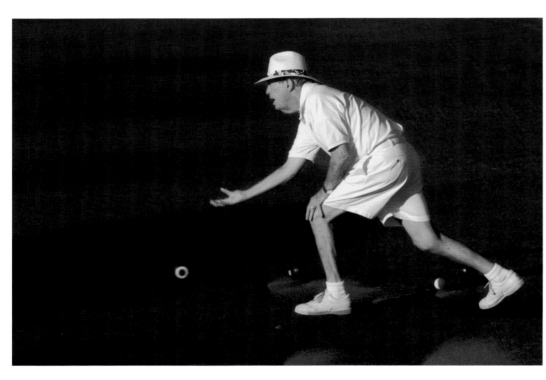

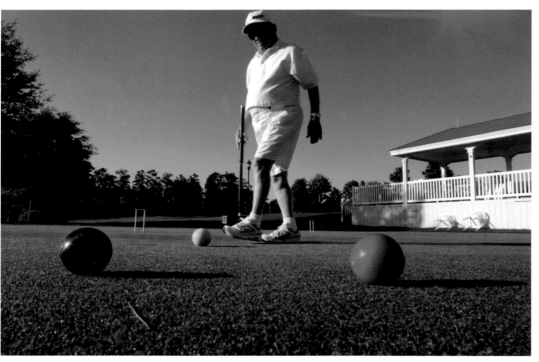

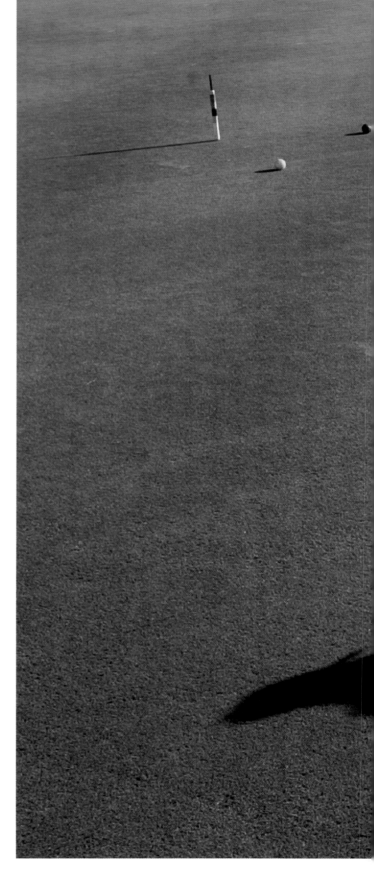

PINEHURST

Form follows function. Not as easy as it looks, croquet uses a handicap system similar to golf's, which suits Al Conolly just fine. He's a four handicap, one below championship level.

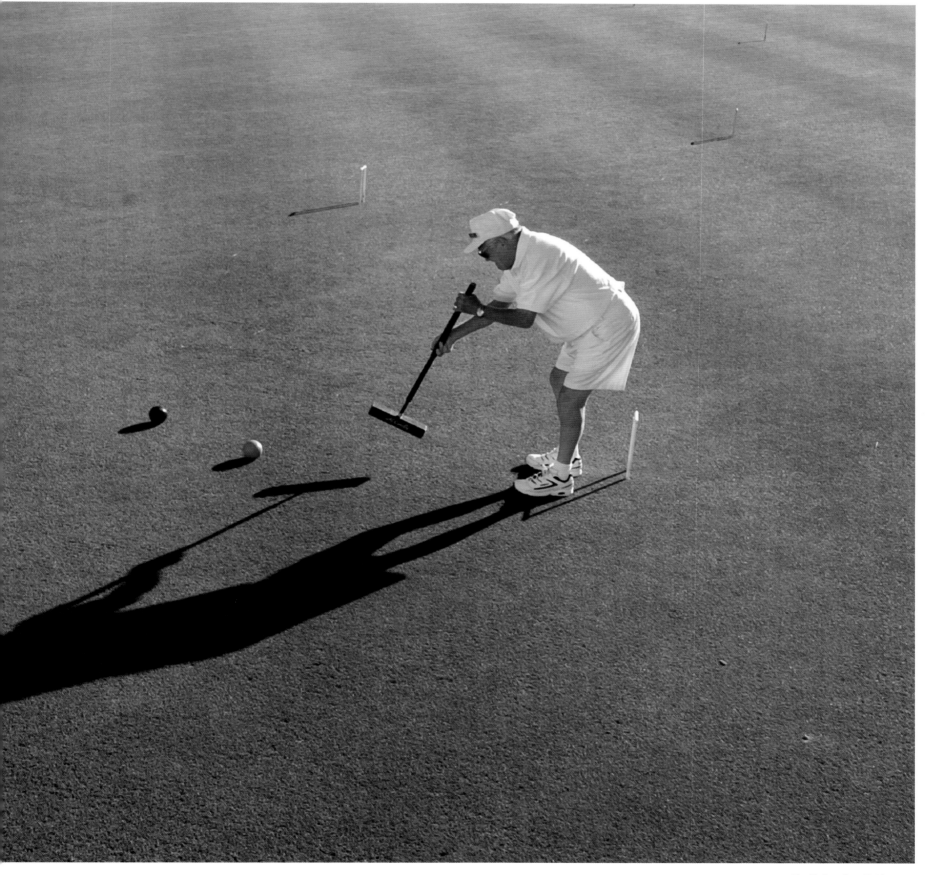

HICKORY

Mike Hadley bought his first Studebaker when he was 16. He now has seven, ranging in year from 1912 (pictured here) to 1961. He does most of the cleanup and refinishing work himself but leaves the engines to mechanics. Hadley says he's single so he can spend his money and time on his passion. "I truly love these cars," he says.
Photo by Duston Barto

LINVILLE

"I've been coming up to Grandfather Mountain since I was a kid," says John Soule, who now brings his 3-year-old daughter Charlotte up the mountain to walk across the mile-high swinging bridge. Built in 1952, the 228-foot suspension bridge affords unobstructed views into the heart of the Blue Ridge Mountains.
Photo by Christopher Record

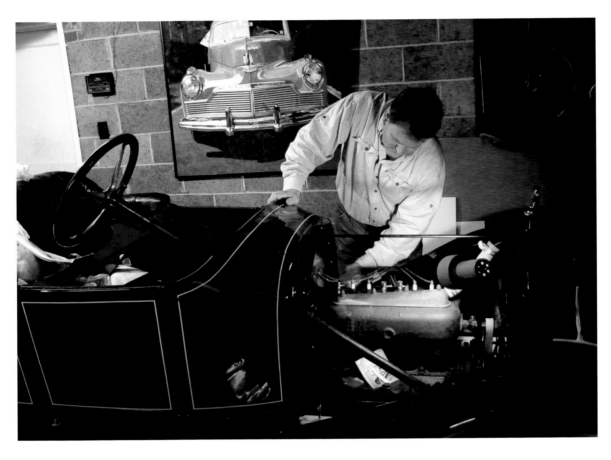

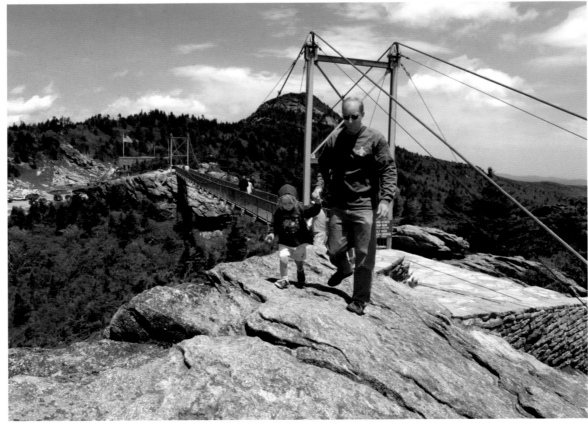

ROBERSONVILLE

Sunday *fútbol* games are the weekend highlight for Robersonville's Spanish-speaking community. In the last decade, the state's Hispanic population grew 400 percent. *Tiendas*, tortilla factories, and Catholic churches now stand alongside steak-houses and Baptist churches. And soccer—the great Latin American pastime—rivals NASCAR as the state's favored sport.

Photo by Janet Jarman, Contact Press Images

OXFORD

Keith Wade plants one on Amy Elliott while on a trail ride. "This is my playtime," Elliott says. "I love riding through the woods and creeks with old friends." Wade, who helps break horses for a living, was gallant earlier in the day—he switched horses with Elliott when she found hers too energetic.

Photo by Ami Vitale

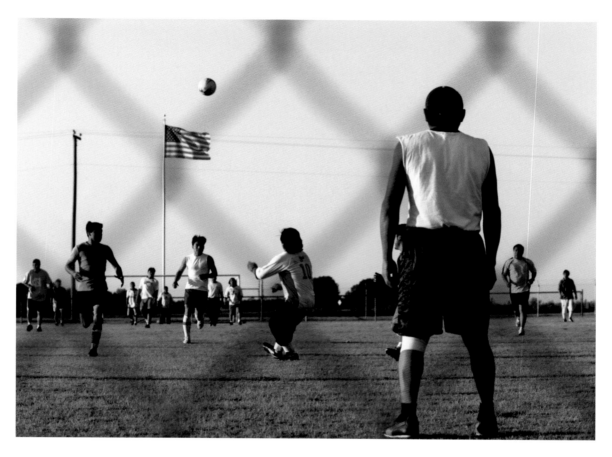

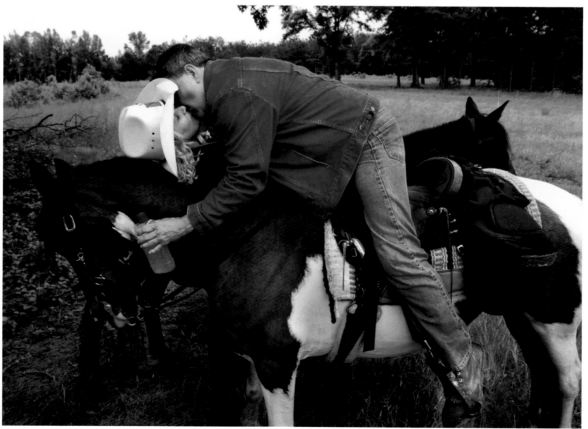

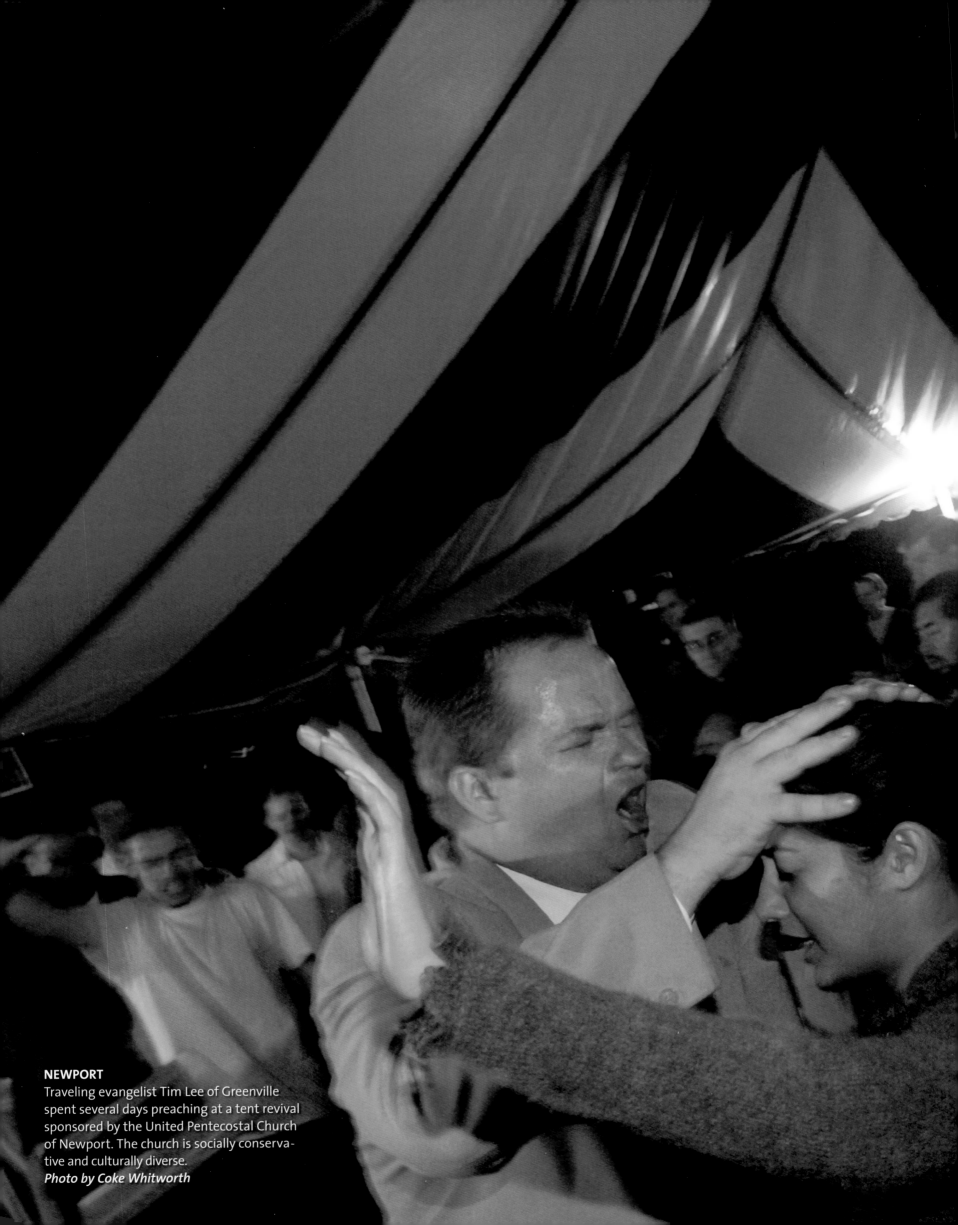

NEWPORT
Traveling evangelist Tim Lee of Greenville spent several days preaching at a tent revival sponsored by the United Pentecostal Church of Newport. The church is socially conservative and culturally diverse.
Photo by Coke Whitworth

Reason To Believe

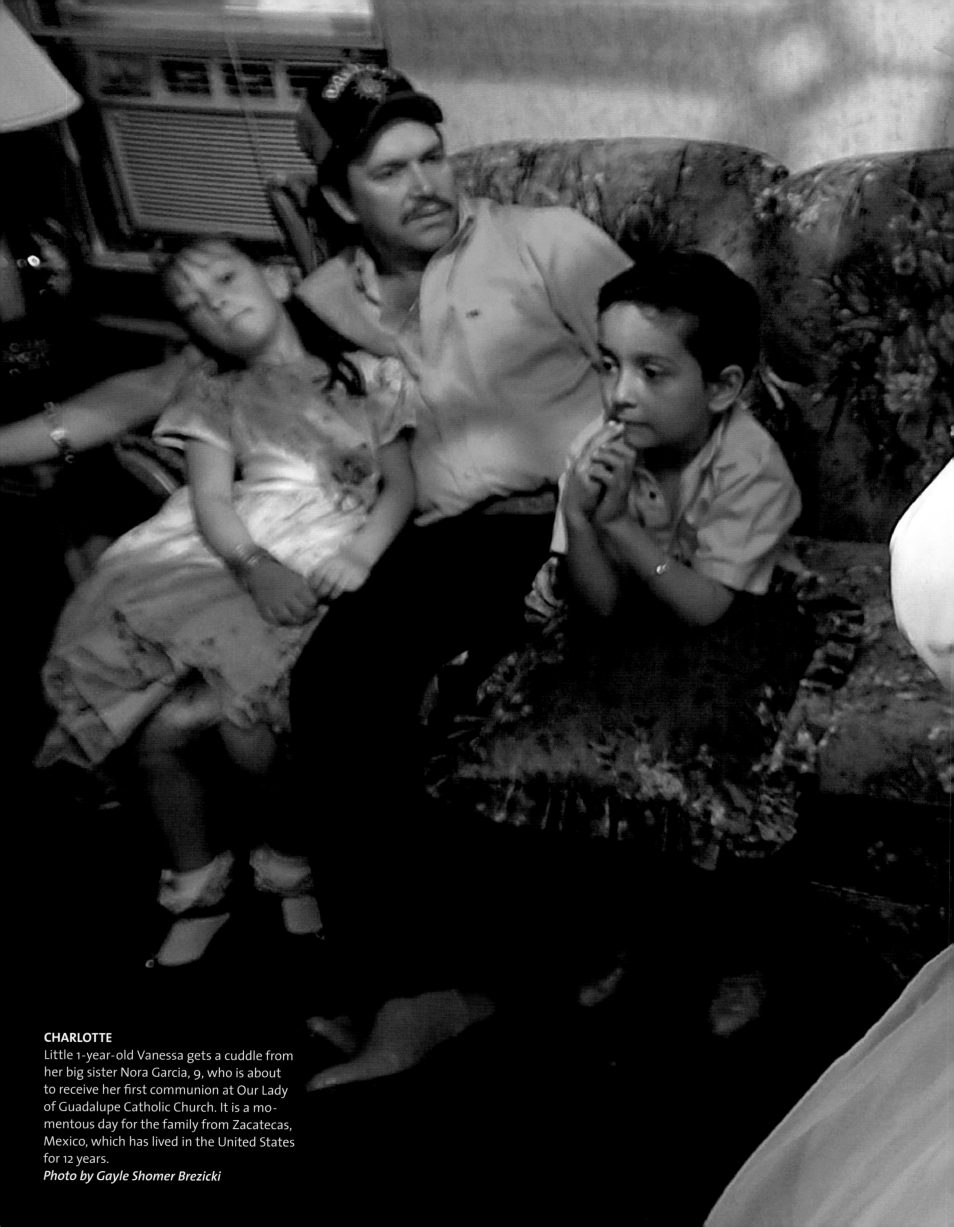

CHARLOTTE
Little 1-year-old Vanessa gets a cuddle from her big sister Nora Garcia, 9, who is about to receive her first communion at Our Lady of Guadalupe Catholic Church. It is a momentous day for the family from Zacatecas, Mexico, which has lived in the United States for 12 years.
Photo by Gayle Shomer Brezicki

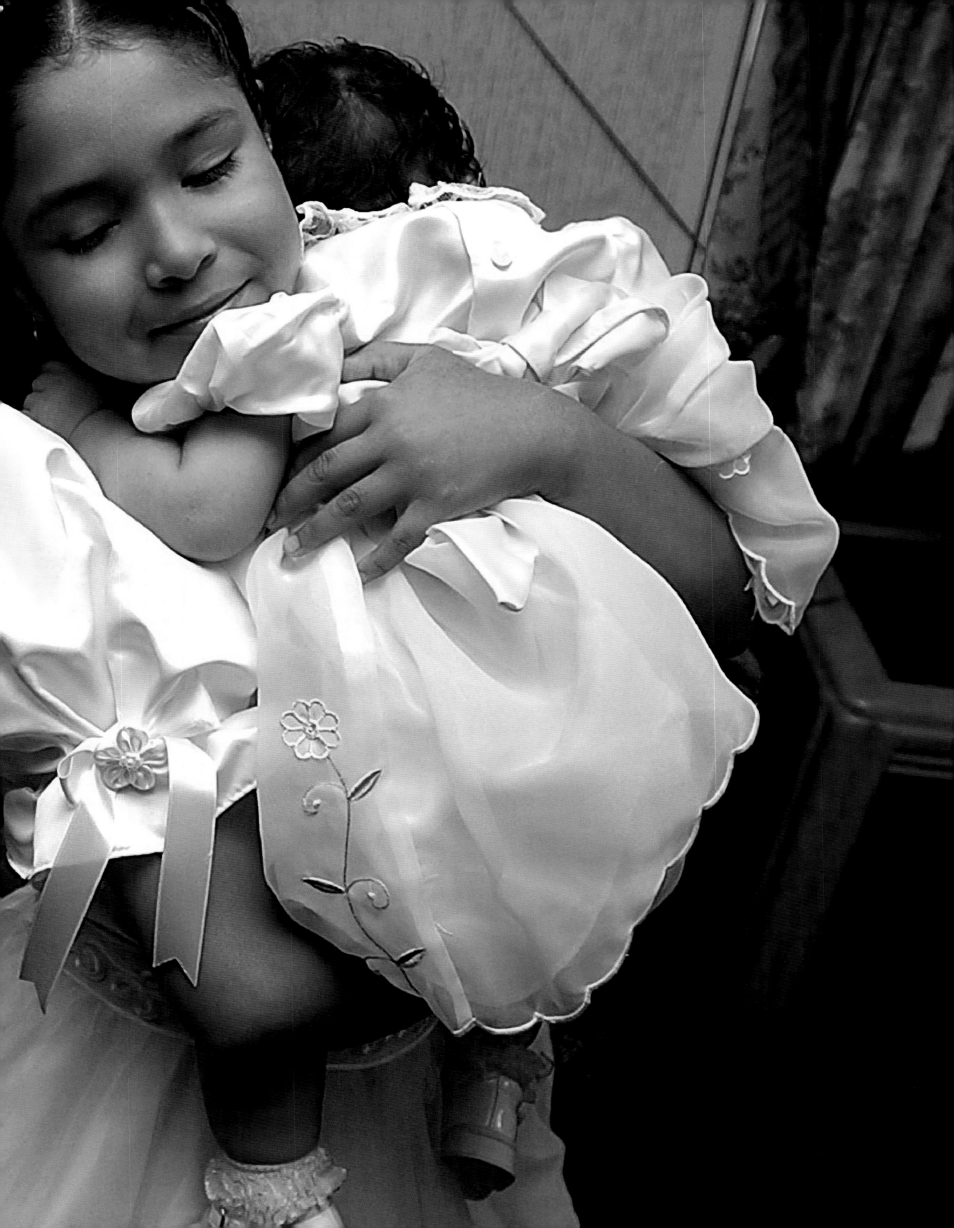

Nora, Rebecca, and Elizabeth Garcia delight in their communion finery as Nora's father prepares a celebratory barbecue of *carne asada*, guacamole, and sheet cake.

Photos by Gayle Shomer Brezicki

CHARLOTTE

Cinderella for a day: No expense was spared for Nora's First Communion. The 9-year-old paraded around the grounds of her family's mobile home park in her new dress flanked by sister Elizabeth and cousin Rebecca.

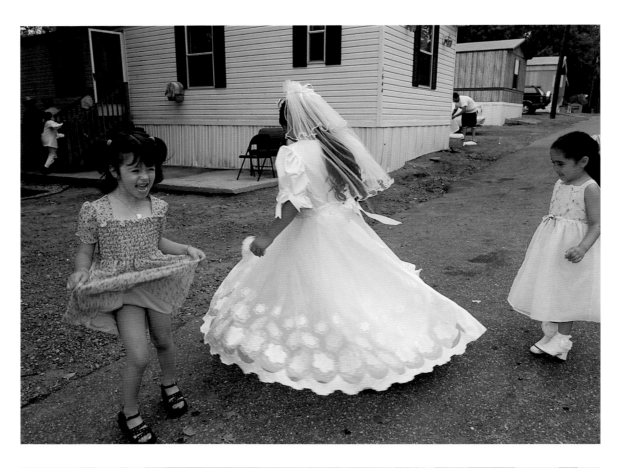

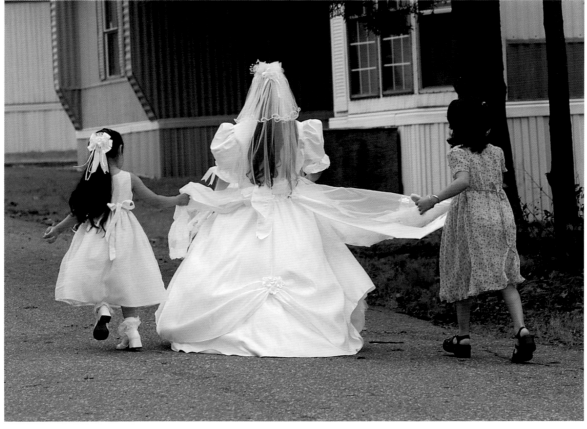

CHARLOTTE

Nora prays with her family at Our Lady of Guadalupe Church, which formed two years ago to accommodate the Catholic immigrants arriving in the Charlotte area from Latin America. With its growing congregation of 4,000 members, the church conducts seven daily masses in Spanish. An eighth may soon be added.

CHARLOTTE

A scuffed knee and a Band-Aid were the only vestiges of Elizabeth's usual tomboy look on her sister's big day.

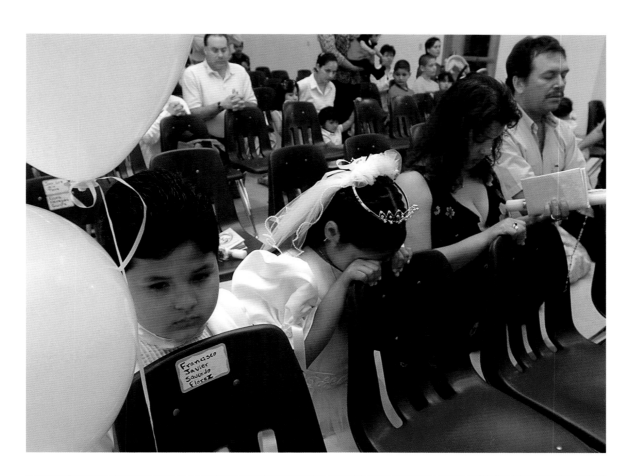

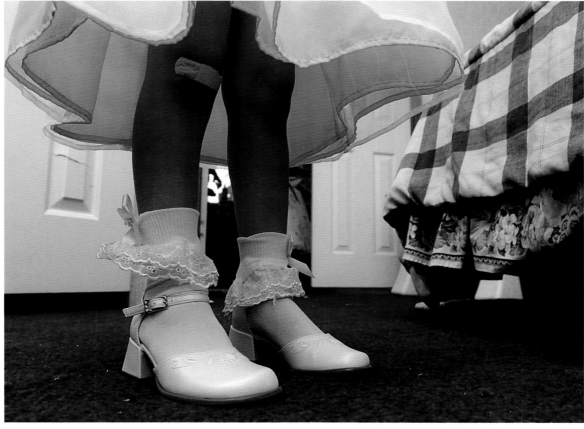

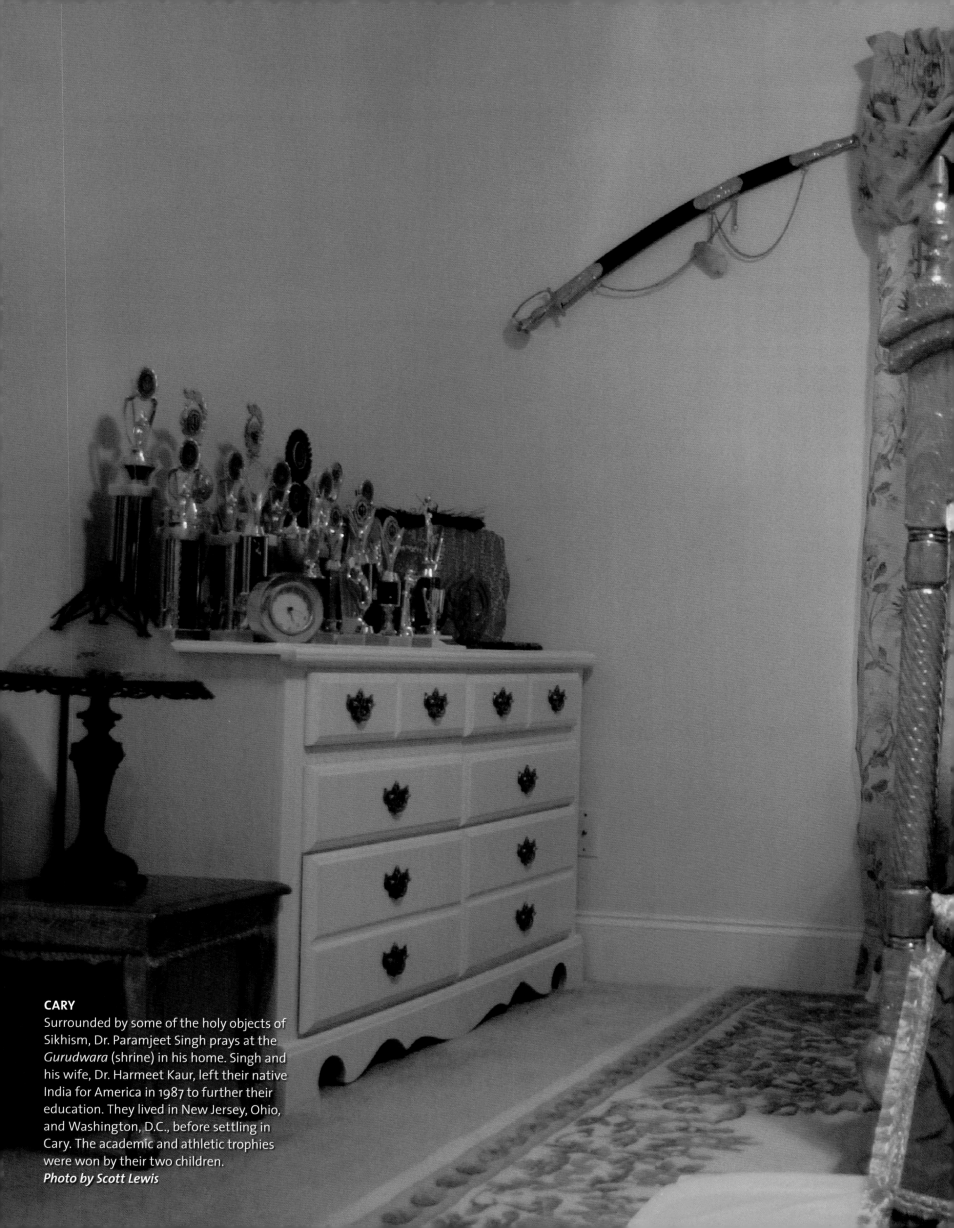

CARY
Surrounded by some of the holy objects of Sikhism, Dr. Paramjeet Singh prays at the *Gurudwara* (shrine) in his home. Singh and his wife, Dr. Harmeet Kaur, left their native India for America in 1987 to further their education. They lived in New Jersey, Ohio, and Washington, D.C., before settling in Cary. The academic and athletic trophies were won by their two children.
Photo by Scott Lewis

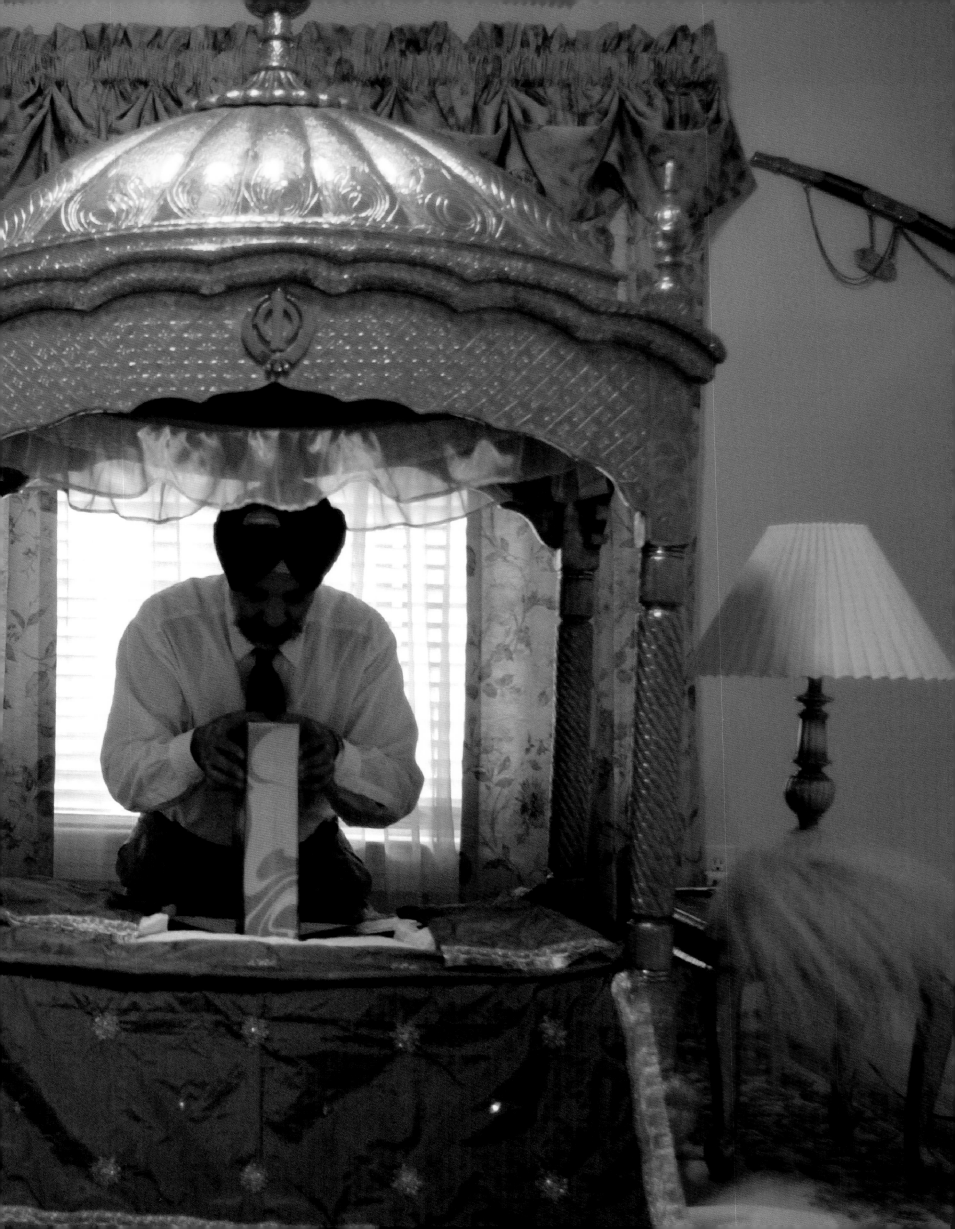

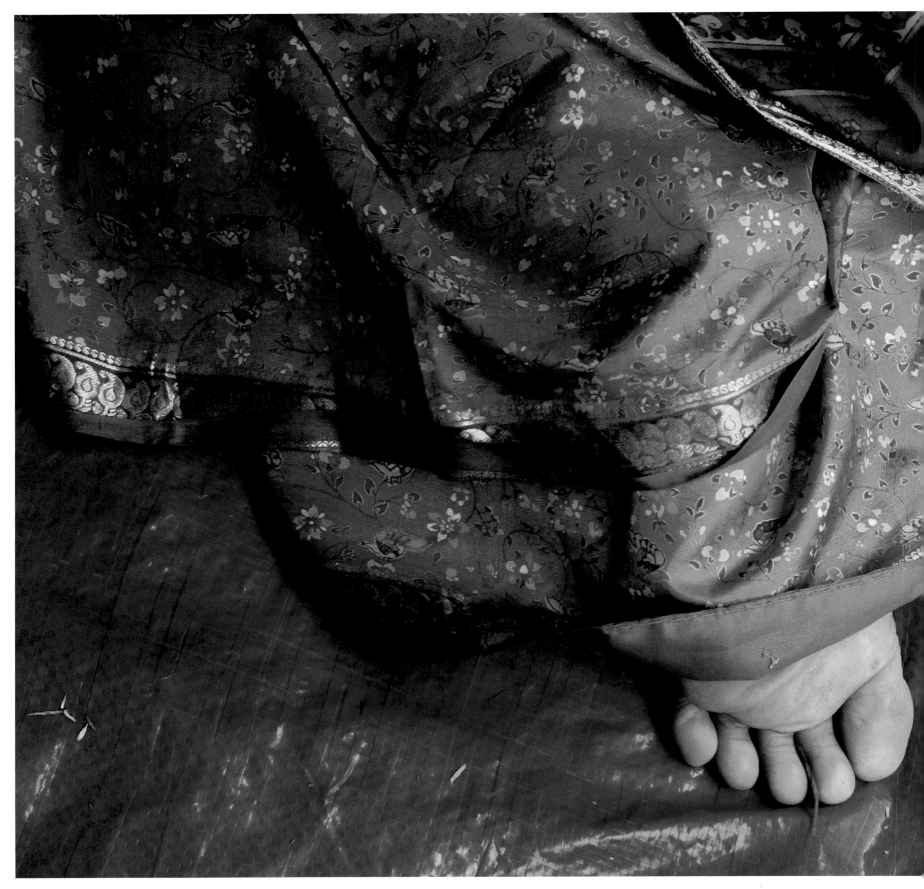

CARY

Barefooted acknowledgement of sacred ground occurs in many religions, especially those native to India. When entering a Hindu sanctuary, worshippers, like this woman at the Sri Venkateswara temple, take off their shoes.

Photos by Scott Lewis

CARY

The Sri Venkateswara temple, which serves the Triangle, is part of an international network of shrines honoring the Hindu god Vishnu. All locations perform a monthly *Satyanarayana puja*, in which priests offer the deity milk, honey, coconut water, and yogurt. The remaining *prasad* is shared with worshippers to help them overcome temptations and lead virtuous lives.

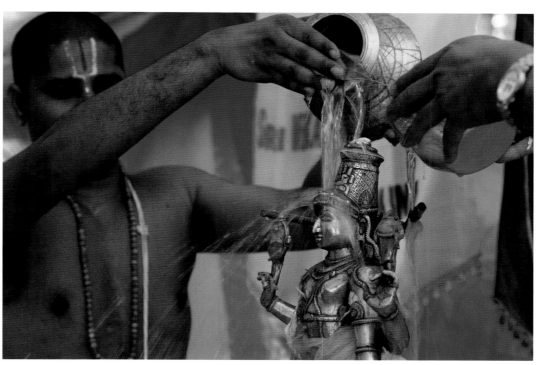

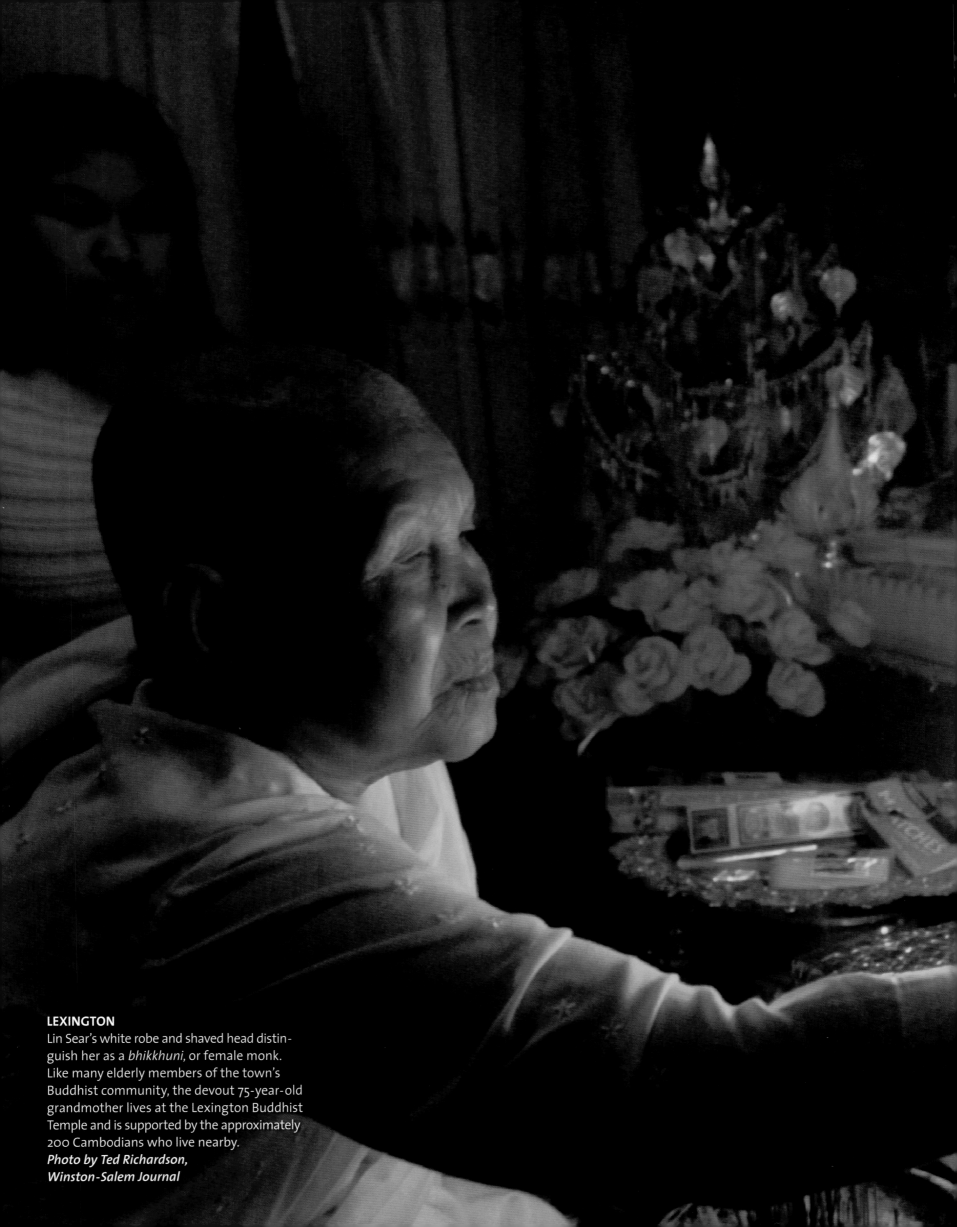

LEXINGTON

Lin Sear's white robe and shaved head distin-
guish her as a *bhikkhuni*, or female monk.
Like many elderly members of the town's
Buddhist community, the devout 75-year-old
grandmother lives at the Lexington Buddhist
Temple and is supported by the approximately
200 Cambodians who live nearby.
Photo by Ted Richardson,
Winston-Salem Journal

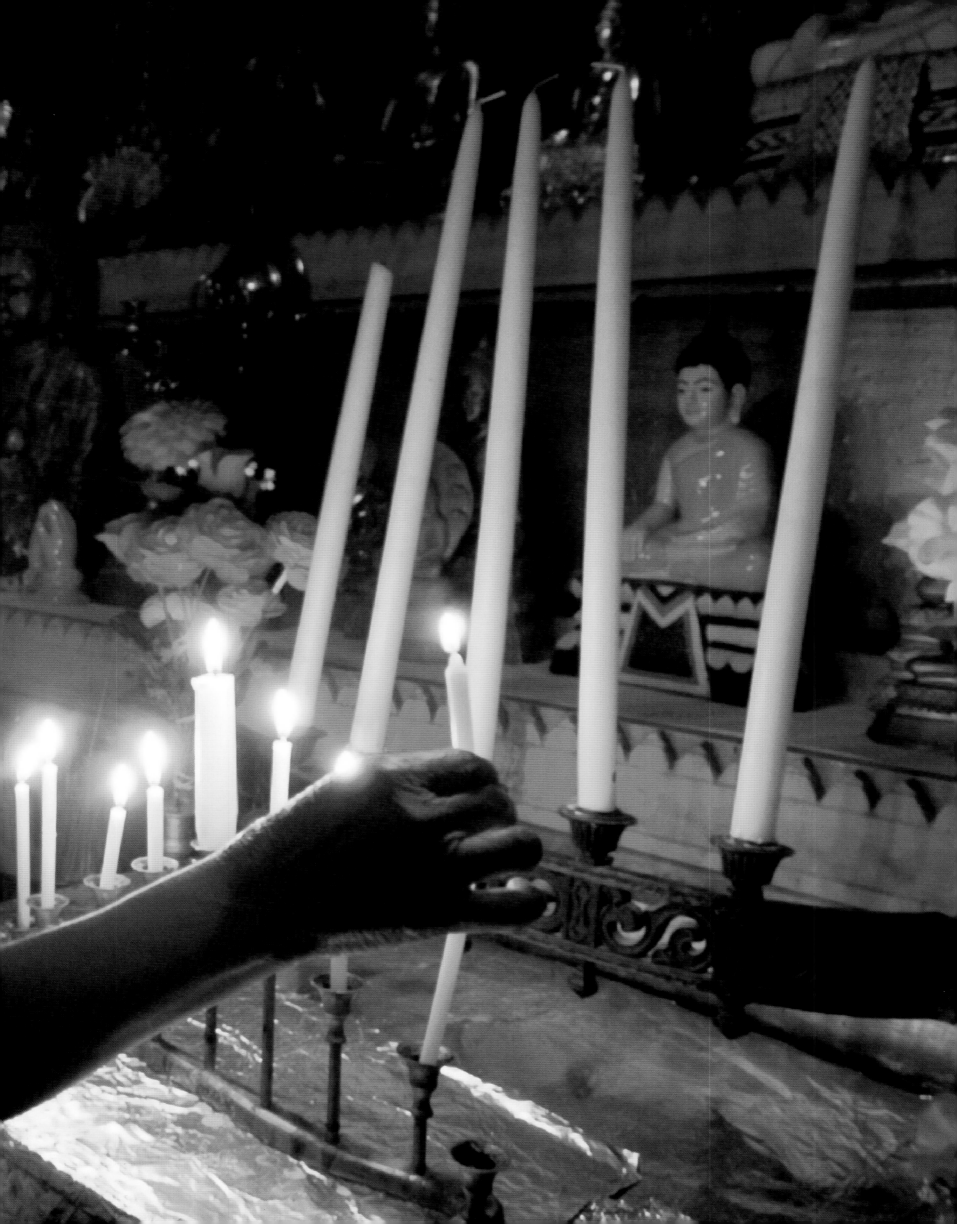

BELMONT
Father Kieran and Abbot Placid Solari, two Belmont Abbey leaders, confer before morning prayers. The Benedictine monastery was founded in 1876 on 700 acres, west of Charlotte. Son of a Roman nobleman, St. Benedict cast the privileged life aside for one of asceticism, study, and prayer. In his first miracle, he repaired a broken earthenware sieve by praying over it.
Photos by Patrick Davison,
The University of North Carolina

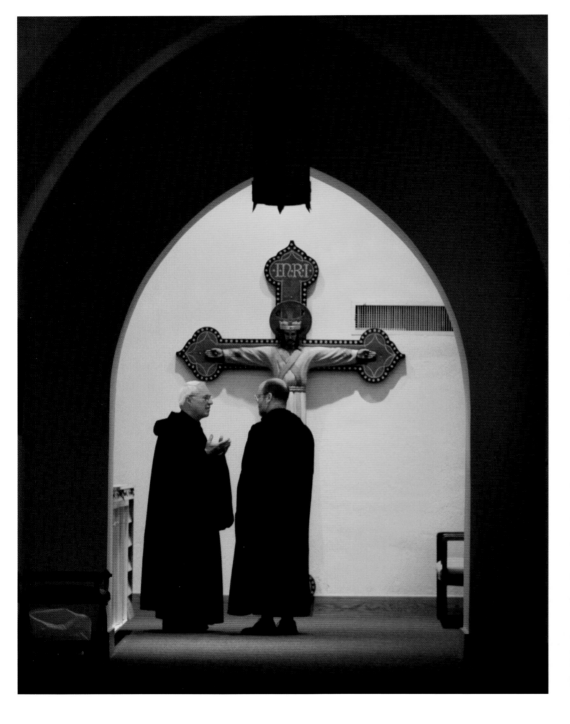

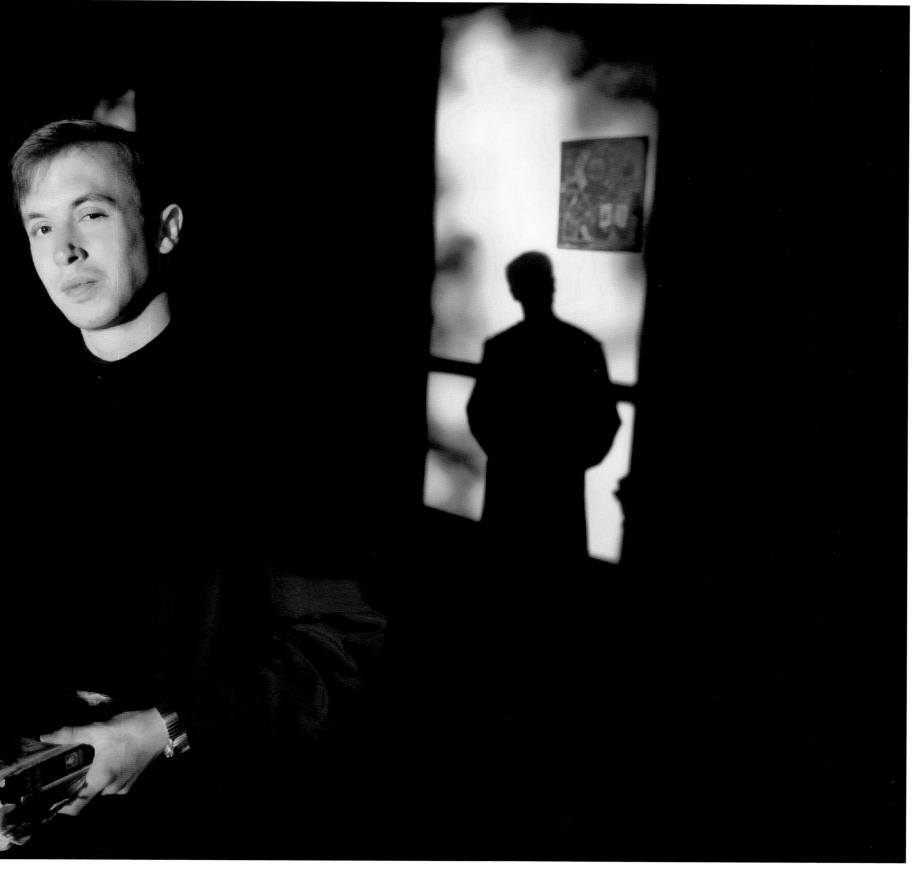

BELMONT

Michael Boes of New Jersey studies to become a monk. After graduating from Belmont Abbey College in 2002, he took the first step by becoming a novitiate. In 2003, the 22-year-old professed his vows, leading to another three years of study. After the fourth year, he can commit for life.

BELMONT

Brother Paul Shanley of New York mugs for the camera. His antics relax Brother Agostino Fernandez, a Cuban native raised in Philadelphia, who had been a bit nervous about the photo session. In their leisure time, the monks garden, cycle, backpack, and watch videos.

Photos by Patrick Davison,
The University of North Carolina

BELMONT

Monks meditate in Lourdes Grotto, a replica the grotto in southern France where the Virg Mary reportedly appeared to St. Bernadette. monastery has 21 resident monks today, dow from its early 1900s peak of 85. In addition t praying, the monks teach classes at Belmont Abbey College, a private, liberal arts school c the monastery grounds.

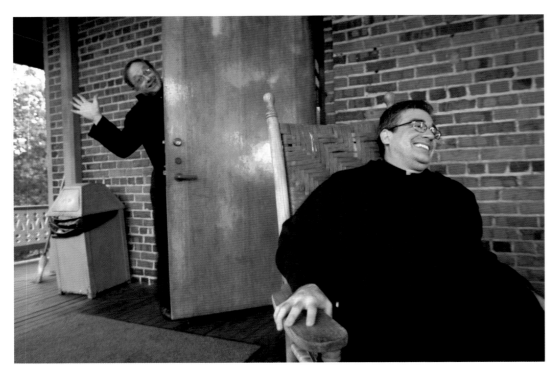

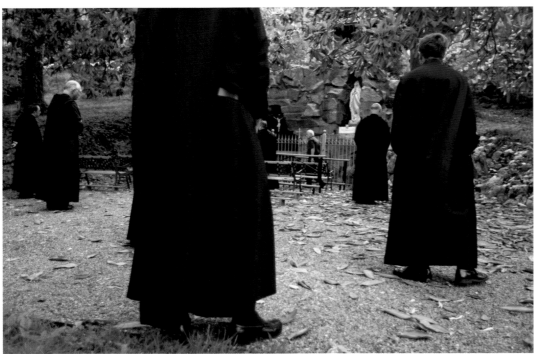

BELMONT

Lectio divina, a reflective meditation on the Bible, is an essential aspect of monastic life. Several hours are devoted to its study each day. Passages vary in their appeal, and each of Belmont Abbey's monks has a favorite.

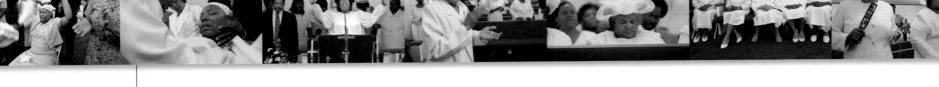

NEWTON GROVE
Pastor David N. Atkinson prays on Denise
Strickland during a healing at the Long Branch
Disciple Church.
Photos by Ami Vitale

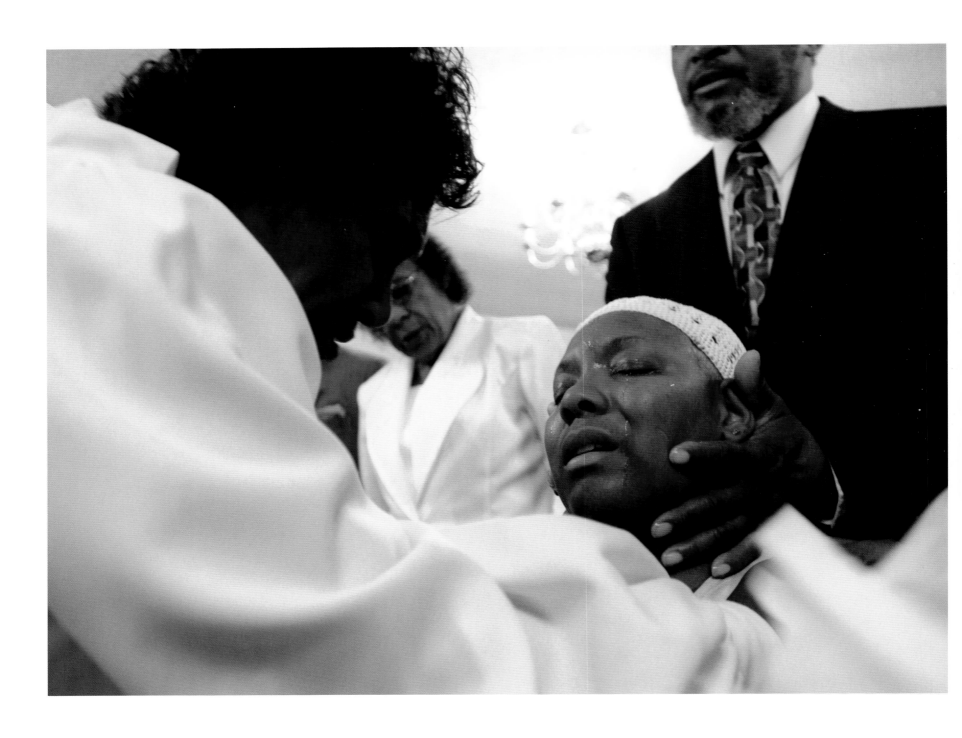

Worshippers fold into prayer during a Sunday sermon at Long Branch. The church is famous for its two-woman choir, The Branchettes, who won the North Carolina Folk Heritage Award in 1995.

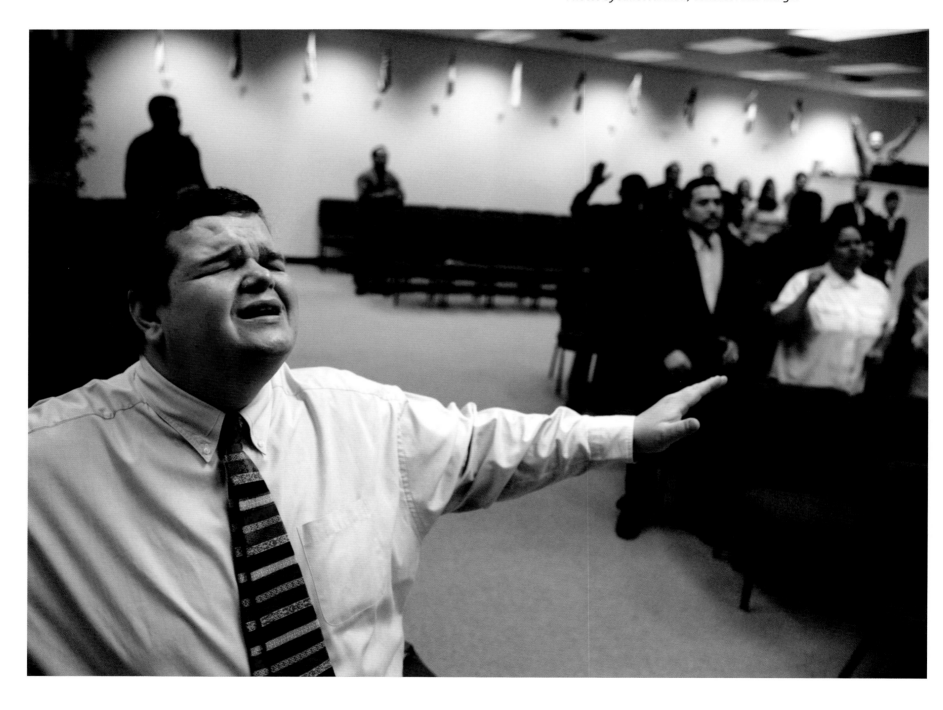

SALISBURY

"You can be a Christian here and not have to worry about stereotyping," says William Carlton, a member of the nondenominational Cornerstone Church. Rowan County's racial divisions—including an active Ku Klux Klan contingent—challenged Pastor Bill Goddair to create a multicultural church. Seventeen years later, his church is 50 percent white, 35 percent Hispanic, and 15 percent African American.

Photos by Janet Jarman, Contact Press Images

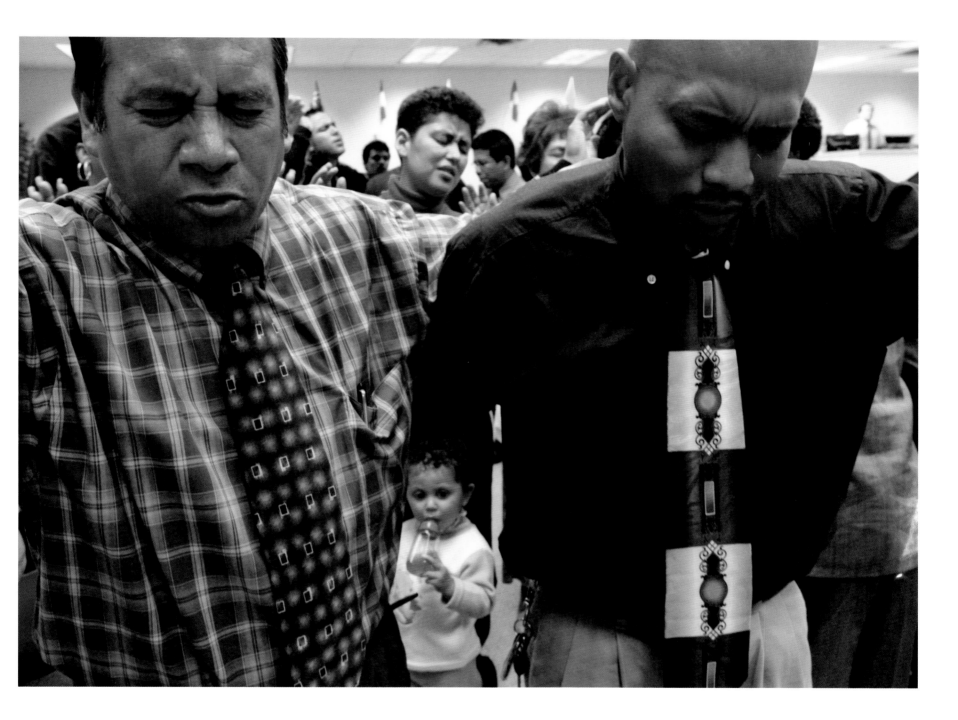

SALISBURY

José Flores and José Luis Carmona are Mexican Catholics who joined Cornerstone after arriving in North Carolina for work. The church's Spanish-speaking pastor, Orlando Zapata, says the singing, dancing, and active participation appeal to Latino immigrants looking for an alternative to the somber Catholic mass. "They like the excitement and the freedom of expression," Zapata says.

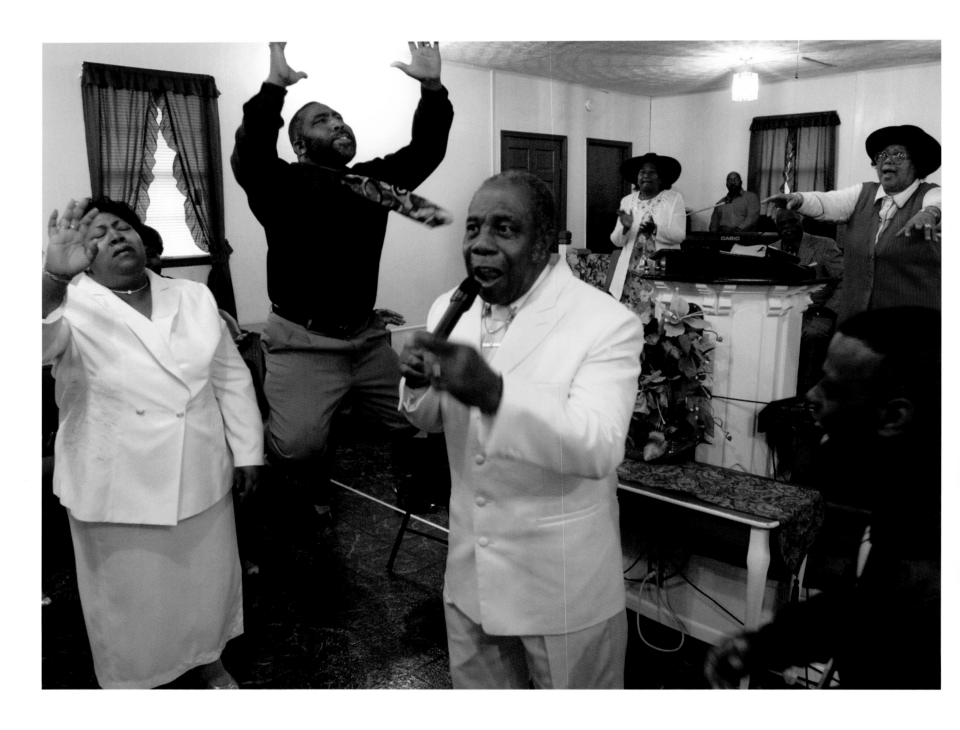

ROANOKE RAPIDS

"Before I was saved, it was a miserable life," recalls Bishop Dready Manning. He played blues guitar—and drank—until a mysterious nosebleed was cured by prayer. The reverend now leads services at St. Mark Holiness Church, located in a rural area west of Roanoke Rapids. Manning's services can last for more than four hours.

Photo by Scott Sharpe

GREENSBORO

To the delight of 4-year-old Tavazigeé Rodgers, worship at Greater Metropolitan Restoration Center involves dancing, singing, clapping, and jumping.
Photo by Janet Jarman, Contact Press Images

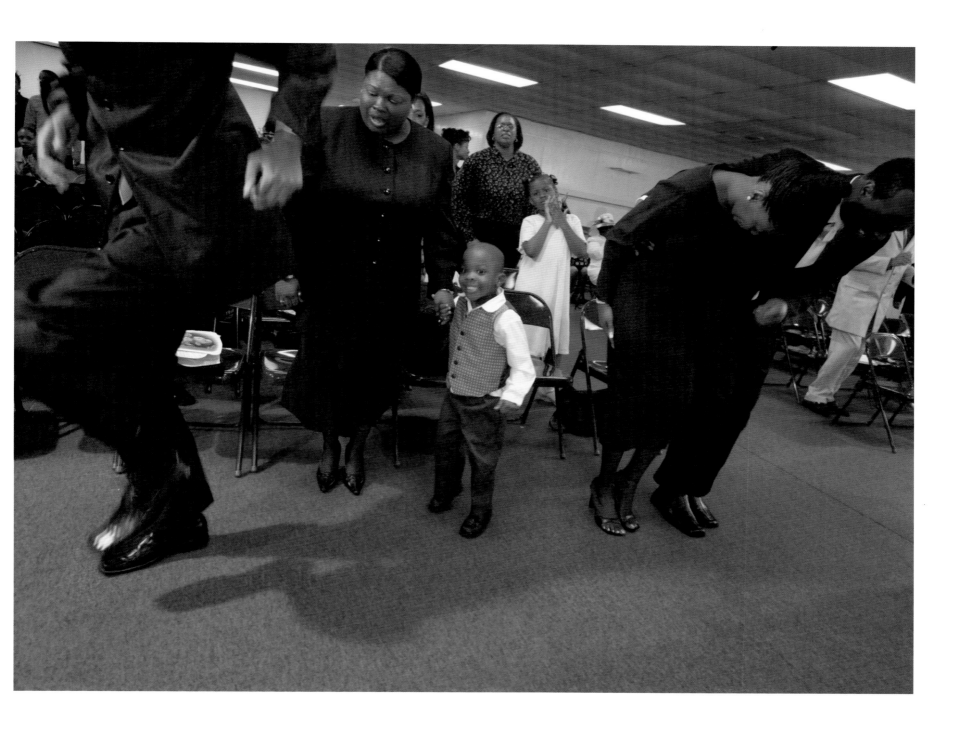

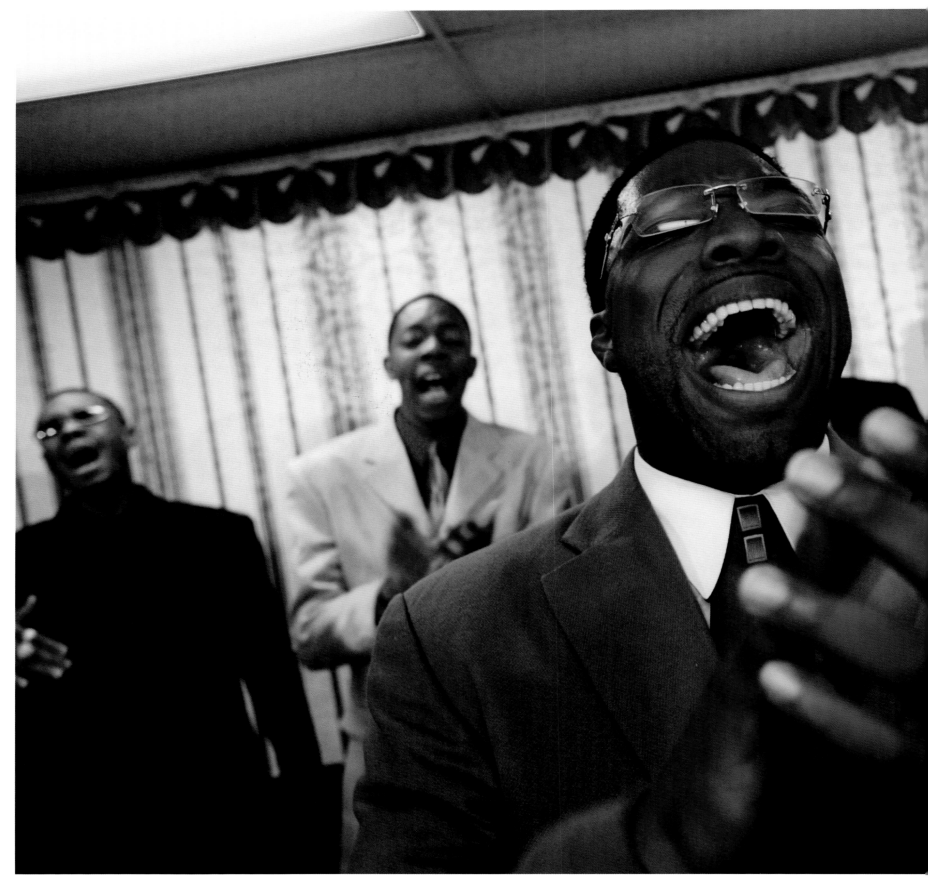

GREENSBORO
Pentecostal Minister Marcus Daniel leads the congregation in "Awesome God" during Sunday services at the Deliverance Temple Holy Church. Singing gospel in church helped Daniel through teenage bouts of depression and motivated him to become a healer and advisor to others in his congregation. "A lot of people come to the service with stresses and troubles and leave totally victorious," he says.
Photos by Janet Jarman, Contact Press Images

SALISBURY

Mexican immigrants like Minerva Morales (second row) and daughter Daniela (foreground) of Cornerstone church are increasingly choosing evangelical Protestantism over Catholicism. The movement mirrors a shift occurring throughout Latin America, where 8,000 Catholics are converting to evangelical religions each day.

SALISBURY

In rapture: Pastor Bill Goddair's grandmother, Irene Goddair, and wife Tina lose themselves in worship.

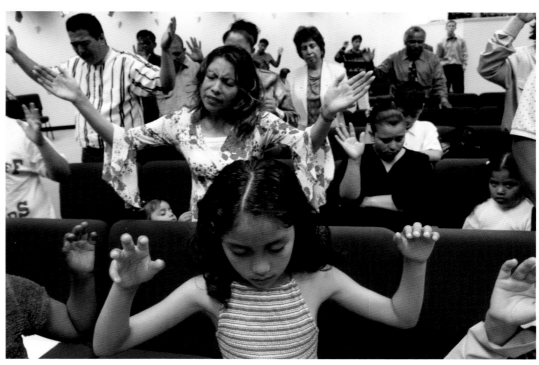

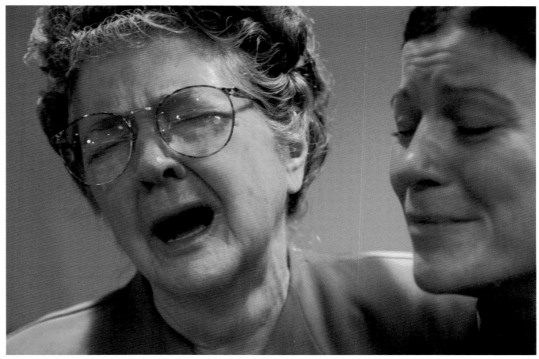

LOUISBURG

Tonto, a miniature seeing-eye horse is introduced to restaurant etiquette by trainers Don and Janet Burleson (seated left). Horses are natural guide animals. If one horse in a herd goes blind, another horse will serve as its guide for life. Miniature horses live much longer than dogs (up to 50 years) and, yes, they can be housebroken.
Photo by Ami Vitale

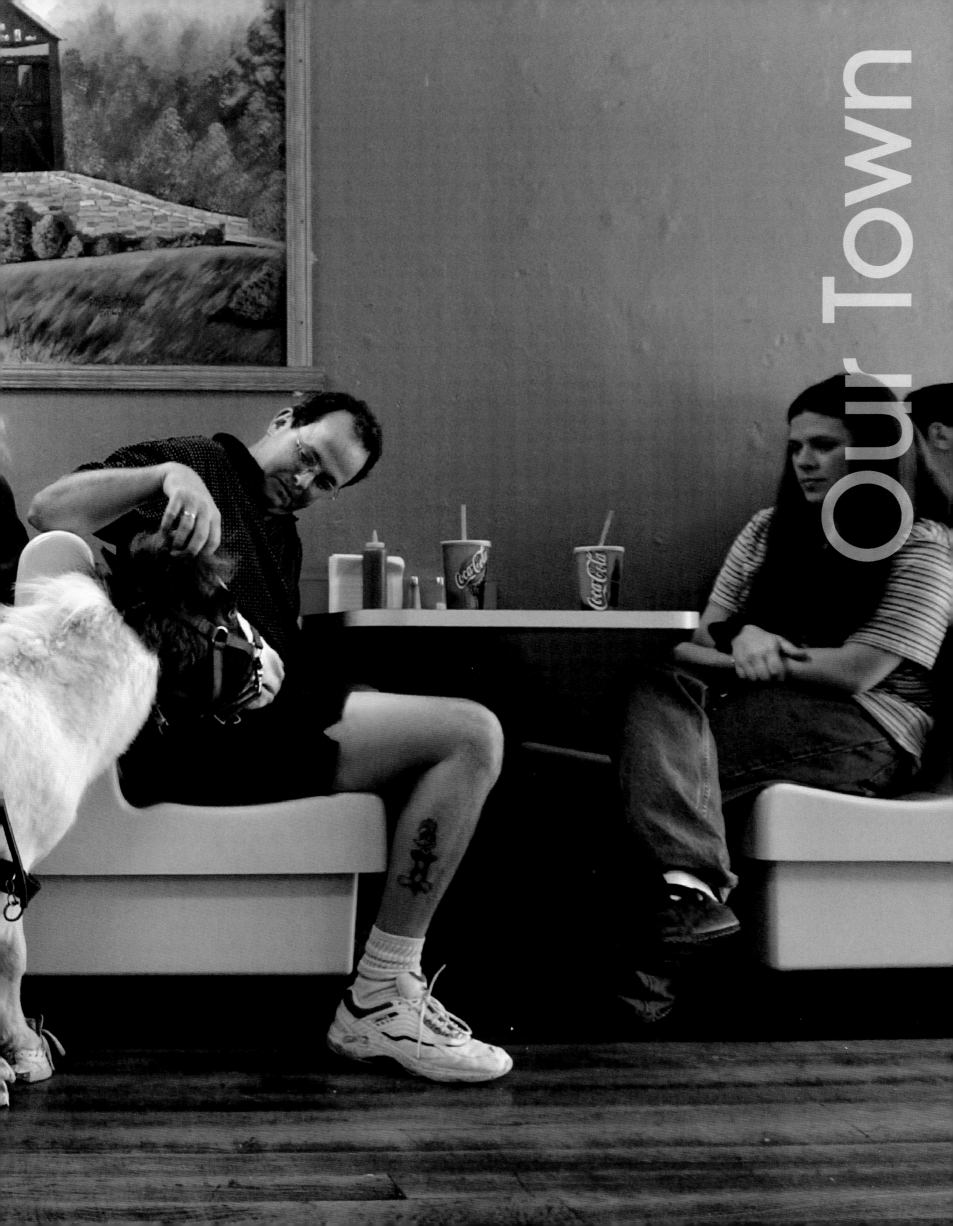

DREXEL

"I pick up the guitar, and here comes some dude wanting a haircut, and that kind of messes me up," jokes Lawrence Anthony, 80-year-old owner of The Barber Shop. Most regulars aren't looking for a trim anyway. They come by to talk or play bluegrass and country western music and eat skillet peanuts, collard greens, and corn bread between tunes.

Photos by Scott Sharpe

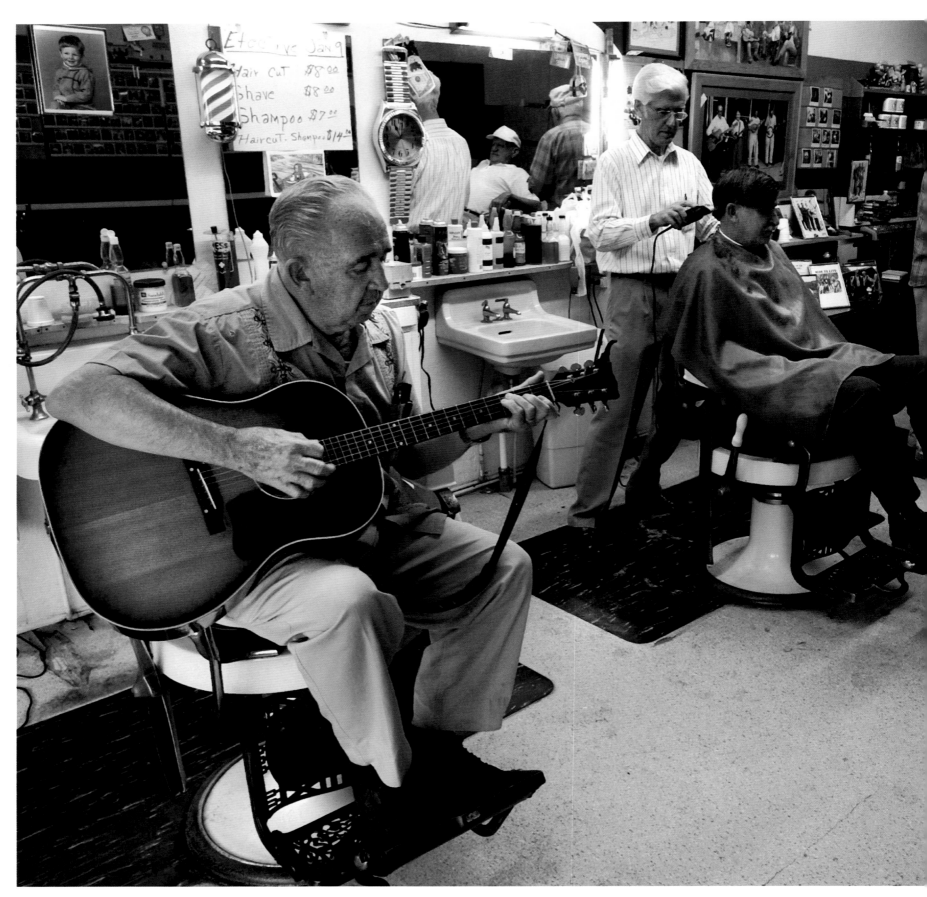

DREXEL

The jam sessions at Anthony's barbershop began 40 years ago when the police chief started playing his mandolin there between calls. Then someone brought a fiddle, and so it went. Regulars calling themselves the Barbershop Grass made a few tapes, but the fellows don't tour much beyond the barbershop's back room.

DREXEL

Rex Annis, 37, a regular at the jam sessions, plays a doghouse bass his friend made. "My favorite subgenre in bluegrass is probably gospel," says Annis. Gospel seems fitting. Annis was diagnosed with diabetes when he was 9 and eventually needed a new kidney and pancreas. He recently received both transplants and continues to jam.

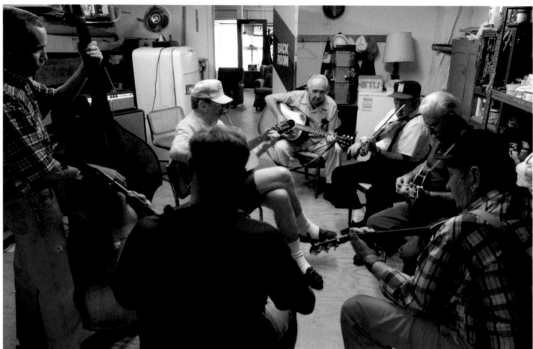

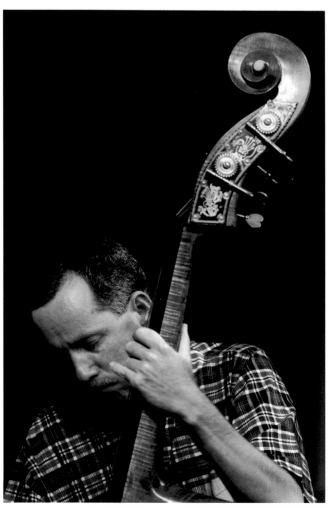

RODANTHE

Forced inside from their beach nuptials by an unexpected spring rain, Sean and April Moser are all smiles at their wedding party. California friend Chelsea Merritt dances with the couple. Sean owns Quick Move, a moving company; April is taking classes at the University of North Carolina in Chapel Hill.

Photo by Micah Zunil Intrator

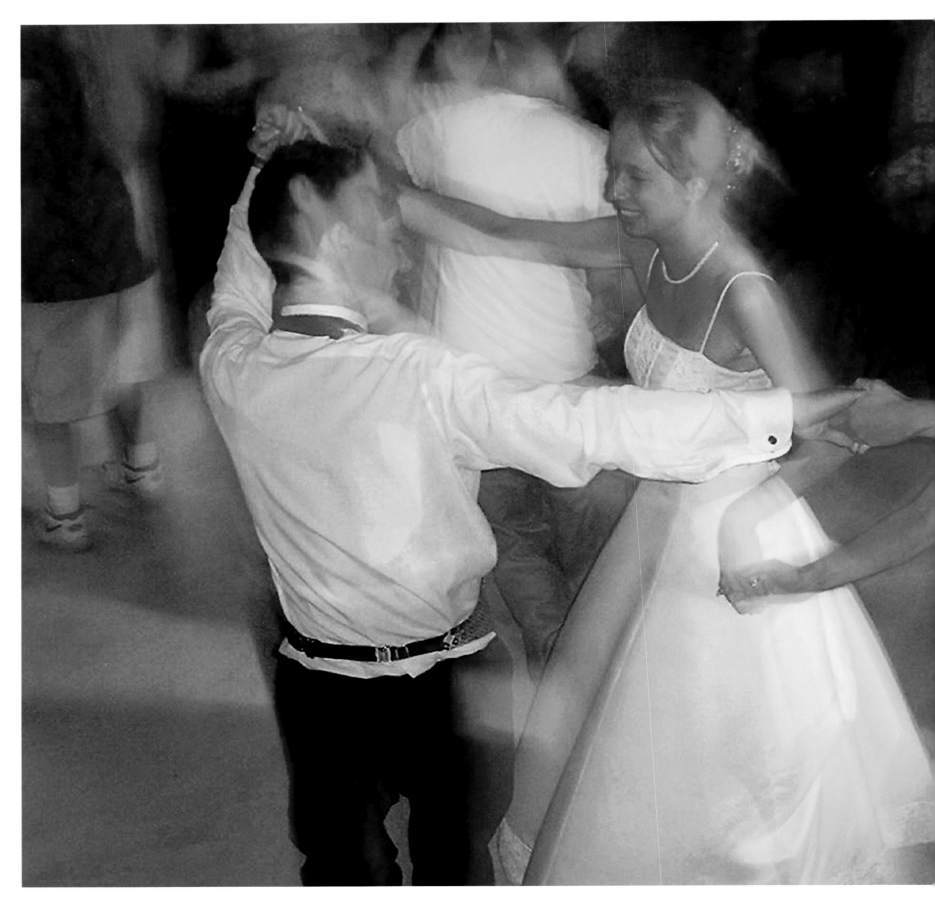

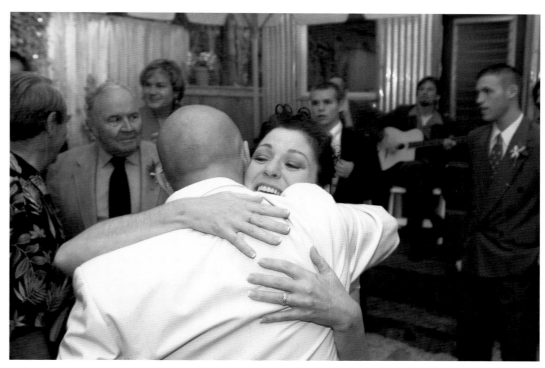

WILMINGTON
Moments after her wedding ceremony, Barbara Eavey hugs close friend Steve Ward, a New York City hairdresser who did her hair for the special day. The intimate wedding was held in the garden of the 175-year-old home Eavey shares with new husband Greg.
Photo by Logan Mock-Bunting

MAGGIE VALLEY
Popcorn Sutton's antique shop provides a peek into the way life used to be in the Smoky Mountains. Among the items Sutton has for sale are old horse collars and handcrafted moonshine stills. In his book *Me and My Likker*, Sutton recounts his youthful moonshining days, and shows how to build a still and make "ruckus juice" from corn and rye.
Photo by Melody Ko

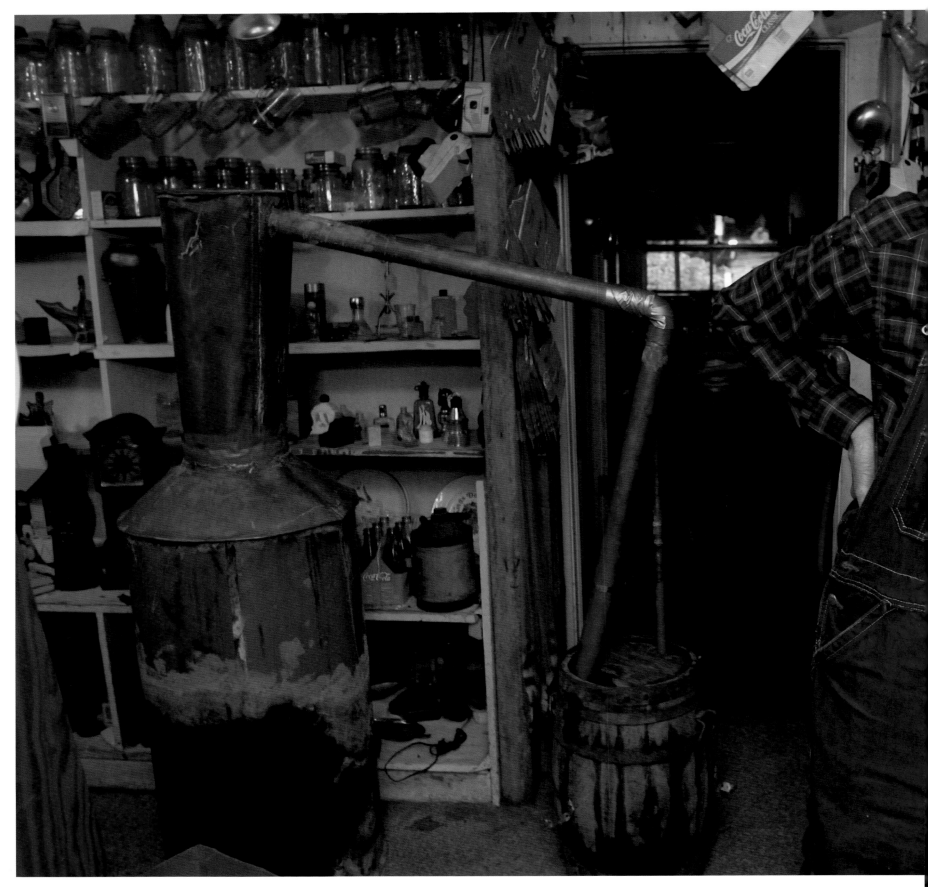

ROBERSONVILLE

In the 1950s, Robert Edwards earned $3 a day for farmwork. He later operated potato peeling machines for Eagle Snacks and as a hobby now sells the golf balls he gathers at a local course. The decades-old hat stays on, mostly. "When I say grace, I take it off."

Photo by Janet Jarman, Contact Press Images

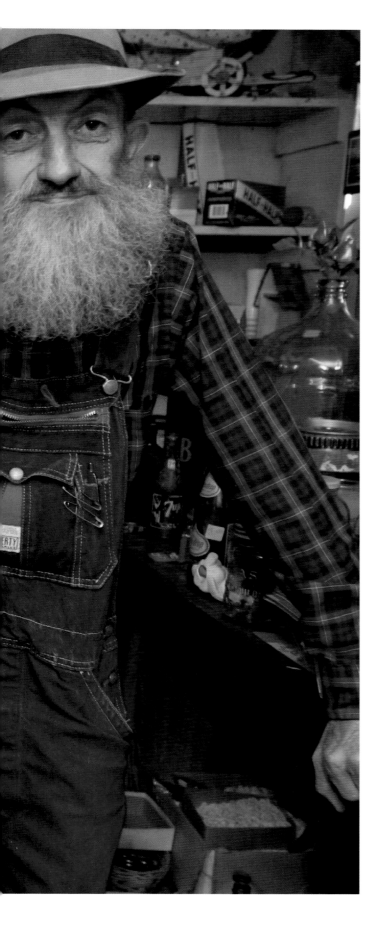

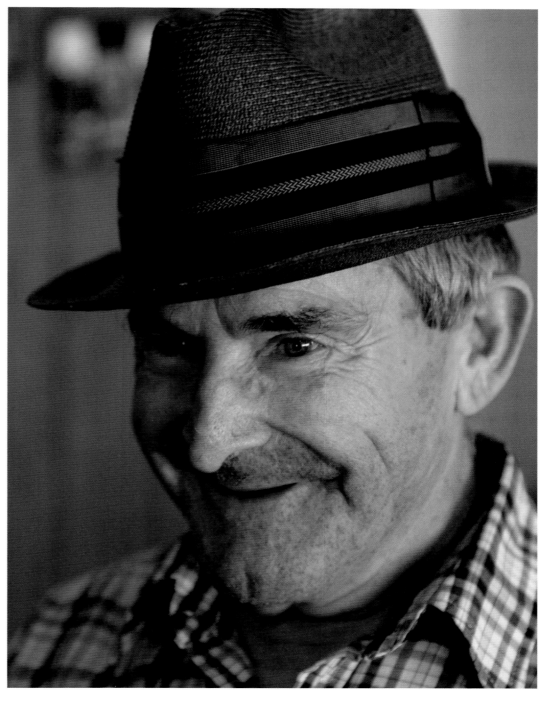

SPARTA

Tradition reigns at the Alleghany Jubilee. Barbara Helms of Jonesville and Milton Scott of Sparta are among the dozens of folks who come every Friday and Saturday night to do the Virginia Reel, the flatfoot, and the two-step. A live band supplies the music, but the Jubilee does not allow alcohol. "We're family oriented," says co-owner Agnes Joines.
Photo by Janet Jarman, Contact Press Images

WRIGHTSVILLE BEACH

Lauren Smith and J. Andrew McKee bust some moves at Red Dog's Bar. Filled with early-20-somethings and loud rock music, it's known as the rowdiest place in Wrightsville Beach.
Photo by Logan Mock-Bunting

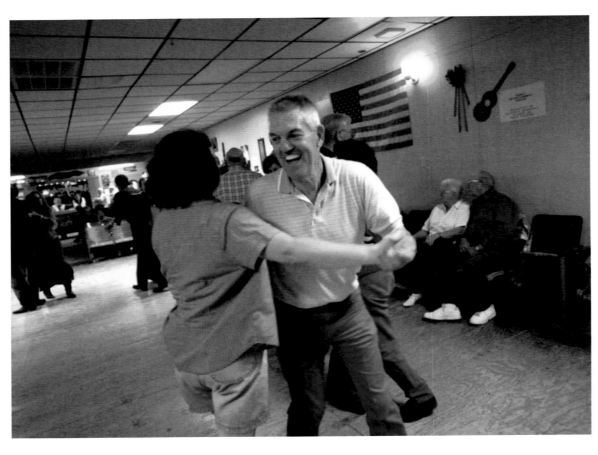

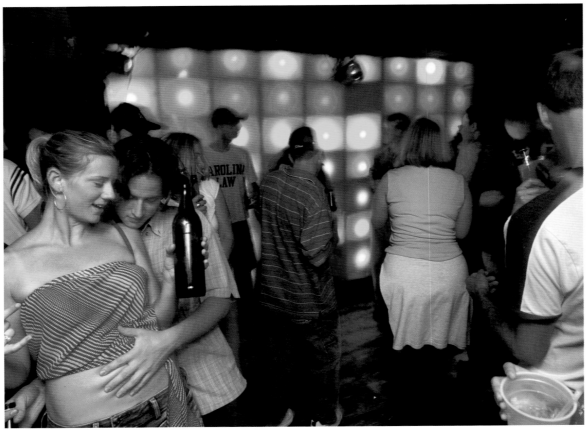

RALEIGH

A B-boy takes his turn in a freestyle circle at Retail, a downtown nightclub. James Brown break beats and old-school hip-hop tunes set the stage for the club's first B-boy battle. The winner took home $1,000, and bragging rights until the next competition.

Photo by John L. White

RALEIGH

Drag performer Busted Cherry collects tips from the audience after her lip-synch performance at Flex, a gay nightclub downtown. The bar's Thursday "Trailer Park" night draws a SRO crowd with its kitschy Spam and macramé door prizes, stand-up comedy routines, and drag contests.

Photo by Bruce DeBoer

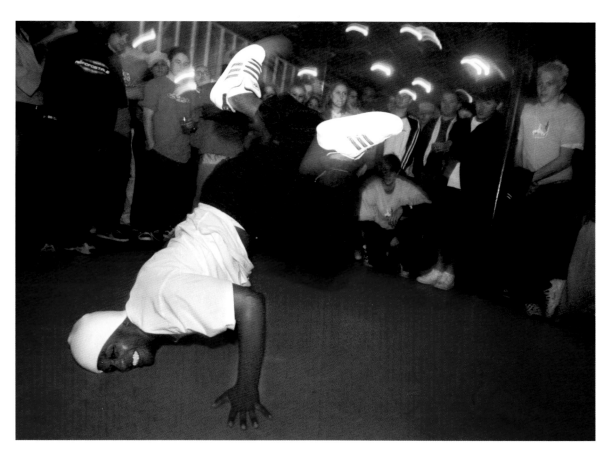

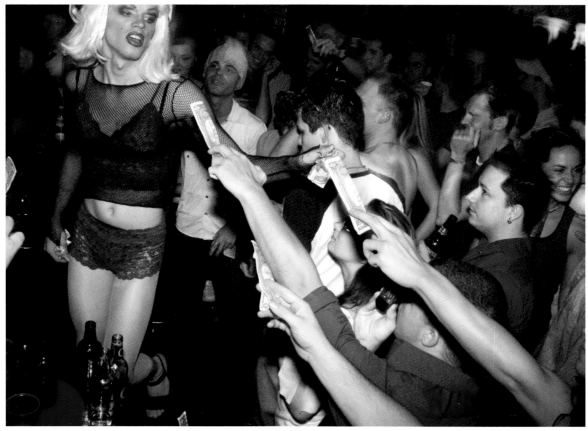

BAR-B-Q
CENTER
PIT-COOKED

AMERICAN EXPRESS
Cards Welcome

MasterCard
VISA

CURB
SERVICE

Hot Dogs
&
Corn Dogs
89¢

LEXINGTON

In the western, or Lexington, style of North Carolina barbecue, pig shoulders—rather than a whole pig—are roasted, and the sauce contains a small amount of tomato base. It's impossible to get any closer to western style than at the Bar-B-Q Center.

Photos by Janet Jarman,
Contact Press Images

LEXINGTON

Kitchen helper Anthony Conrad delivers hot coals to the pit barbecue oven at Bar-B-Q Center. His job also includes putting pork shoulders in the oven and turning them. The restaurant has served up western-style barbecue for more than 40 years.

LEXINGTON

During her 6 a.m. to 2 p.m. shift at the Bar-B-Q Center, Edna Vestal serves 200 people, including Dennis McElroy and Larry Hamilton. Vestal, who's worked at the restaurant for 10 years, says she wouldn't trade her customers for anything in the world.

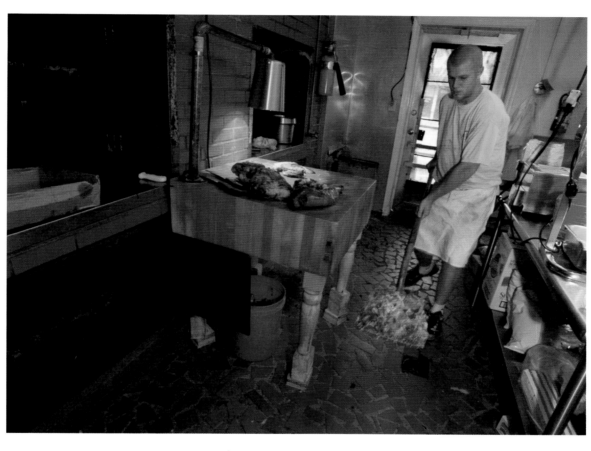

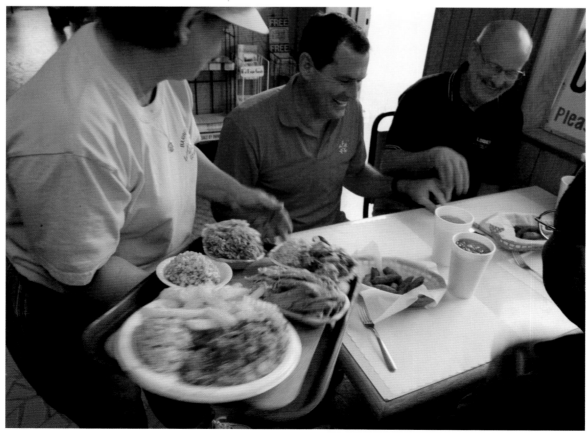

CHAPEL HILL
The nation's first state university, the University of North Carolina was chartered in 1789. Degrees were conferred on 4,685 students at the 2003 graduation. Comedian Bill Cosby (an alum of Temple University in Philadelphia) was the commencement speaker.
Photo by Susie Post Rust, Aurora

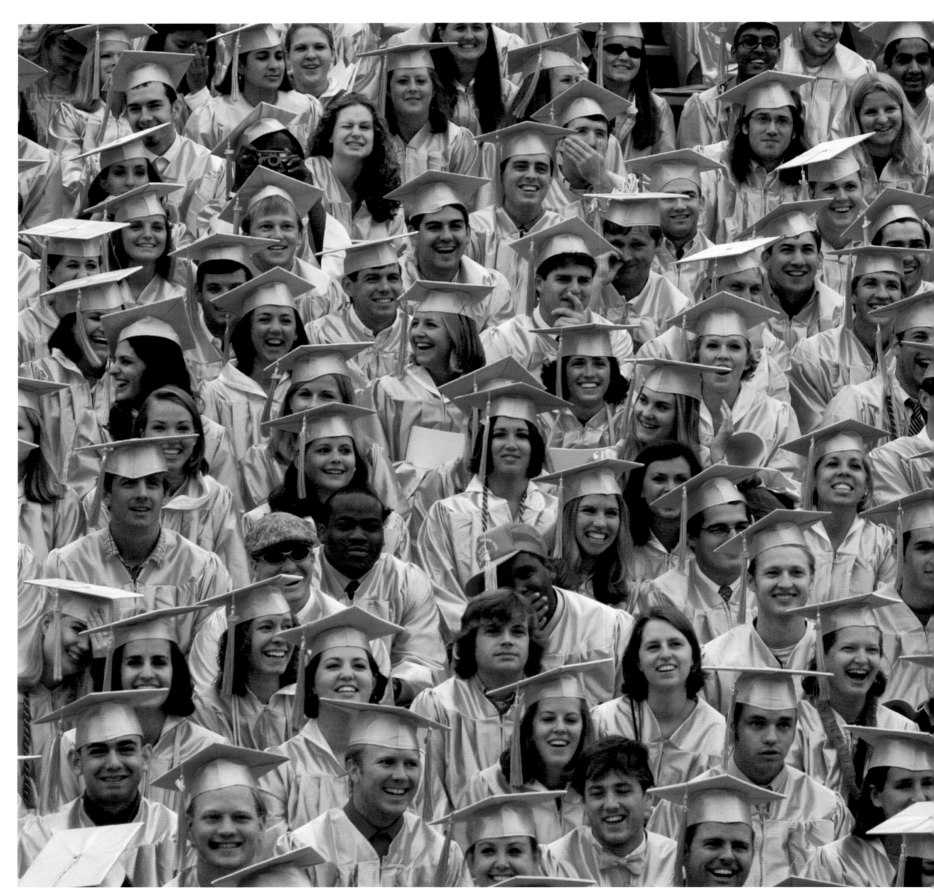

CHAPEL HILL

The University of North Carolina holds a separate graduation for its Department of City and Regional Planning. The two-year master's program is ranked among the top five in America and attracts students from all over the world. Relatives and friends of the 32 members of the class of 2003 record the event for posterity.

Photo by Susie Post Rust, Aurora

CHAPEL HILL

U.S. Navy veteran and mother of two Waleska Domeneck (left) celebrates her graduation from UNC. The first in her family to finish college, she hopes to attend law school.

Photo by Patrick Davison,
The University of North Carolina

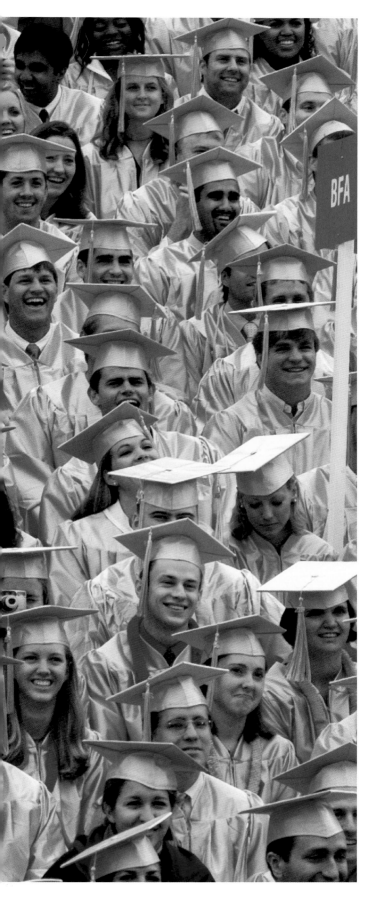

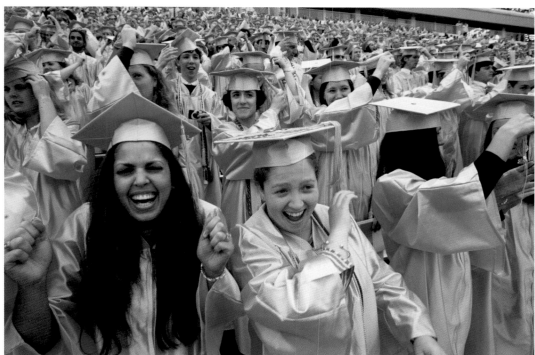

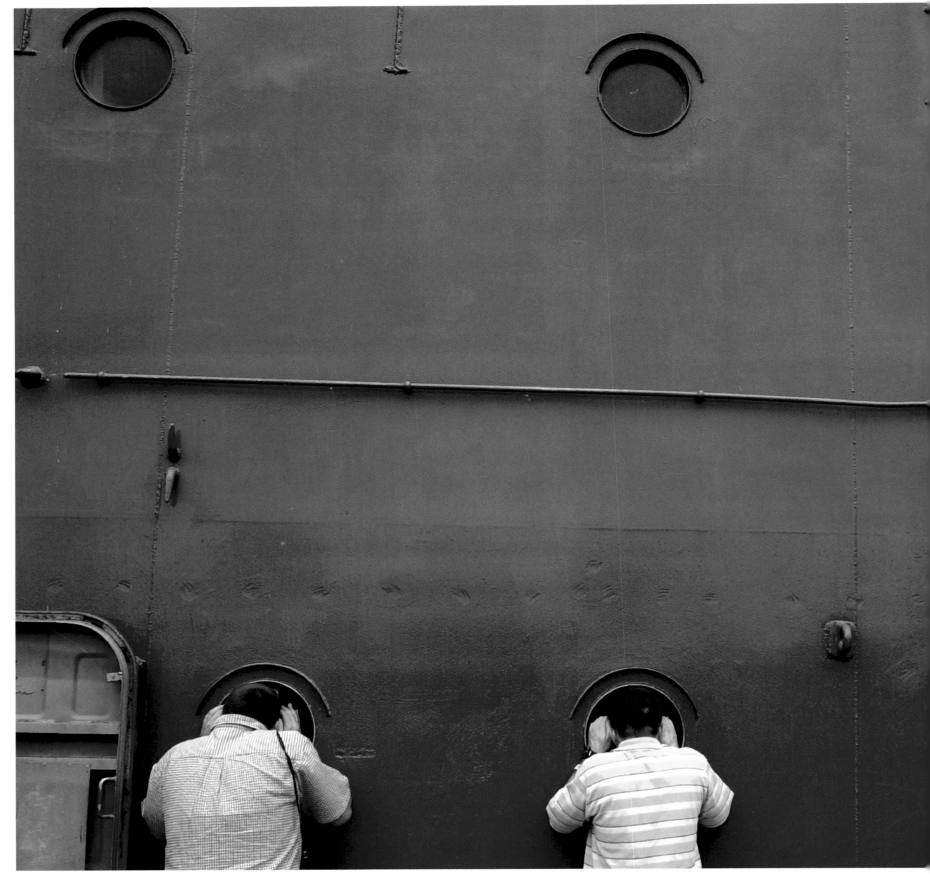

WILMINGTON
Tourists peer into the officers' meeting room on USS *North Carolina* or, "Showboat" as she is called for being the most decorated battleship in World War II. The ship participated in every major Pacific naval offensive, surviving a direct hit from a Japanese torpedo and earning 15 battle stars. Since 1962, she has been a war memorial berthed on the Cape Fear River.
Photo by Logan Mock-Bunting

NASHVILLE

Downtown Nashville—unlike the business districts of other small towns along Highway 64—is doing well. It helps to be the seat of Nash County, with its courthouse traffic. It helps to have a preservation group. And it helps to have the Nashville Exchange, a café where people can exchange one used book for another for $1.

Photo by Janet Jarman, Contact Press Images

BANNER ELK

Air apparent: Aaron Kraemer takes a break from selling skateboards at the Edge of the World skate and snowboard shop to practice a kick turn on the 6-foot half-pipe behind the store.

Photo by Jason Arthurs

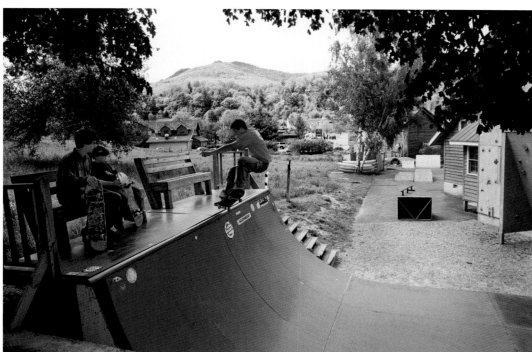

Earning his stripes: A determined zebra invades the back of a horse-drawn wagon at the Lazy 5 Ranch in search of a midday snack. The ranch's nondescript exterior and unlikely location on the outskirts of Charlotte belie the strange and exotic beasts—including giraffes, rhinos, and camels— that roam its grounds.
Photo by Gayle Shomer Brezicki

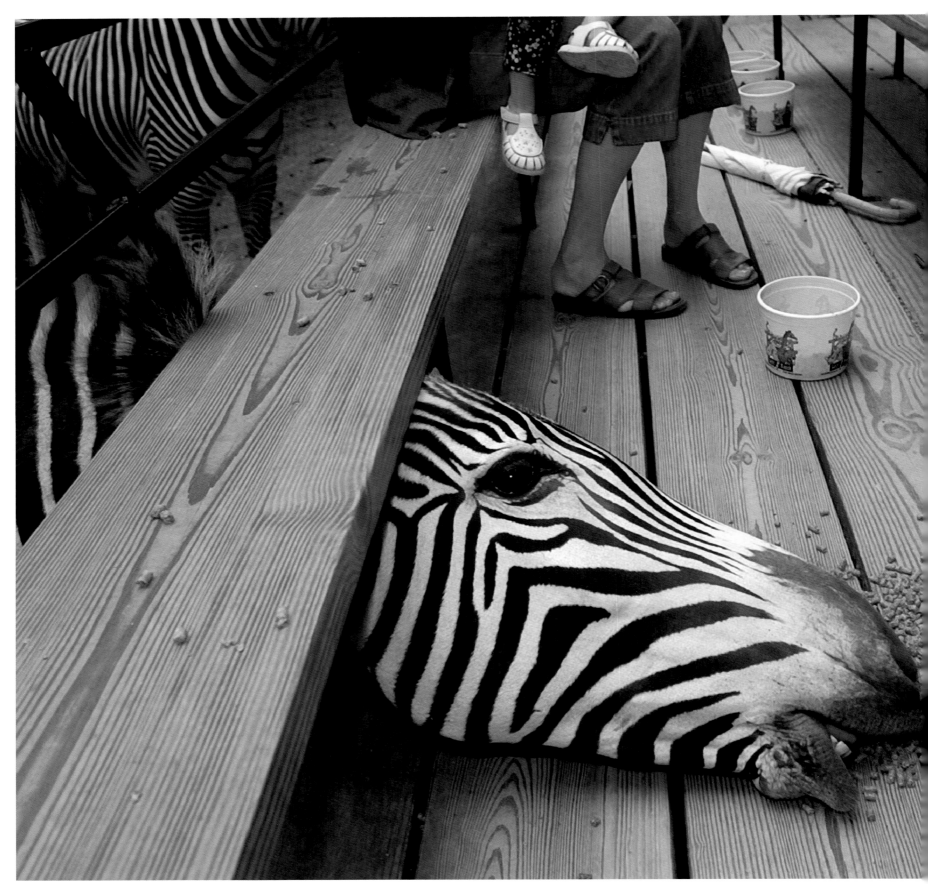

MOORESVILLE

Where the buffalo roam: A 450-pound American bison opens wide for a handful of feed at the Lazy 5 Ranch. In 1993, owner Henry Hampton opened up his private collection of exotic animals to the public and inaugurated the state's first drive-through zoo. The ranch now receives 130,000 visitors per year.

Photo by Gayle Shomer Brezicki

CARY

Keep your eyes on the ball and your mouth open. Within a split-second of this photo, 3-year-old Oscar snared the Dunlop.

Photo by Tim Lytvinenko

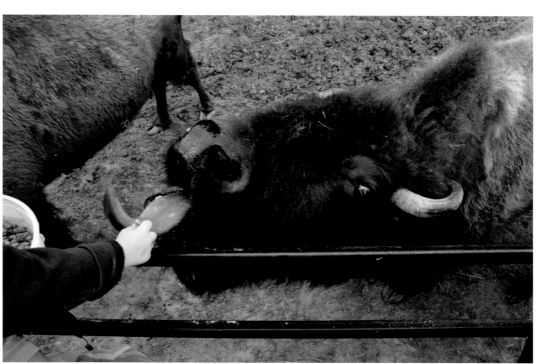

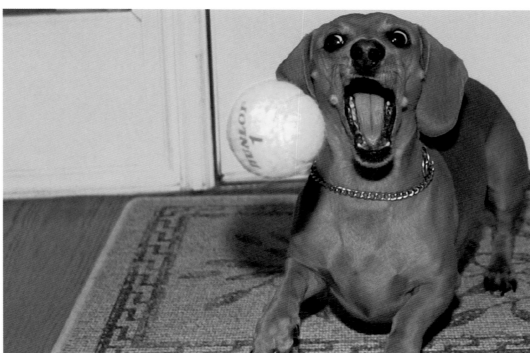

WILMINGTON

Sassy visits James Howard at the New Hanover Regional Medical Center. Hospital volunteer Betty Ames rescued the poodle from the pound and had her trained in pet therapy. Every Wednesday the little dog winks, dances, and cuddles her way around the oncology floor. "She gives patients a few minutes away from their problems," says Ames.
Photo by Logan Mock-Bunting

TRIPLETT

Eustace Conway and 3-week-old Tierra live on Turtle Island Preserve, the environmental education center and wildlife sanctuary Conway started in 1987. The no-electricity, no-plumbing preserve—which literally depends on horsepower—offers classes that teach wilderness skills. Conway calls himself "a martyr, giving my life to this cause."
Photo by Scott Sharpe

FAYETTEVILLE

"It looked like Mike Tyson punched him in the face, so I named him Tyson," says Noah Steere of his 6-month-old English bulldog. The professional bodybuilder always wanted a bulldog but couldn't afford Tyson's $1,500 price tag until he saved up enough from the nutritional supplement store he runs.
Photo by Cindy Burnham, Nautilus Productions

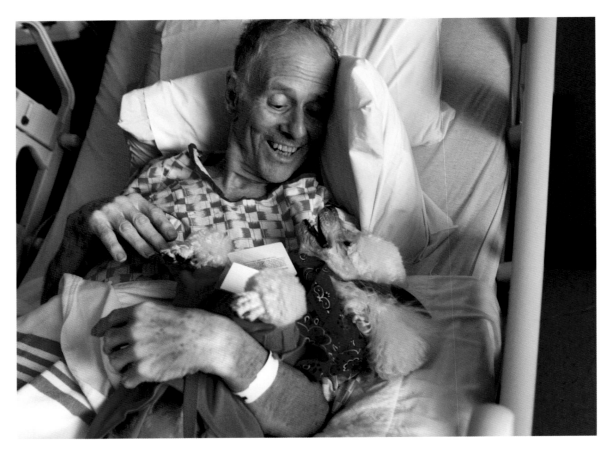

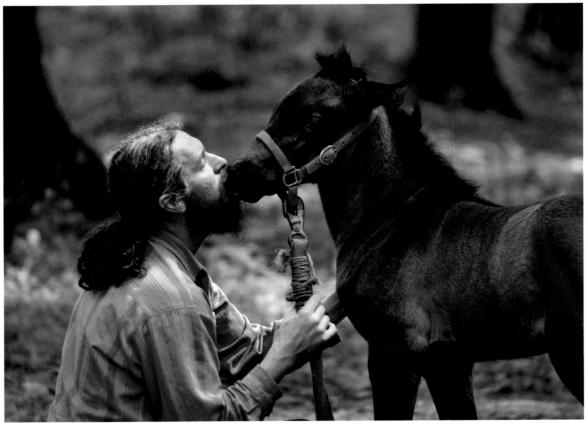

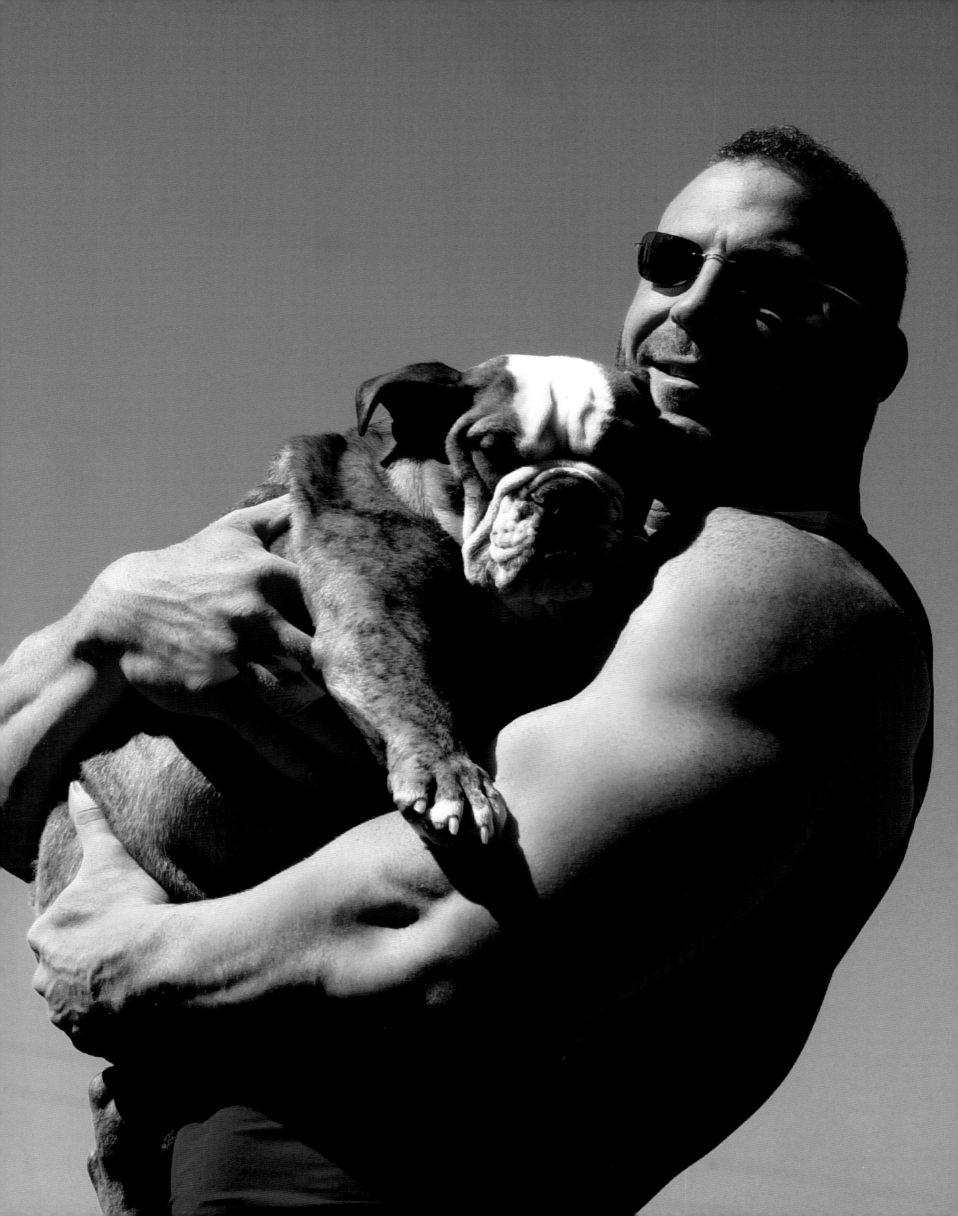

CHAPEL HILL

The First Methodist church reflected in a campus store window is a fitting image for the 12th state, where religion and basketball often seem to be one. Souvenir jerseys for the Tarheels remember legendary players—Michael Jordan wore number 23 during the 1981 through 1984 seasons.
Photo by Coke Whitworth

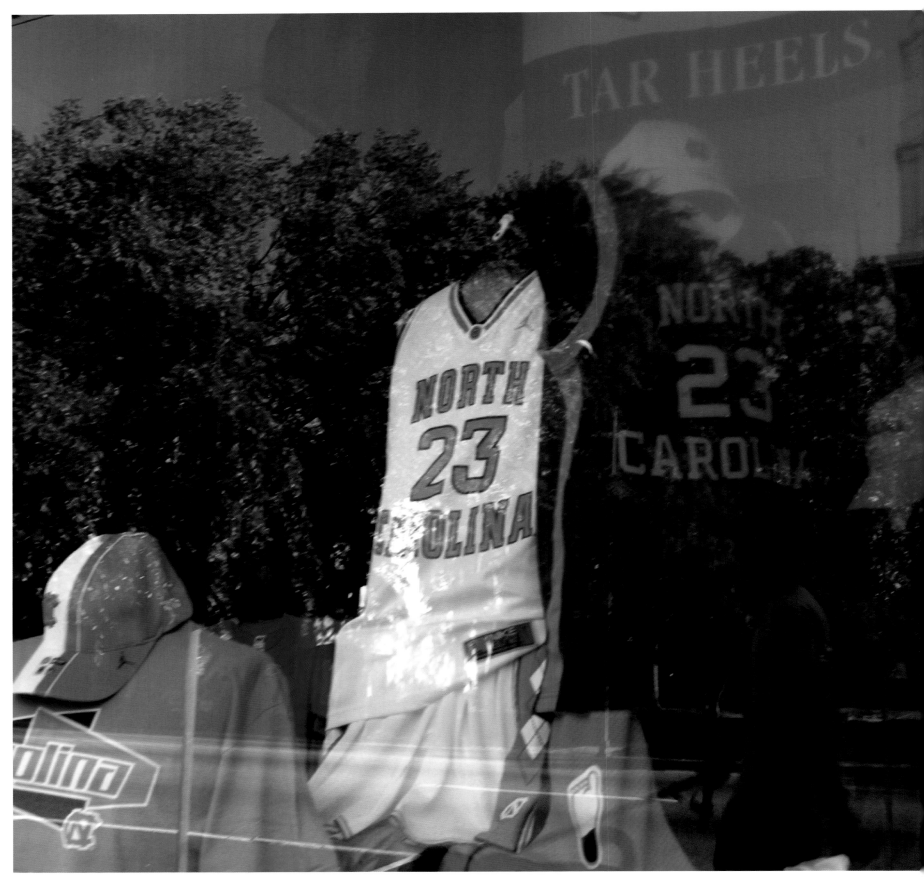

CASWELL BEACH

Andrea Lackey of Chattanooga, Tennessee, shops for tomatoes at A&A Produce Stand on Highway 87 in Caswell Beach. She's in town for her daughter's wedding. The small resort town gets its name from nearby Fort Caswell, which changed hands four times during the Civil War without a casualty.

Photo by Logan Mock-Bunting

LEXINGTON

Nearly every day during spring semester, Wake Forest College psychology major Kasie Norris drives an hour to have lunch with Clayton Dagenhardt, who is getting his basic law enforcement training at Davidson Community College. Their romance began, Dagenhardt says, "After I replaced her left headlight and wouldn't let her pay for it."

Photo by Janet Jarman, Contact Press Images

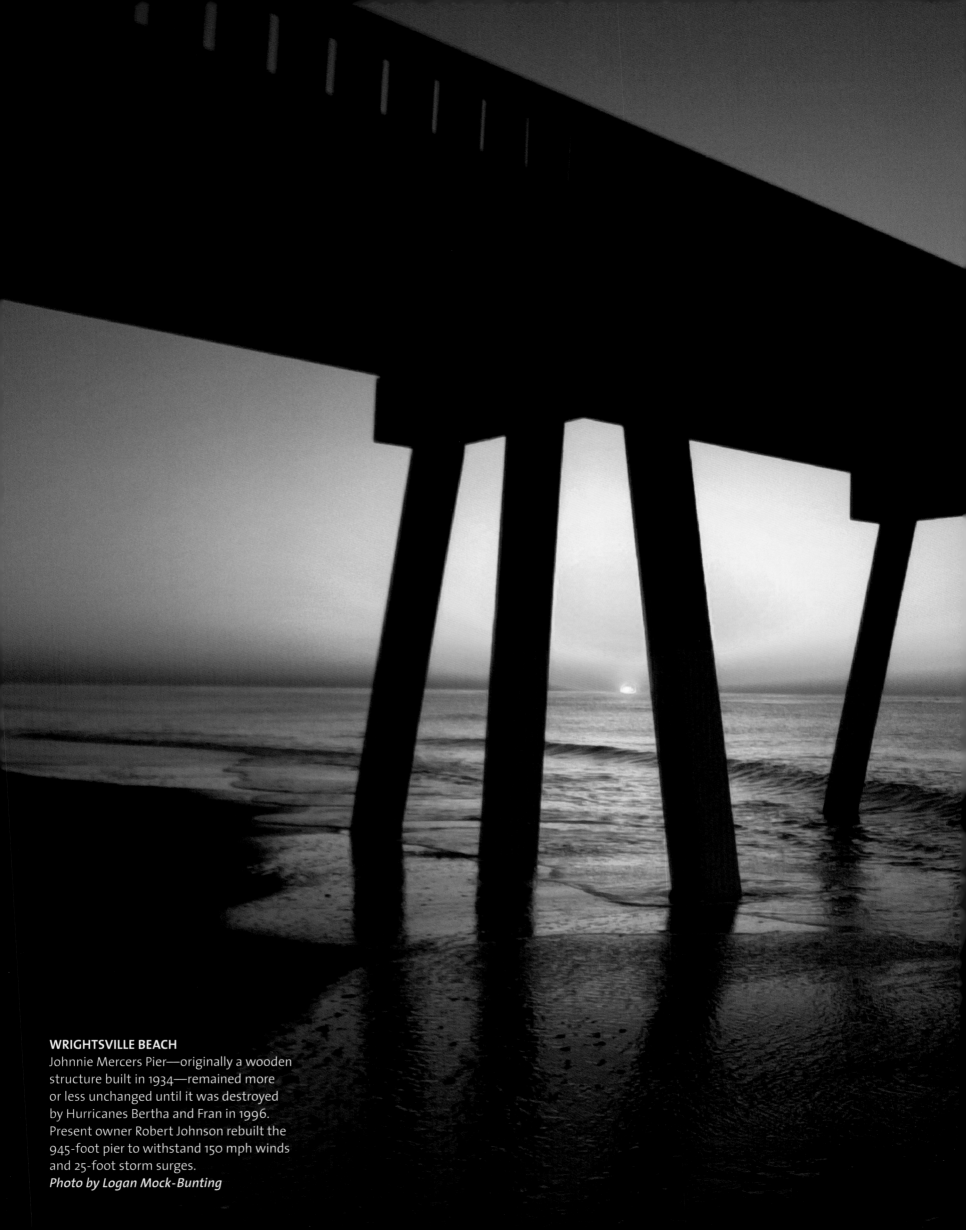

WRIGHTSVILLE BEACH
Johnnie Mercers Pier—originally a wooden
structure built in 1934—remained more
or less unchanged until it was destroyed
by Hurricanes Bertha and Fran in 1996.
Present owner Robert Johnson rebuilt the
945-foot pier to withstand 150 mph winds
and 25-foot storm surges.
Photo by Logan Mock-Bunting

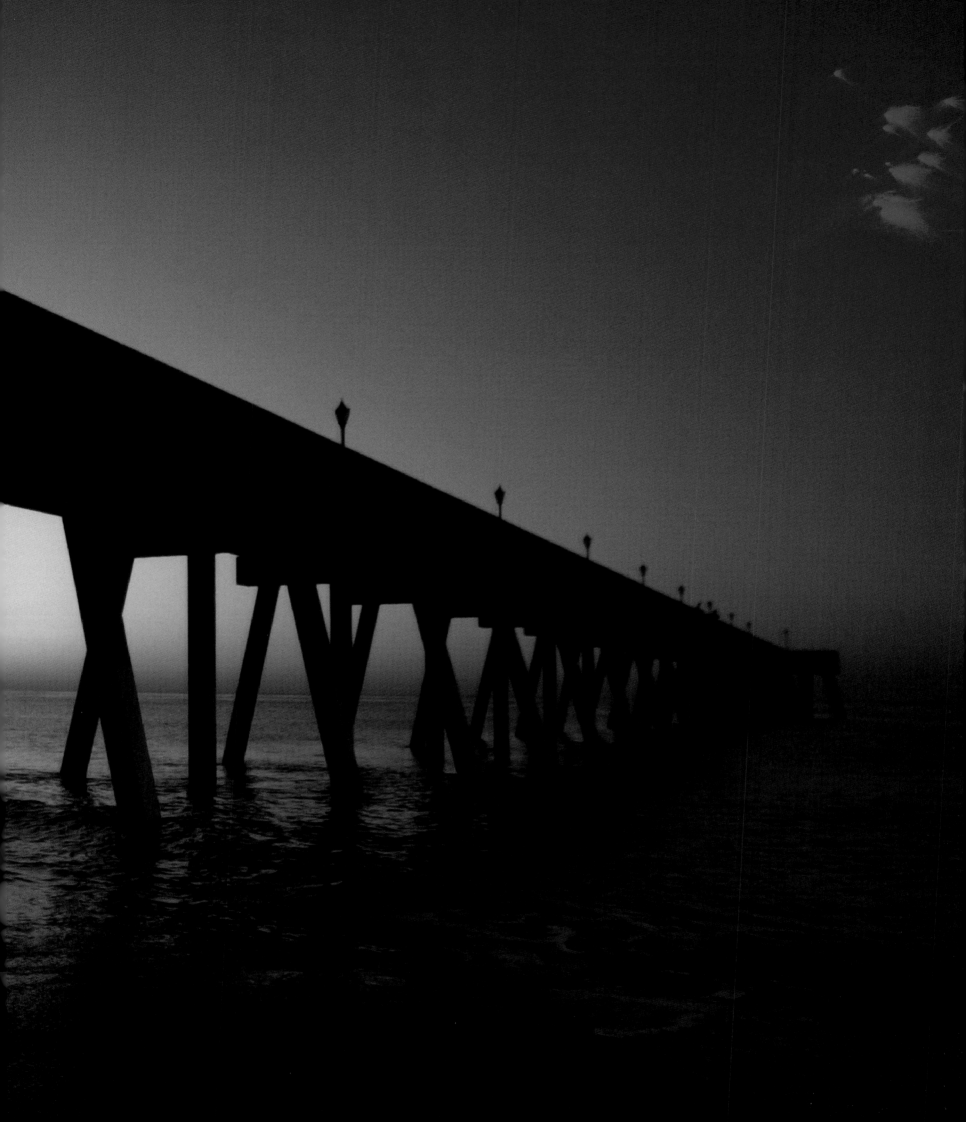

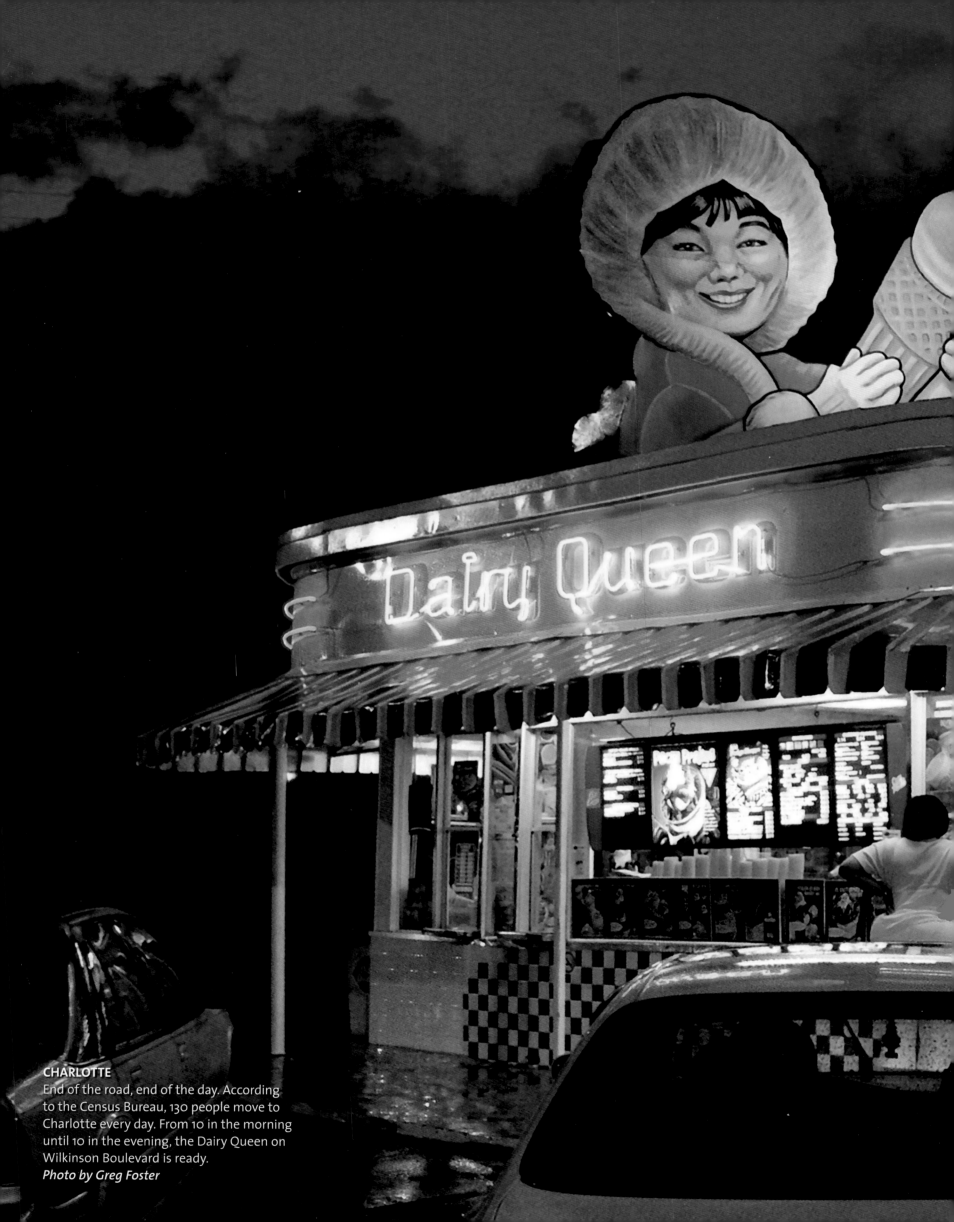

CHARLOTTE
End of the road, end of the day. According to the Census Bureau, 130 people move to Charlotte every day. From 10 in the morning until 10 in the evening, the Dairy Queen on Wilkinson Boulevard is ready.
Photo by Greg Foster

How It Worked

The week of May 12-18, 2003, more than 25,000 professional and amateur photographers spread out across the nation to shoot over a million digital photographs with the goal of capturing the essence of daily life in America.

The professional photographers were equipped with Adobe Photoshop and Adobe Album software, Olympus C-5050 digital cameras, and Lexar Media's high-speed compact flash cards.

The 1,000 professional contract photographers plus another 5,000 stringers and students sent their images via FTP (file transfer protocol) directly to the *America 24/7* website. Meanwhile, thousands of amateur photographers uploaded their images to Snapfish's servers.

At *America 24/7*'s Mission Control headquarters, located at CNET in San Francisco, dozens of picture editors from the nation's most prestigious publications culled the images down to 25,000 of the very best, using Photo Mechanic by Camera Bits. These photos were transferred into Webware's ActiveMedia Digital Asset Management (DAM) system, which served as a central image library and enabled the designers to track, search, distribute, and reformat the images for the creation of the 51 books, foreign language editions, web and magazine syndication, posters, and exhibitions.

Once in the DAM, images were optimized (and in some cases resampled to increase image resolution) using Adobe Photoshop. Adobe InDesign and Adobe InCopy were used to design and produce the 51 books, which were edited and reviewed in multiple locations around the world in the form of Adobe Acrobat PDFs. Epson Stylus printers were used for photo proofing and to produce large-format images for exhibitions. The companies providing support for the *America 24/7* project offer many of the essential components for anyone building a digital darkroom. We encourage you to read more on the following pages about their respective roles in making *America 24/7* possible.

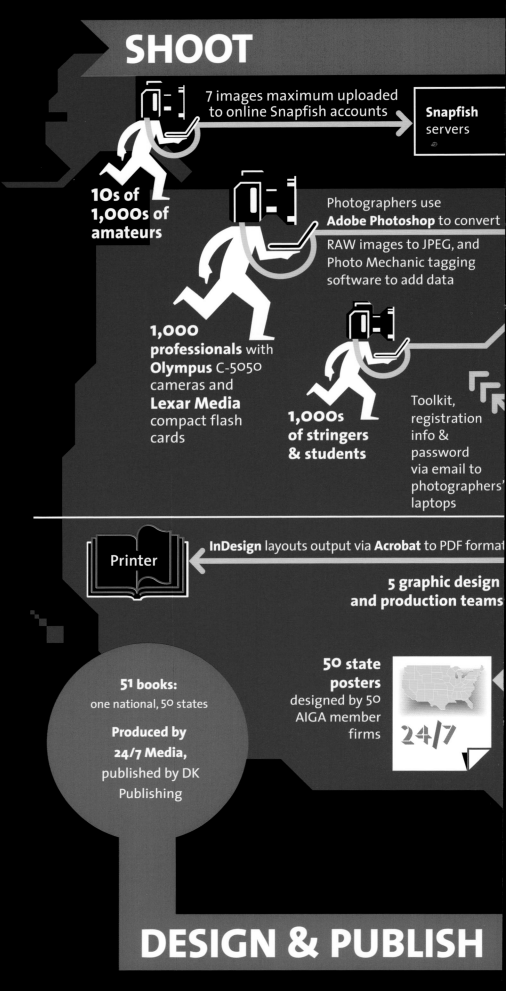

SHOOT

7 images maximum uploaded to online Snapfish accounts

Snapfish servers

10s of 1,000s of amateurs

Photographers use **Adobe Photoshop** to convert RAW images to JPEG, and Photo Mechanic tagging software to add data

1,000 professionals with **Olympus** C-5050 cameras and **Lexar Media** compact flash cards

1,000s of stringers & students

Toolkit, registration info & password via email to photographers' laptops

Printer

InDesign layouts output via **Acrobat** to PDF format

5 graphic design and production teams

51 books: one national, 50 states

Produced by 24/7 Media, published by DK Publishing

50 state posters designed by 50 AIGA member firms

24/7

DESIGN & PUBLISH

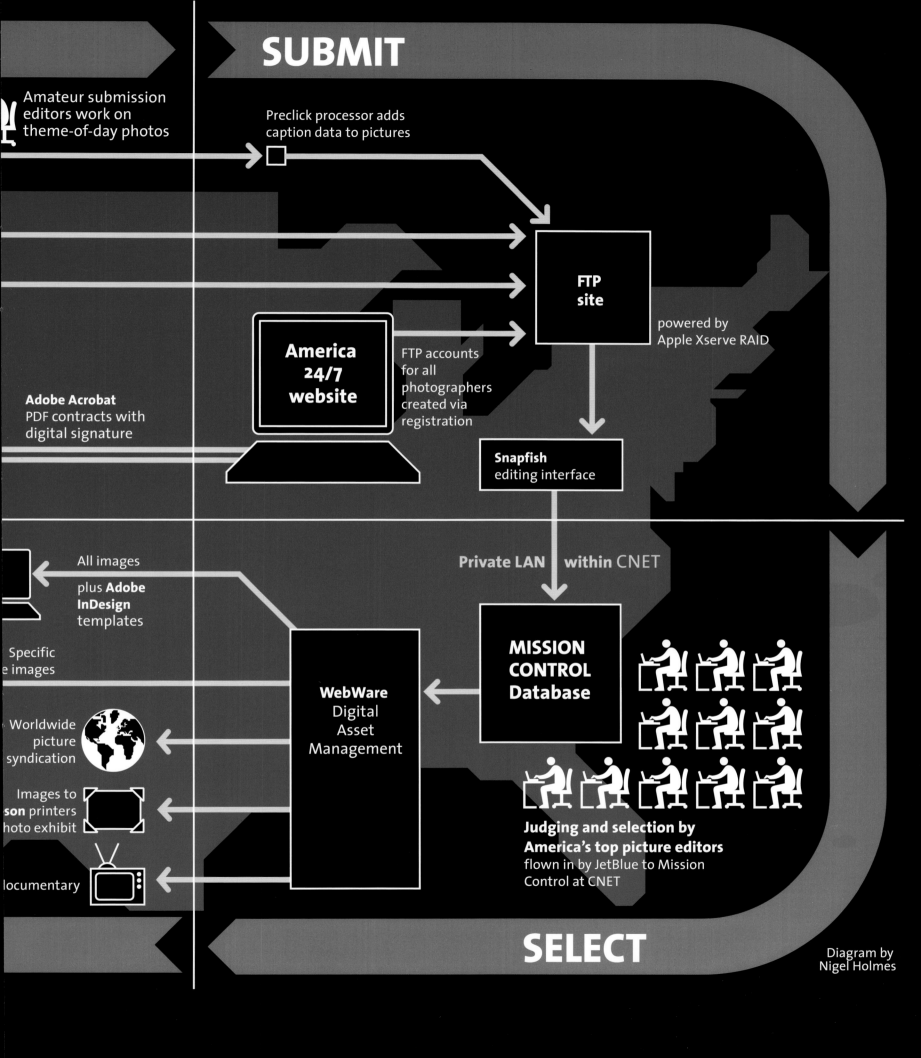

SUBMIT

Amateur submission editors work on theme-of-day photos

Preclick processor adds caption data to pictures

FTP site

powered by Apple Xserve RAID

Adobe Acrobat PDF contracts with digital signature

America 24/7 website

FTP accounts for all photographers created via registration

Snapfish editing interface

Private LAN **within** CNET

All images

plus **Adobe InDesign** templates

MISSION CONTROL Database

Specific e images

WebWare Digital Asset Management

Worldwide picture syndication

Images to son printers hoto exhibit

Judging and selection by America's top picture editors flown in by JetBlue to Mission Control at CNET

locumentary

SELECT

Diagram by Nigel Holmes

About Our Sponsors

America 24/7 gave digital photographers of all levels the opportunity to share their visions of what it means to live in the United States. This project was made possible by a digital photography revolution that is dramatically changing and improving picture-taking for professionals and amateurs alike. And an Adobe product, Photoshop®, has been at the center of this sea change.

Adobe's products reflect our customers' passion for the creative process, be it the photographer, graphic designer, layout artist, or printer. Adobe is the Publishing and Imaging Software Partner for *America 24/7* and products such as Adobe InDesign®, Photoshop, Acrobat®, and Illustrator® were used to produce this stunning book in a matter of weeks. We hope that our software has helped do justice to the mythic images, contributed by well-known photographers and the inspired hobbyist.

Adobe is proud to be a lead sponsor of *America 24/7*, a project that celebrates the vibrancy of the American spirit: the same spirit that helped found Adobe and inspires our employees and customers to deliver the very best.

Bruce Chizen
President and CEO
Adobe Systems Incorporated

Olympus, a global technology leader in designing precision healthcare solutions and innovative consumer electronics, is proud to be the official digital camera sponsor of *America 24/7*. The opportunity to introduce Americans from coast to coast to the thrill, excitement, and possibility of digital photography makes the vision behind this book a perfect fit for Olympus, a leader in digital cameras since 1996.

For most people, the essence of digital photography is best grasped through firsthand experience with the technology, which is precisely what *America 24/7* is about. We understand that direct experience is the pathway to inspiration, and welcome opportunities like this sponsorship to bring the power of the digital experience into the lives of people everywhere. To Olympus, *America 24/7* offers a platform to help realize a core mission: to deliver and make accessible the power of the digital experience to millions of American photographers, amateurs, and professionals alike.

The 1,000 professional photographers contracted to shoot on the America 24/7 project were all equipped with Olympus C-5050 digital cameras. Like all Olympus products, the C-5050 is offered by a company well known for designing, manufacturing, and servicing products used by professionals to perform their work, every day. Olympus is a customer-centric company committed to working one-to-one with a diverse group of professionals. From biomedical researchers who use our clinical microscopes, to doctors who perform life-saving procedures with our endoscopes, to professional photographers who use cameras in their daily work, Olympus is a trusted brand.

The digital imaging technology involved with *America 24/7* has enabled the soul of America to be visually conveyed, not just by professional observers, but by the American public who participated in this project—the very people who collectively breath life into this country's existence each day.

We are proud to be enabling so many photographers to capture the pictures on these pages that tell the story of who we are as a nation. From sea to shining sea, digital imagery allows us to connect to one another in ways we never dreamed possible.

At Olympus, our ideas have proliferated as rapidly as technology has evolved. We have channeled these visions into breakthrough products and solutions to meet the demands of our changing world-products like microscopes, endoscopes, and digital voice recorders, supported by the highly regarded training, educational, and consulting services we offer our customers.

Today, 83 years after we introduced our first microscope, we remain as young, as curious, and as committed as ever.

Lexar Media has grown from the digital photography revolution, which is why we are proud to have supplied the digital memory cards used in the America 24/7 project. Lexar Media's high-performance memory cards utilize our unique and patented controller coupled with high-speed flash memory from Samsung, the world's largest flash memory supplier. This powerful combination brings out the ultimate performance of any digital camera.

Photographers who demand the most from their equipment choose our products for their advanced features like write speeds up to 40X, Write Acceleration technology for enabled cameras, and Image Rescue, which recovers previously deleted or lost images. Leading camera manufacturers bundle Lexar Media digital memory cards with their cameras because they value its performance and reliability.

Lexar Media is at the forefront of digital photography as it transforms picture-taking worldwide, and we will continue to be a leader with new and innovative solutions for professionals and amateurs alike.

Snapfish, which developed the technology behind the *America 24/7* amateur photo event, is a leading online photo service, with more than 5 million members and 100 million photos posted online. Snapfish enables both film and digital camera owners to share, print, and store their most important photo memories, at prices that cannot be equaled. Digital camera users upload photos into a password-protected online album for free. Users can also order film-quality prints on professional photographic paper for as low as 25¢. Film camera users get a full set of prints, plus online sharing and storage, for just $2.99 per roll.

Founded in 1995, eBay created a powerful platform for the sale of goods and services by a passionate community of individuals and businesses. On any given day, there are millions of items across thousands of categories for sale on eBay. eBay enables trade on a local, national and international basis with customized sites in markets around the world.

Through an array of services, such as its payment solution provider PayPal, eBay is enabling global e-commerce for an ever-growing online community.

JetBlue Airways is proud to be *America 24/7's* preferred carrier, flying photographers, photo editors, and organizers across the United States.

Winner of Condé Nast Traveler's Readers' Choice Awards for Best Domestic Airline 2002, JetBlue provides friendly service and low fares for travelers in 22 cities in nine states across America.

On behalf of JetBlue's 5,000 crew members, we're excited to be involved in this remarkable project, and for the opportunity to serve American travelers each and every day, coast to coast, 24/7.

DIGITAL POND

Digital Pond has been a leading creator of large graphic displays for museums, corporations, trade shows, retail environments and fine art since 1992.

We were proud to bring together our creative, print and display capabilities to produce signage and displays for mission control, critical retouching for numerous key images for the book, and art galleries for the New York Public Library and Bryant Park.

The Pond's team and SplashPic® Online service enabled us to nimbly design, produce and install over 200 large graphic panels in two NYC locations within the truly "24/7" production schedule of less than ten days.

WebWare Corporation is pleased to be a major sponsor of the America 24/7 project. We take pride in being part of a groundbreaking adventure that is stretching the boundaries—and the imagination—in digital photography, digital asset management, publishing, news, and global events.

Our ActiveMedia Enterprise™ digital asset management software is the "nerve center" of *America 24/7*, the central repository for managing, sharing, and collaborating on the project's photographs. From photo editors and book publishers to 24/7's media relations and marketing personnel, ActiveMedia provides the application support that links all facets of the project team to the content worldwide.

WebWare helps Global 2000 firms securely manage, reuse, and distribute media assets locally or globally. Its suite of ActiveMedia software products provide powerful media services platforms for integrating rich media into content management systems marketing and communication portals; web publishing systems; and e-commerce portals.

Google's mission is to organize the world's information and make it universally accessible and useful.

With our focus on plucking just the right answer from an ocean of data, we were naturally drawn to the America 24/7 project. The book you hold is a compendium of images of American life distilled from thousands of photographs and infinite possibilities. Are you looking for emotion? Narrative? Shadows? Light? It's all here, thanks to a multitude of photographers and writers creating links between you, the reader, and a sea of wonderful stories. We celebrate the connections that constitute the human experience and are pleased to help engender them. And we're pleased to have been a small part of this project, which captures the results of that interaction so vividly, so dynamically, and so dramatically.

Special thanks to additional contributors: FileMaker, Apple, Camera Bits, LaCie, Now Software, Preclick, Outpost Digital, Xerox, Microsoft, WoodWing Software, net-linx Publishing Solutions, and Radical Media. The Savoy Hotel, San Francisco; The Pan Pacific, San Francisco; Four Seasons Hotel, San Francisco; and The Queen Anne Hotel. Photography editing facilities were generously hosted by CNET Networks, Inc.

Participating Photographers

Coordinator: Patrick Davison*, Assistant Professor, Visual Communication, The University of North Carolina

Jason Arthurs
Duston Barto
Gayle Shomer Brezicki
Fred Brown
Cindy Burnham, Nautilus Productions
Patrick Davison*,
The University of North Carolina
Bruce DeBoer
Greg Foster
Bruce Gourley
Ethan Hyman
Micah Zunil Intrator
Janet Jarman, Contact Press Images
Melody Ko
Scott Lewis
Corey Lowenstein
Tim Lytvinenko
Logan Mock-Bunting

Thomas Morris
Susie Post Rust, Aurora
Christopher Record
Ted Richardson, *Winston-Salem Journal*
Teri Saylor
Pamela Schaard-Snell
Patrick Schneider,
The Charlotte Observer
Adam Sebastian
Scott Sharpe
Ford Smith
Ross Taylor
Ami Vitale
John L. White
Coke Whitworth
Lorraine Williams

*Pulitzer Prize winner

Thumbnail Picture Credits

Credits for thumbnail photographs are listed by the page number and are in order from left to right.

20 Navin R. Mahabir
Navin R. Mahabir
Patrick Schneider, *The Charlotte Observer*
Navin R. Mahabir
Navin R. Mahabir
Navin R. Mahabir
Navin R. Mahabir

21 Patrick Schneider, *The Charlotte Observer*
Patrick Schneider, *The Charlotte Observer*
Patrick Schneider, *The Charlotte Observer*
Ron Flory, New York Institute of Photography
Patrick Schneider, *The Charlotte Observer*
Patrick Schneider, *The Charlotte Observer*
Ron Flory, New York Institute of Photography

22 Ted Richardson, *Winston-Salem Journal*
Ted Richardson, *Winston-Salem Journal*
Ted Richardson, *Winston-Salem Journal*
Janet Jarman, Contact Press Images
Ford Smith
Mara Smith
Ford Smith

23 Tim Lytvinenko
Ted Richardson, *Winston-Salem Journal*
Melody Ko
Melody Ko
Melody Ko
Melody Ko
Melody Ko

24 Mara Smith
Ted Richardson, *Winston-Salem Journal*
Ted Richardson, *Winston-Salem Journal*
Ted Richardson, *Winston-Salem Journal*
Ted Richardson, *Winston-Salem Journal*
Ted Richardson, *Winston-Salem Journal*
Owen Riley, Jr.

25 Rhonda B. Lowe, RBL Photography
Ted Richardson, *Winston-Salem Journal*
John L. White
John L. White
Mara Smith
John L. White
John L. White

26 Gayle Shomer Brezicki
Gayle Shomer Brezicki
Gayle Shomer Brezicki
Melody Ko
Coke Whitworth
Coke Whitworth
Gayle Shomer Brezicki

27 Rhonda B. Lowe, RBL Photography
Gayle Shomer Brezicki
Sonia Katchian
Melody Ko

Gayle Shomer Brezicki
Sonia Katchian
Coke Whitworth

28 Patrick Davison, The University of North Carolina
Patrick Davison, The University of North Carolina
Patrick Davison, The University of North Carolina
Patrick Davison, The University of North Carolina
Patrick Davison, The University of North Carolina
Patrick Davison, The University of North Carolina
Patrick Davison, The University of North Carolina

29 Patrick Davison, The University of North Carolina
Patrick Davison, The University of North Carolina
Patrick Davison, The University of North Carolina
Patrick Davison, The University of North Carolina
Patrick Davison, The University of North Carolina
Patrick Davison, The University of North Carolina
Patrick Davison, The University of North Carolina

30 Corey Lowenstein
Corey Lowenstein
Corey Lowenstein
Corey Lowenstein
Corey Lowenstein
Corey Lowenstein
Corey Lowenstein

31 Corey Lowenstein
Corey Lowenstein
Corey Lowenstein
Corey Lowenstein
Corey Lowenstein
Corey Lowenstein
Coke Whitworth

34 Ted Richardson, *Winston-Salem Journal*
Scott Lewis
Ted Richardson, *Winston-Salem Journal*
Janet Jarman, Contact Press Images
Patrick Schneider, *The Charlotte Observer*
Scott Lewis
Navin R. Mahabir

35 Scott Lewis
Ted Richardson, *Winston-Salem Journal*
Navin R. Mahabir
Ted Richardson, *Winston-Salem Journal*
Janet Jarman, Contact Press Images
Navin R. Mahabir
Ted Richardson, *Winston-Salem Journal*

42 Janet Jarman, Contact Press Images
Scott Sharpe
Janet Jarman, Contact Press Images
Janet Jarman, Contact Press Images
Scott Sharpe
Janet Jarman, Contact Press Images
Janet Jarman, Contact Press Images

43 Janet Jarman, Contact Press Images
Ted Richardson, *Winston-Salem Journal*
Ted Richardson, *Winston-Salem Journal*
Ted Richardson, *Winston-Salem Journal*
Ted Richardson, *Winston-Salem Journal*
Scott Sharpe
Janet Jarman, Contact Press Images

44 Ethan Hyman
Ethan Hyman
Ethan Hyman
Ethan Hyman
Ethan Hyman
Ethan Hyman
Ethan Hyman

45 Ethan Hyman
Ethan Hyman
Ethan Hyman
Ethan Hyman
Ethan Hyman
Ethan Hyman
Ethan Hyman

46 Janet Jarman, Contact Press Images
Susie Post Rust, Aurora
Janet Jarman, Contact Press Images
Susie Post Rust, Aurora
Janet Jarman, Contact Press Images
Susie Post Rust, Aurora

47 Susie Post Rust, Aurora
Janet Jarman, Contact Press Images
Susie Post Rust, Aurora
Janet Jarman, Contact Press Images
Susie Post Rust, Aurora
Susie Post Rust, Aurora

48 Janet Jarman, Contact Press Images
Janet Jarman, Contact Press Images
Janet Jarman, Contact Press Images
Janet Jarman, Contact Press Images
Janet Jarman, Contact Press Images
Janet Jarman, Contact Press Images
Janet Jarman, Contact Press Images

49 Coke Whitworth
Coke Whitworth
Coke Whitworth
Coke Whitworth
Coke Whitworth
Coke Whitworth
Coke Whitworth

50 Ross Taylor
Ethan Hyman
Ethan Hyman
Ethan Hyman
Ethan Hyman
Ethan Hyman
Ethan Hyman

51 Ted Richardson, *Winston-Salem Journal*
Mara Smith
Ethan Hyman
Ted Richardson, *Winston-Salem Journal*
Ethan Hyman
Melody Ko
Coke Whitworth

52 Ross Taylor
Melody Ko
Melody Ko
Ross Taylor
Mara Smith
Melody Ko
Mara Smith

53 Sonia Katchian
Melody Ko
Sonia Katchian
Sonia Katchian
Ted Richardson, *Winston-Salem Journal*
Sonia Katchian
Ted Richardson, *Winston-Salem Journal*

54 Melody Ko
Melody Ko
Melody Ko
Mara Smith
Christopher Record
Mara Smith
Melody Ko

55 Janet Jarman, Contact Press Images
Christopher Record
Christopher Record
Christopher Record
Janet Jarman, Contact Press Images
Christopher Record
Mara Smith

56 Melody Ko
Melody Ko
Ted Richardson, *Winston-Salem Journal*
Melody Ko

Melody Ko
Melody Ko
Melody Ko

57 Melody Ko
Melody Ko
Melody Ko
Melody Ko
Melody Ko
Melody Ko

60 Ted Richardson, *Winston-Salem Journal*
Ted Richardson, *Winston-Salem Journal*
Ted Richardson, *Winston-Salem Journal*
Ted Richardson, *Winston-Salem Journal*
Ted Richardson, *Winston-Salem Journal*
Ted Richardson, *Winston-Salem Journal*

61 Ted Richardson, *Winston-Salem Journal*
Ted Richardson, *Winston-Salem Journal*
Ted Richardson, *Winston-Salem Journal*
Ted Richardson, *Winston-Salem Journal*
Ted Richardson, *Winston-Salem Journal*
Ted Richardson, *Winston-Salem Journal*

62 Corey Lowenstein
Janet Jarman, Contact Press Images
Corey Lowenstein
Janet Jarman, Contact Press Images
Corey Lowenstein
Corey Lowenstein

63 Corey Lowenstein
Corey Lowenstein
Corey Lowenstein
Corey Lowenstein
Janet Jarman, Contact Press Images
Corey Lowenstein
Janet Jarman, Contact Press Images

64 Melody Ko
Melody Ko
Melody Ko
Melody Ko
Melody Ko
Melody Ko
Melody Ko

65 Melody Ko
Melody Ko
Melody Ko
Melody Ko
Melody Ko
Melody Ko
Melody Ko

66 Christopher Record
Christopher Record
Christopher Record
Christopher Record
Christopher Record
Christopher Record

67 Christopher Record
Christopher Record
Christopher Record
Christopher Record
Christopher Record
Christopher Record

70 Bruce DeBoer
Cindy Burnham, Nautilus Productions
Cindy Burnham, Nautilus Productions
Cindy Burnham, Nautilus Productions
Cindy Burnham, Nautilus Productions
Bruce DeBoer
Bruce DeBoer

71 Cindy Burnham, Nautilus Productions
Bruce DeBoer
Cindy Burnham, Nautilus Productions
Bruce DeBoer
Cindy Burnham, Nautilus Productions
Bruce DeBoer
Bruce DeBoer

74 Coke Whitworth
Logan Mock-Bunting
Logan Mock-Bunting
Logan Mock-Bunting
Coke Whitworth
Logan Mock-Bunting
Logan Mock-Bunting

75 Logan Mock-Bunting
Logan Mock-Bunting
Rhonda B. Lowe, RBL Photography
Logan Mock-Bunting
Coke Whitworth
Logan Mock-Bunting
Logan Mock-Bunting

76 Logan Mock-Bunting
Jason Arthurs
Logan Mock-Bunting
Jason Arthurs
Logan Mock-Bunting
Logan Mock-Bunting

77 Logan Mock-Bunting
Logan Mock-Bunting
Susie Post Rust, Aurora
Susie Post Rust, Aurora
Susie Post Rust, Aurora
Susie Post Rust, Aurora
Logan Mock-Bunting

80 Cindy Burnham, Nautilus Productions
Scott Lewis
Scott Lewis
Scott Lewis
Logan Mock-Bunting
Scott Lewis
Scott Lewis

81 Scott Lewis
Scott Lewis
Scott Lewis
Scott Lewis
Scott Lewis
Scott Lewis
Logan Mock-Bunting

85 Patrick Davison, The University of North Carolina
Patrick Davison, The University of North Carolina
Patrick Davison, The University of North Carolina
Patrick Davison, The University of North Carolina
Patrick Davison, The University of North Carolina
Patrick Davison, The University of North Carolina
Patrick Davison, The University of North Carolina

86 Patrick Davison, The University of North Carolina
Patrick Davison, The University of North Carolina
Patrick Davison, The University of North Carolina
Patrick Davison, The University of North Carolina
Patrick Davison, The University of North Carolina
Patrick Davison, The University of North Carolina

87 Patrick Davison, The University of North Carolina
Patrick Davison, The University of North Carolina
Patrick Davison, The University of North Carolina
Patrick Davison, The University of North Carolina
Patrick Davison, The University of North Carolina
Patrick Davison, The University of North Carolina

88 Corey Lowenstein
Corey Lowenstein
Corey Lowenstein
Corey Lowenstein
Corey Lowenstein
Corey Lowenstein

89 Corey Lowenstein
Corey Lowenstein
Kristian McAdams
Corey Lowenstein
Corey Lowenstein
Ross Taylor

90 Patrick Schneider, *The Charlotte Observer*
Patrick Schneider, *The Charlotte Observer*
Patrick Schneider, *The Charlotte Observer*
Patrick Schneider, *The Charlotte Observer*
Patrick Schneider, *The Charlotte Observer*
Patrick Schneider, *The Charlotte Observer*

91 Patrick Schneider, *The Charlotte Observer*
Patrick Schneider, *The Charlotte Observer*
Patrick Schneider, *The Charlotte Observer*
Patrick Schneider, *The Charlotte Observer*
Patrick Schneider, *The Charlotte Observer*
Patrick Schneider, *The Charlotte Observer*
Patrick Schneider, *The Charlotte Observer*

92 Patrick Schneider, *The Charlotte Observer*
Patrick Schneider, *The Charlotte Observer*
Patrick Schneider, *The Charlotte Observer*
Patrick Schneider, *The Charlotte Observer*
Patrick Schneider, *The Charlotte Observer*
Patrick Schneider, *The Charlotte Observer*
Patrick Schneider, *The Charlotte Observer*

93 Patrick Schneider, *The Charlotte Observer*
Patrick Schneider, *The Charlotte Observer*
Patrick Schneider, *The Charlotte Observer*
Patrick Schneider, *The Charlotte Observer*
Patrick Schneider, *The Charlotte Observer*
Patrick Schneider, *The Charlotte Observer*
Patrick Schneider, *The Charlotte Observer*

96 Melody Ko
Melody Ko
Melody Ko
Melody Ko

Melody Ko
Patrick Davison, The University of North Carolina
Patrick Davison, The University of North Carolina

97 Patrick Davison, The University of North Carolina
Melody Ko
Melody Ko
Melody Ko
Melody Ko
Melody Ko
Patrick Davison, The University of North Carolina

100 Duston Barto
Jason Arthurs
Christopher Record
Jason Arthurs
Susie Post Rust, Aurora
Christopher Record
Susie Post Rust, Aurora

101 Jason Arthurs
Ron Flory, New York Institute of Photography
Melody Ko
Christopher Record
Ford Smith
Melody Ko
Jason Arthurs

102 Jerry Bryant
Duston Barto
Bob Carey
Ami Vitale
Christopher Record
Duston Barto
Christopher Record

103 Cindy Burnham, Nautilus Productions
Janet Jarman, Contact Press Images
Kristian McAdams
Ami Vitale
Ami Vitale
Janet Jarman, Contact Press Images
Owen Riley, Jr.

108 Gayle Shomer Brezicki
Gayle Shomer Brezicki
Gayle Shomer Brezicki
Gayle Shomer Brezicki
Gayle Shomer Brezicki
Gayle Shomer Brezicki

109 Gayle Shomer Brezicki
Gayle Shomer Brezicki
Gayle Shomer Brezicki
Gayle Shomer Brezicki
Gayle Shomer Brezicki
Gayle Shomer Brezicki

112 Ted Richardson, *Winston-Salem Journal*
Scott Lewis
Scott Lewis
Scott Lewis
Scott Lewis
Scott Lewis
Scott Lewis

113 Scott Lewis
Scott Lewis
Scott Lewis
Scott Lewis
Scott Lewis
Ted Richardson, *Winston-Salem Journal*
Scott Lewis

116 Patrick Davison, The University of North Carolina
Patrick Davison, The University of North Carolina
Patrick Davison, The University of North Carolina
Patrick Davison, The University of North Carolina
Patrick Davison, The University of North Carolina
Patrick Davison, The University of North Carolina

117 Patrick Davison, The University of North Carolina
Patrick Davison, The University of North Carolina
Patrick Davison, The University of North Carolina
Patrick Davison, The University of North Carolina
Patrick Davison, The University of North Carolina
Patrick Davison, The University of North Carolina

118 Patrick Davison, The University of North Carolina
Patrick Davison, The University of North Carolina
Patrick Davison, The University of North Carolina
Patrick Davison, The University of North Carolina
Patrick Davison, The University of North Carolina
Patrick Davison, The University of North Carolina
Patrick Davison, The University of North Carolina

119 Patrick Davison, The University of North Carolina
Patrick Davison, The University of North Carolina
Patrick Davison, The University of North Carolina
Patrick Davison, The University of North Carolina
Patrick Davison, The University of North Carolina
Patrick Davison, The University of North Carolina
Patrick Davison, The University of North Carolina

120 Ami Vitale
Ami Vitale
Ami Vitale
Ami Vitale
Ami Vitale
Ami Vitale

121 Ami Vitale
Ami Vitale
Ami Vitale
Ami Vitale
Ami Vitale
Ami Vitale

122 Patrick Davison, The University of North Carolina
Janet Jarman, Contact Press Images
Janet Jarman, Contact Press Images
Janet Jarman, Contact Press Images
Janet Jarman, Contact Press Images
Janet Jarman, Contact Press Images
Kristian McAdams

123 Janet Jarman, Contact Press Images
Janet Jarman, Contact Press Images
Ross Taylor
Janet Jarman, Contact Press Images
Janet Jarman, Contact Press Images
Logan Mock-Bunting
Janet Jarman, Contact Press Images

124 Scott Sharpe
Janet Jarman, Contact Press Images
Mara Smith
Scott Sharpe
Scott Sharpe
Janet Jarman, Contact Press Images
Janet Jarman, Contact Press Images

125 Scott Sharpe
Janet Jarman, Contact Press Images
Janet Jarman, Contact Press Images
Scott Sharpe
Mara Smith
Scott Sharpe
Scott Sharpe

126 Coke Whitworth
Coke Whitworth
Coke Whitworth
Janet Jarman, Contact Press Images
Coke Whitworth
Coke Whitworth
Coke Whitworth

127 Coke Whitworth
Janet Jarman, Contact Press Images
Coke Whitworth
Janet Jarman, Contact Press Images
Coke Whitworth
Janet Jarman, Contact Press Images
Coke Whitworth

130 Charles S. Powell
Tim Lytvinenko
Scott Sharpe
Ross Taylor
Ross Taylor
Tim Lytvinenko
Scott Sharpe

131 Scott Sharpe
Scott Sharpe
Mara Smith
John L. White
Scott Sharpe
Tim Lytvinenko
Scott Sharpe

132 Ross Taylor
Micah Zunil Intrator
Ross Taylor
Janet Jarman, Contact Press Images
Janet Jarman, Contact Press Images
Janet Jarman, Contact Press Images
Janet Jarman, Contact Press Images

133 Janet Jarman, Contact Press Images
Janet Jarman, Contact Press Images
Logan Mock-Bunting
Janet Jarman, Contact Press Images
Logan Mock-Bunting
Mara Smith
Micah Zunil Intrator

134 Cindy Burnham, Nautilus Productions
Cindy Burnham, Nautilus Productions
Melody Ko
Duston Barto
Gillian Bolsover
Janet Jarman, Contact Press Images
Ted Richardson, *Winston-Salem Journal*

135 Janet Jarman, Contact Press Images
Janet Jarman, Contact Press Images
Melody Ko
Janet Jarman, Contact Press Images

Janet Jarman, Contact Press Images
Scott Sharpe
Christopher Record

136 John L. White
Janet Jarman, Contact Press Images
John L. White
Janet Jarman, Contact Press Images
Logan Mock-Bunting
John L. White
John L. White

137 John L. White
John L. White
Logan Mock-Bunting
John L. White
Bruce DeBoer
John L. White
Logan Mock-Bunting

139 Janet Jarman, Contact Press Images
Janet Jarman, Contact Press Images
Janet Jarman, Contact Press Images
Janet Jarman, Contact Press Images
Janet Jarman, Contact Press Images
Janet Jarman, Contact Press Images

140 Patrick Davison, The University of North Carolina
Patrick Davison, The University of North Carolina
Susie Post Rust, Aurora
Patrick Davison, The University of North Carolina
Susie Post Rust, Aurora
Sonia Katchian
Susie Post Rust, Aurora

141 Susie Post Rust, Aurora
Susie Post Rust, Aurora
Sonia Katchian
Susie Post Rust, Aurora
Patrick Davison, The University of North Carolina
Patrick Davison, The University of North Carolina
Susie Post Rust, Aurora

142 Ted Richardson, *Winston-Salem Journal*
Cindy Burnham, Nautilus Productions
Logan Mock-Bunting
Janet Jarman, Contact Press Images
Logan Mock-Bunting
Logan Mock-Bunting
Ron Flory, New York Institute of Photography

143 Logan Mock-Bunting
Sonia Katchian
Janet Jarman, Contact Press Images
Logan Mock-Bunting
Jason Arthurs
Sonia Katchian
Micah Zunil Intrator

144 Sonia Katchian
Gayle Shomer Brezicki
Christopher Record
Christopher Record
Christopher Record
Gayle Shomer Brezicki
Ami Vitale

145 Tim Lytvinenko
Gayle Shomer Brezicki
Mara Smith
Gayle Shomer Brezicki
Tim Lytvinenko
Rhonda B. Lowe, RBL Photography
Patrick Davison, The University of North Carolina

146 Ross Taylor
Logan Mock-Bunting
Logan Mock-Bunting
Scott Sharpe
Susie Post Rust, Aurora
Cindy Burnham, Nautilus Productions
Ami Vitale

148 Gillian Bolsover
Gayle Shomer Brezicki
Ron Flory, New York Institute of Photography
Coke Whitworth
Tim Lytvinenko
Patrick Owens, Greenville Technical College
Janet Jarman, Contact Press Images

149 Scott Sharpe
Logan Mock-Bunting
Janet Jarman, Contact Press Images
Janet Jarman, Contact Press Images
Logan Mock-Bunting
Logan Mock-Bunting
Janet Jarman, Contact Press Images

Staff

The *America 24/7* series was imagined years ago by our friend Oscar Dystel, a publishing legend whose vision and enthusiasm have been a source of great inspiration.

We also wish to express our gratitude to our truly visionary publisher, DK.

Rick Smolan, Project Director
David Elliot Cohen, Project Director

Administrative
Katya Able, Operations Director
Gina Privitere, Communications Director
Chuck Gathard, Technology Director
Kim Shannon, Photographer Relations Director
Erin O'Connor, Photographer Relations Intern
Leslie Hunter, Partnership Director
Annie Polk, Publicity Manager
John McAlester, Website Manager
Alex Notides, Office Manager
C. Thomas Hardin, State Photography Coordinator

Design
Brad Zucroff, Creative Director
Karen Mullarkey, Photography Director
Judy Zimola, Production Manager
David Simoni, Production Designer
Mary Dias, Production Designer
Heidi Madison, Associate Picture Editor
Don McCartney, Production Designer
Diane Dempsey Murray, Production Designer
Jan Rogers, Associate Picture Editor
Bill Shore, Production Designer and Image Artist
Larry Nighswander, Senior Picture Editor
Bill Marr, Sarah Leen, Senior Picture Editors
Peter Truskier, Workflow Consultant
Jim Birkenseer, Workflow Consultant

Editorial
Maggie Canon, Managing Editor
Curt Sanburn, Senior Editor
Teresa L. Trego, Production Editor
Lea Aschkenas, Writer
Olivia Boler, Writer
Korey Capozza, Writer
Beverly Hanly, Writer
Bridgett Novak, Writer
Alison Owings, Writer
Fred Raker, Writer
Joe Wolff, Writer
Elise O'Keefe, Copy Chief
Daisy Hernández, Copy Editor
Jennifer Wolfe, Copy Editor

Infographic Design
Nigel Holmes

Literary Agent
Carol Mann, The Carol Mann Agency

Legal Counsel
Barry Reder, Coblentz, Patch, Duffy & Bass, LLP
Phil Feldman, Coblentz, Patch, Duffy & Bass, LLP
Gabe Perle, Ohlandt, Greeley, Ruggiero & Perle, LLP
Jon Hart, Dow, Lohnes & Albertson, PLLC
Mike Hays, Dow, Lohnes & Albertson, PLLC
Stephen Pollen, Warshaw Burstein, Cohen, Schlesinger & Kuh, LLP
Rick Pappas

Accounting and Finance
Rita Dulebohn, Accountant
Robert Powers, Calegari, Morris & Co. Accountants
Eugene Blumberg, Blumberg & Associates
Arthur Langhaus, KLS Professional Advisors Group, Inc.

Picture Editors
J. David Ake, Associated Press
Caren Alpert, formerly *Health* magazine
Simon Barnett, *Newsweek*
Caroline Couig, *San Jose Mercury News*
Mike Davis, formerly *National Geographic*
Michel duCille, *Washington Post*
Deborah Dragon, *Rolling Stone*
Victor Fisher, formerly Associated Press
Frank Folwell, *USA Today*
MaryAnne Golon, *Time*
Liz Grady, formerly *National Geographic*
Randall Greenwell, *San Francisco Chronicle*
C. Thomas Hardin, formerly *Louisville Courier-Journal*
Kathleen Hennessy, *San Francisco Chronicle*
Scot Jahn, *U.S. News & World Report*
Steve Jessmore, *Flint Journal*
John Kaplan, University of Florida
Kim Komenich, *San Francisco Chronicle*
Eliane Laffont, *Hachette Filipacchi Media*
Jean-Pierre Laffont, *Hachette Filipacchi Media*
Andrew Locke, MSNBC
Jose Lopez, *The New York Times*
Maria Mann, formerly AFP
Bill Marr, formerly *National Geographic*
Michele McNally, *Fortune*
James Merithew, *San Francisco Chronicle*
Eric Meskauskas, *New York Daily News*
Maddy Miller, *People* magazine
Michelle Molloy, *Newsweek*
Dolores Morrison, *New York Daily News*
Karen Mullarkey, formerly *Newsweek, Rolling Stone, Sports Illustrated*
Larry Nighswander, Ohio University School of Visual Communication
Jim Preston, *Baltimore Sun*
Sarah Rozen, formerly *Entertainment Weekly*
Mike Smith, *The New York Times*
Neal Ulevich, formerly Associated Press

Website and Digital Systems
Jeff Burchell, Applications Engineer

Television Documentary
Sandy Smolan, Producer/Director
Rick King, Producer/Director
Bill Medsker, Producer

Video News Release
Mike Cerre, Producer/Director

Digital Pond
Peter Hogg
Kris Knight
Roger Graham
Philip Bond
Frank De Pace
Lisa Li

Senior Advisors
Jennifer Erwitt, Strategic Advisor
Tom Walker, Creative Advisor
Megan Smith, Technology Advisor
Jon Kamen, Media and Partnership Advisor
Mark Greenberg, Partnership Advisor
Patti Richards, Publicity Advisor
Cotton Coulson, Mission Control Advisor

Executive Advisors
Sonia Land
George Craig
Carole Bidnick

Advisors
Chris Anderson
Samir Arora
Russell Brown
Craig Cline
Gayle Cline
Harlan Felt
George Fisher
Phillip Moffitt
Clement Mok
Laureen Seeger
Richard Saul Wurman

DK Publishing
Bill Barry
Joanna Bull
Therese Burke
Sarah Coltman
Christopher Davis
Todd Fries
Dick Heffernan
Jay Henry
Stuart Jackman
Stephanie Jackson
Chuck Lang
Sharon Lucas
Cathy Melnicki
Nicola Munro
Eunice Paterson
Andrew Welham

Colourscan
Jimmy Tsao
Eddie Chia
Richard Law
Josephine Yam
Paul Koh
Chee Cheng Yeong
Dan Kang

Chief Morale Officer
Goose, the dog

W9-BVS-314